JIM DINE
PRINTS
1977–1985

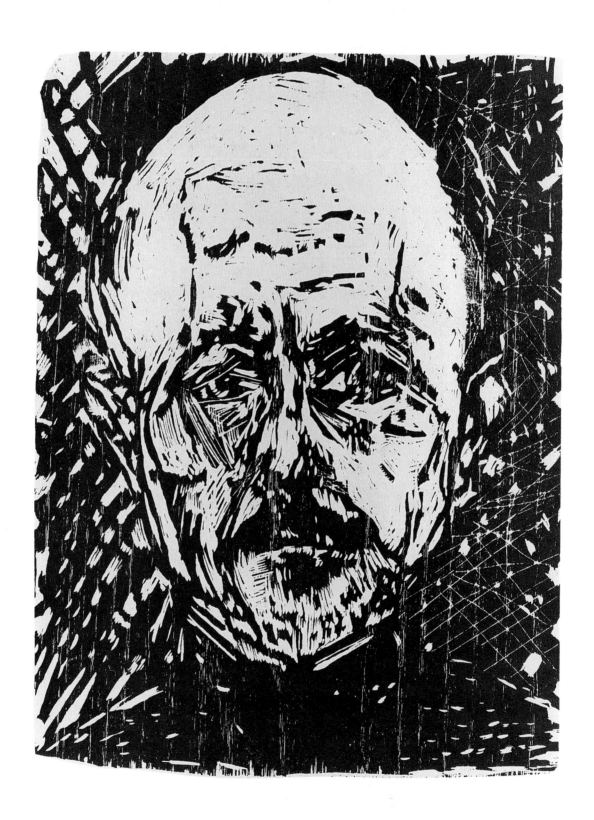

JIM DINE PRINTS 1977-1985

Ellen G. D'Oench and Jean E. Feinberg

Published in association with an exhibition
organized for the Davison Art Center and
the Ezra and Cecile Zilkha Gallery,
Wesleyan University, Middletown, Connecticut

ICON EDITIONS

HARPER & ROW, PUBLISHERS, New York
Cambridge, Philadelphia, San Francisco, London
Mexico City, São Paulo, Singapore, Sydney

PHOTO CREDITS

Unless cited below, all negatives were made by Joe Maloney, Pace Editions. Prints from the negatives were prepared for publication by Joseph Szaszfai.
Angeles Press, 196–205, Fig. 10
Nancy Dine, Figs. 7, 8, 11
Pace Editions, Figs. 9, 12
Petersburg Press, Figs. 1–4, 6
Laura Radin, 141a–141cc, 177a–177cc, Fig. 13
Joseph Szaszfai, 78, 178–181, Fig. 14
Universal Limited Art Editions, 18–22, 61, 68–72, 93–106, 131–136, 148, 149, 176, Fig. 5

Cover illustration: *Double Venus in the Sky at Night* (166).

Frontispiece: *The Artist as Narrator* (141a).

JIM DINE PRINTS, 1977–1985. Copyright © 1986 by Ellen G. D'Oench and Jean E. Feinberg. All rights reserved. Printed in Japan. No part of this book may be used or reproduced in any manner whatsoever without written permission except in the case of brief quotations embodied in critical articles and reviews. For information address Harper & Row, Publishers, Inc., 10 East 53rd Street, New York, N.Y. 10022. Published simultaneously in Canada by Fitzhenry & Whiteside Limited, Toronto.

FIRST EDITION

Designer: Abigail Sturges

Library of Congress Cataloging-in-Publication Data

D'Oench, Ellen.
 Jim Dine prints, 1977–1985.

 (Icon editions)
 "Published in association with an exhibition organized for the Davison Art Center and the Ezra and Cecile Zilkha Gallery, Wesleyan University, Middletown, Connecticut."
 Bibliography: p.
 Includes index.
 1. Dine, Jim, 1935– —Exhibitions.
I. Feinberg, Jean E. II. Dine, Jim, 1935–
III. Davison Art Center. IV. Ezra and Cecile Zilkha Gallery. V. Title.
NE539.D5A4 1986 769'.92'4 85-45188
ISBN 0-06-431501-0 86 87 88 89 90 10 9 8 7 6 5 4 3 2 1
ISBN 0-06-430144-3 (pbk.) 86 87 88 89 90 10 9 8 7 6 5 4 3 2 1

CONTENTS

Tour Schedule for the Exhibition Jim Dine Prints 1977–1985 vi

Acknowledgments vii

Jim Dine: Portrait of a Printmaker 1
Ellen G. D'Oench

"Not Marble": Jim Dine Transforms the Venus 23
Jean E. Feinberg

Catalogue Raisonné 58

Appendix 174

Chronology of Jim Dine's Major Printmaking Activities 176

Selected Bibliography 178

Checklist of Prints in the Exhibition 181

Index of Print Titles 182

TOUR SCHEDULE FOR THE EXHIBITION
JIM DINE PRINTS 1977–1985

Davison Art Center and Ezra and Cecile Zilkha Gallery
Wesleyan University
Middletown, Connecticut
January 22–March 9, 1986

Archer M. Huntington Art Gallery
The University of Texas at Austin
Austin, Texas
June 15–August 17, 1986

The Los Angeles County Museum of Art
Los Angeles, California
September 25–November 16, 1986

The Toledo Museum of Art
Toledo, Ohio
December 6–January 25, 1986–87

Des Moines Art Center
Des Moines, Iowa
February 13–April 12, 1987

The Nelson-Atkins Museum of Art
Kansas City, Missouri
April 26–June 14, 1987

The University Gallery
Memphis State University
Memphis, Tennessee
September 12–November 1, 1987

Williams College Museum of Art
Williamstown, Massachusetts
November 21–January 17, 1987–88

This exhibition and catalogue raisonné were made possible
through grants or special funding from the National Endowment
for the Arts, a federal agency; the John R. Jakobson Foundation;
the Lemberg Foundation; the Middlesex Mutual Assurance
Company; and Wesleyan University.

ACKNOWLEDGMENTS

The compilation of a catalogue raisonné is a task that requires the assistance and cooperation of many individuals. Jim Dine has worked with several publishers and many printers, all of whom provided documentation or granted interviews to discuss the editions on which they worked. For their generous assistance, we are grateful to Jeffrey Berman, Christopher Betambeau, Veronica M. Campbell, Alan Cristea, Aldo Crommelynck, Jeremy Dine, Nicholas Dine, Nancy Dine, Alan B. Eaker, Mitchell Friedman, William Goldston, Eileen Kapler, John Lund, Mary Foster Michel, Toby Michel, Nigel Oxley, Deli Sacilotto, Maurice Sanchez, Blake Summers, Robert E. Townsend, and David Yager.

Dine's primary publisher, Pace Editions, has been a constant source of support, making possible the continued viewing of its extensive archive of Dine's prints. Our special thanks go to Richard Solomon and his staff, Matthew Fraser, Christin Heming, Joe Maloney, and Joe Wilfer, for their cooperation and many kindnesses.

At Wesleyan University we have received invaluable assistance from students as well as from the staff of the Art Department and Center for the Arts. It is impossible to list all the members of the Wesleyan community who have helped with this endeavor, but those who have been especially dedicated are: Deborah G. Boothby, Janette G. Boothby, Margaret Daly, James D. Fellows, Lisa Hodermarsky '85, Douglas Kass '86, Kathryn E. Molloy, Laura Radin '83, Jean A. Shaw, Janis Shough '86, Pamela Smith, and Richard H. Wood. For printing of the photographs, we thank Joseph Szaszfai. We are also grateful to David Schorr, Anne F. Greene, and Marjorie and Barry Traub for their support.

This book and accompanying traveling exhibition would not have been undertaken without the encouragement of John R. Jakobson '52. Out of his long friendship and admiration for Jim and Nancy Dine, and his belief in the high quality of art programs at Wesleyan, this project was initiated.

The real burden in the creation of this volume fell on Jim and Nancy Dine. For, after all of their assistants and colleagues were consulted, it was to them that we looked for verification and further explanation. During the past two years, Jim and Nancy have made themselves continually available for hours of interviews and questions. For their guiding spirit and enthusiasm, we offer our profound gratitude. And finally we thank Jim, now at the age of fifty, for deserving the title of master printmaker and for creating the art that this volume documents.

Middletown, Connecticut, 1985

ELLEN G. D'OENCH
JEAN E. FEINBERG

JIM DINE
PORTRAIT OF A PRINTMAKER

Ellen G. D'Oench

Jim Dine has published more than six hundred prints in twenty-five years, almost half of them in the decade since 1975 while he worked as a painter, draftsman, and sculptor.[1] Prolific in production, he calls upon an encyclopedia of printmaking methods. Dine uses—and frequently combines—intaglio, lithography, woodcut, and screenprint. He works with an array of unconventional hand and machine tools on his printing surfaces and, occasionally, on the paper itself. Hand applied color—embedded between printings or painted on plate, block, or sheet—yields one-of-a-kind images that contrast with the traditionally uniform images of printed editions. Dine frequently recycles or returns to his plates to make alterations and erasures, recording changes in the single print or in multiple states to reveal ghost images and pentimenti surviving beneath layers of new work. The evidence of correction and revision enriches Dine's prints with what he describes as their "history." Dine is preoccupied with the tracks of the past, and his preoccupation points to an essential element of printed art: its capacity to reveal the metamorphosis of ideas in the sequence of their evolution.

The primary themes with which Dine first explored the territory of printmaking are isolated objects weighted with private meanings. Since the early 1960s, he has consistently acknowledged his robes, hearts, and tools as the stand-ins of autobiography: the robe as self-portrait, the heart as a "cleaved, full object" associated with the emotions, tools as the utilitarian artifacts of his grandfather's hardware store in Cincinnati.[2] These remain in the Dine iconography, treated as sensual physical objects or dematerialized as the symbols of Dine's private life. In the association of these themes with male and female roles, the robes, hearts, and tools are the prototypes for Dine's expanded vocabulary of subjects, still characterized by their sexual references but now frequently paired or given a landscape context: trees, plants, flowers, shells, gates, and the *Venus* images. But it was Dine's adoption of figurative subject matter that signaled the major thematic departure in his graphic work. In the early 1970s, figure studies multiply in Dine's drawings and prints. In 1971, the first self-portraits and portraits of Nancy Dine appear in his prints. With these, Dine found that he no longer needed to depend solely on the surrogate for human expression. Portraiture is now a major aspect of Dine's graphic work, representing a quarter of his production of the past ten years. Significantly, it was in the portrait that Dine made some of his most important discoveries as an intaglio printmaker. As experimental and serial images, developed to expand upon an initial idea, the portraits yield the clues for much of his recent work.

Because Dine's recent approaches to portraiture represent a break with

the past, a backward look at his work as a printmaker illuminates the subject's meaning in a broader context. The portraits are intimately related to Dine's accustomed scrutiny of objects, but only when he had rejected working modes established in his first decade as a printmaker did portraiture begin to acquire an important role. In the 1960s, Dine worked rarely in etching, occasionally in drypoint, and primarily in lithography. Like many contemporary painters, he was wooed and won by Tatyana Grosman at Universal Limited Art Editions, one of the patron saints of the lithography renaissance in the United States. Her famous printshop on Long Island was geared to help painters in realizing large-scale prints in color and to produce them in meticulously crafted editions, a complex task reserved for highly trained printers. At ULAE and with other printers, notably Chris Prater in London, Dine produced work that was, seemingly, related to the Pop Art movement. Pieces of clothing, robes, hearts, and tools appeared to suggest Pop's deadpan references to objects of mass culture. Dine allied some of these printed images with numbers or words to dispel the possibility of reading them in terms of pictorial illusionism. In his *Tool Box* series with Prater in 1966, screenprinting, collage, acetate papers, and photographic elements deny the artist's hand and ally the representation of the machine-made object with the mechanization of its production in print.

Despite some evidence for Dine's association with Pop, he maintained his close ties to self-referential themes, regarding his subjects as autobiographical rather than as the artifacts of consumerism. In large measure, he also affiliated his printmaking methods with premises rejected by Pop artists. Dine's preference for and approach to lithography had some relationship to his reasons for working occasionally in drypoint at this period: "I hated etching, I didn't want to get into waiting."[3] While etching demands expertise (and patience) with the needle and methods of acid biting, lithography is a more direct process for the painter who, like Dine, wanted to draw directly and spontaneously on the stone or plate. Lithography's reproductive potentials, explored by Rauschenberg, Johns, and other contemporaries, were of little interest to Dine. Characteristic of his work with ULAE is *Four C-Clamps,* 1962, one of his first lithographs, and his 1969 *Robe* images. Dine treated lithographic tusche (a greasy ink) with the freedom of watercolor, allowing it to flow across the stone in transparent washes or to drip and spatter in seemingly accidental marks. His manipulation of the crayon and brush insisted upon the authority of the moving arm and hand. In the private nature of their subject matter and their emphasis on activated surface, these early prints testify to Dine's frequently acknowledged debt to the Abstract Expressionists. Since his student years, he had admired de Kooning, Pollock, Rothko, and Motherwell. While Pop Art liberated itself from the expressive handling of materials linked with past traditions, Dine retained strong ties to a movement which he believes freed him to examine his European forebears.[4]

Dine's fundamentally expressionist attachment to the physical act of

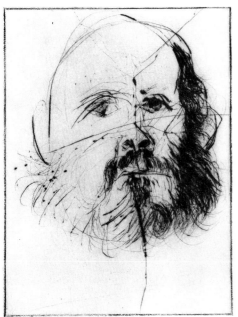

Fig. 1. *Self-Portrait*, 1st state, 1971, drypoint.

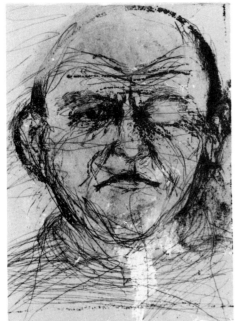

Fig. 2. *Self-Portrait (Dartmouth)*, 2nd state, 1975, drypoint, soft-ground etching, and electric tools.

working the image led him to become dissatisfied with the technology of lithography and to reconsider the more autographic qualities of etching. During the 1960s he had published several hard-ground etchings, including the *Bathrobe*, 1965. But it was not until 1969 that Dine began to explore the linear technique that was to become his signature as an intaglio printmaker for the next few years. After Dine moved to Putney in 1971, following a five-year sojourn in England, he produced a series of nine drypoint self-portraits (Fig. 1) emphasizing the wiry character of his hair and beard by the brittle incisions on the plate made with the drypoint needle. These are related to the etchings of this period, also made with Petersburg Press, in which hairy bitten line is analogous to the hirsute subjects it depicts, notable in *Four Kinds of Pubic Hair*, 1971, and *Braid*, 1972–73. In his extraordinary group devoted to the *Five Paintbrushes*, 1972–73,[5] Dine worked changes on the single plate and editioned the image in six successive states. These alterations were primarily additive in their sequence. As Dine increased the number of brushes from five to ten, so he built up in succession the tangled growth of their bristles and the tonal incident of their environment.

By 1973, at a time when lithography was still paramount among Dine's generation of painters, he had found that working with needles and acid stimulated his imagination. "To me, finally," he states,

there is in etching—work on copper—the most exciting work you can do. I really think so. I think lithography is the most boring, although I've gotten results I think are quite pretty. But it's like drawing, and then you reproduce the drawing. . . . Lithography always, for me, remains a bit knocked back, unlike etching, a bit unphysical. . . . With intaglio or with drypoint, you are drawing with metal or with acid, and it's something very much like an extension of my hand rather than me reproducing my fingerprints.

But Dine had reached something of an impasse. Having found a medium that engaged him, he had also discovered, in the *Paintbrushes* and other prints, etching's traditional adaptability to the creation of variant images from the single plate. This raised questions, if he was to amplify his ideas, about his limitations as an intaglio printmaker. Despite his many and innovative hard-ground etchings with Petersburg Press, Dine still regarded himself as a neophyte—a self-taught etcher whose experience had expanded little since his student years.[6] He was frustrated by his sense that there was more to learn. This was made more acute by his stimulating discussions in 1973 and 1974 about the history of prints and printmaking with Donald J. Saff, the master printer, then Director of USF Graphicstudio in Tampa. In separating himself from the high-tech aspects of lithography, Dine was equally critical of the machine-made look of uniform etching editions. He lacked challenge from expert printers whose expertise, as he saw it, signified their specific ways of doing things rather than his own. At this point in his career, Dine began the process of "getting away from the printers," as he describes it, and made a decision that was to have a profound and lasting effect on his approaches to

intaglio printmaking. Determined to focus his energies on experimentation, Dine spent three months in the fall of 1974 as a visiting artist at Dartmouth, not far from his house in Putney. The small printshop there offered both privacy and total control over working, inking, and printing the plates. More important, it offered Dine the assistance of Mitchell Friedman, a recent Dartmouth graduate working in the shop. Friedman was the first collaborator, Dine recalls, "who understood my natural bent."

Dine and Friedman worked together in Dartmouth, Putney, Cambridge, and New York until 1979 and again in Putney in 1981. The two men became partners in the process of making discoveries, capitalizing on accidents, and improvising with idiosyncratic methods. "Sometimes the work was sloppy in a technical sense," Friedman recalls.[7] He cites hectic periods when they worked on up to twelve prints at a time, some of them requiring three plates each, and others undergoing as many as twenty states in the same number of days. But for Friedman, Dine was an inspiration: "Jim will learn from anybody and then change the printer's own approaches." He shared Dine's exhilaration in what he describes as "the joy of discovery in building a vocabulary in shorthand." For Dine, it was a period of intense printmaking when he was free to experiment with a youth who brought few preconceptions to the printshop—only a willingness to try almost any technique.

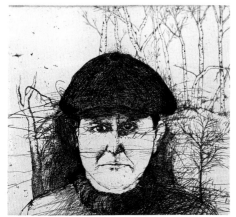

Fig. 3. *Self-Portrait in a Flat Cap,* 2nd state, 1974, etching and electric tools.

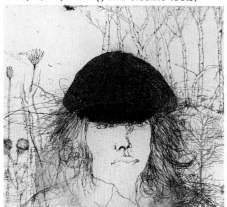

Fig. 4. *Self-Portrait in a Flat Cap,* 4th state, 1974, etching and electric tools.

Dine credits Friedman with encouraging some of his most important new discoveries in tonal methods. Among these was the use of electric tools, which, significantly, Dine explored first in his portraits. In 1973, he had experimented with the power-driven disc sander for the successive states of his *Self-Portrait in a Ski Hat* and *Self-Portrait in a Flat Cap* (Figs. 3 and 4). For the later states, Dine sanded down earlier work with a buffing wheel, preliminary to making revisions, and manipulated the electric tool to leave traces of grayed tones on the images. But the turning point in his use of power tools came with the second states of Dine's nine *Self-Portrait* drypoints of 1971 (Figs. 1 and 2), proofed by Friedman in 1975 in the Putney studio. Here Dine introduced the more radical revisions made possible with the die-grinder. With this electric tool and its various bit attachments, Dine found that he could adapt a single implement to the different functions of expressing tone and line. "It was amazing," Dine recalls, "because it doesn't just erase, it gives you another thing to draw with." He eradicated portions of the drypoint portraits, erasing lines (and his beard) with sanding discs, and smudging and blurring for tonal incident. But he further enhanced their transformations by plowing coarse incisions into the plates. These disruptions contrast with the remnants of drypoint and lend a kinetic energy to the alterations of the portraits. Laborious burnishing by hand no longer had to be a limiting factor—"I just couldn't stand the scraping out." The machine accomplished for him in minutes what normally would have taken many hours or days.

More than any other single factor, Dine's mastery of electric tools made possible his new approaches to etching. Before 1974, his exploration of

states had been primarily a process of adding imagery and tonal markings to the plate. It now became an integral part of his printmaking to revise, obliterate, and rebuild. A testament to Dine's engagement with his new working methods is found in his three states of the Dartmouth tool prints, culminating with *Piranesi's 24 Colored Marks,* 1974–76. Like the earlier *Paintbrushes,* objects and tonal markings multiply in the series of states. But the images are blacker because of Friedman and Dine's preference for deep biting and heavy inking. More important, they progressively record Dine's erasures and corrections, the charcoal-like smudging which he achieved with the power-driven implement. In the monumental, Piranesian architecture of the objects arrayed along the foreground of the third state, Dine intensifies the autobiographical exploration of the tool theme, which he had introduced in his prints more than a decade earlier. He now adds to his vocabulary both literally and metaphorically the presence of the die-grinder, which appears on the far right of the row of tools in the second and third states.

The Dartmouth portraits and other prints of this period also incorporate work with soft-ground etching and aquatint, two of the many techniques which Dine explored with Friedman. As he established his use of soft-ground, Dine draws the initial image on a sheet of paper affixed to the plate and then further works up contour and texture by pressing his fingers, towels, or cloth into the tacky ground. Aquatint was a more problematic medium. Before he began to work with Friedman, Dine "hated using aquatint; hard-ground and foul bite were good enough for what I wanted." Now he ignored aquatint's traditional applications and became more physically involved with it as a direct process by splashing acid on the grounded plate, by drawing on it in the open-bite technique, or most frequently, by using spit-bite.[8] With this technique, Dine paints acid on the plate and, to prevent it from beading up, smudges it with saliva to achieve the subtle cloudlike effects resembling areas of watercolor, seen in *The Brown Coat* (3). Dine and Friedman also explored the use of ink films left on the plate surface and selectively wiped (1, 2, 8), and ink pulled out of the lines in retroussage.

Working on the etching press in Putney,[9] Dine produced in 1976 the first states of his figurative studies, *Eight Sheets from an Undefined Novel,* derived from charcoal drawings. Here the use of soft-ground's blurred contour and grainy texture becomes the printed equivalent of effects of charcoal on paper. Two years later, Dine effaced areas of the *Eight Sheets* plates with a sander and die-grinder (33–40), altering the appearance of his characters with added work in etching and aquatint. These prints were among the first to exploit what, normally, printers try to avoid. By printing the same plate twice to sandwich color between runs, Dine deliberately encouraged their slightly off-kilter placement on the press. The result is off-registration, a characteristic of the Dine-Friedman collaboration. To Dine, it expresses "the non-machine, it's a little more human, as if a human printed it. I like a mistake. Off-registration is about connecting, leaving pentimenti, leaving tracks."

Off-registration is also a method of enhancing the relationship between soft-ground etching and charcoal, a medium with which Dine had become preoccupied. Indeed, there are numerous parallels between his new methods of printmaking and his renderings in charcoal and pastel of the human figure made during the same period. Always a draftsman, Dine renewed his examination of the live model in Putney in 1974 and 1975, producing large numbers of figure studies and, occasionally, portraits. Their likeness to the sitter was important to Dine, as was his interest in the specifics of anatomy and private emotions—"what life has done to the face."[10] These and his large-scale drawings of a range of subjects in the following years are characterized by their emphatic physicality of method. As in his approaches to printmaking, Dine draws by correcting, by rubbing out, sanding, and making new marks, erasing again, and starting over. The paper is frequently gouged and torn, and occasionally ruptured by electric sanders. Charcoal and pastel marks reveal multilayered accretions which Dine has described in numerous interviews as giving the work a past history: "I love people's tracks. . . . I want all that history."[11]

Both the drawings and prints owe a debt to Dine's study of figurative works, which intensified while he lived in Europe. Van Gogh, Matisse, and Giacometti are those he most frequently cites as among the sources of his ideas.[12] He is interested in these artists' approaches to characterization by their rendering of the expression, pose, or gesture particular to the sitter. Perhaps as important, Dine sees the artist's evident struggle with drawing and its materials, particularly charcoal, as a means of associating the viewer with a sense of the sitter's emotional life. Heightening the expressive charge of the image are the visible traces of the process through which it has been constructed over a period of time. Dine's renewed interest in these artists stimulated him to adopt a public stance as a figurative printmaker before mounting major exhibitions of his drawings. Significantly, Dine has stated that, until mid-1970, printmaking was the only medium in which he felt "free enough to be figurative. . . . making prints was the first place my interest in figurative art raised its head."[13] This is indicated by his *Rimbaud* series as well as his early 1970s self-portraits and portraits of Nancy. But his self-confidence and methods as a draftsman were so closely allied to his new directions as a printmaker that the two endeavors are inextricable when considering his graphic work at midcareer.

Dine's quotations in etching are also allied to his expanded interest in European forebears in printmaking (his own collection includes etchings by Castiglione and Picasso). In terms of exploration of states and tonal experimentation, Rembrandt's portraits and self-portraits, undergoing as many as eleven states, are the primary ancestors of this tradition in intaglio portraiture. It is perhaps no coincidence that Dine's *Self-Portrait in a Flat Cap,* developed in four states in 1973, is a patent reference to Rembrandt's many portraits bearing similar titles. Both Dine and Friedman recall their discussions about Rembrandt's etchings and drypoints during the mid-1970s and, moreover, relate the early

Fig. 5. *Self-Portrait as a Negative,* 1975, etching, drypoint, and electric tools.

monoprinting experiments to Rembrandt's use of ink film, selectively wiped on the plate for coloristic effects.[14]

Although Dine had hand colored his prints since the early 1960s, Friedman's lavish inking was the springboard for his ideas of more radical experimentation with handwork. As with his tonal experiments, Dine's major new directions in the use of color in his prints appear first in his portraits. *The Hand Painted Self-Portrait,* printed at ULAE in 1975 (the first state of *Self-Portrait as a Negative,* Fig. 5), is one of the earliest examples of his extensive use of monoprinting and hand coloring in his etchings of the succeeding years.[15] Following this with the *Dark Blue Self-Portrait,* 1976, and two prints in the *Harvard Self-Portrait* series, 1978 (24, 28), printed with Friedman, Dine established several approaches. These include monoprinting at the same time that the inked lines are imprinted on the sheet, painting on the plate or sheet before or between printings to sandwich the color, and painting on the image after printing. One of Dine's most innovative uses of color printing is seen in the tree diptych, *Blue,* 1981 (89). This project was one of his last associations with Friedman, who turned to painting full time in 1981. Dine first had the sheets printed in blue from a plate formerly used for his *Strelitzia* series (73–78). But rather than printing from the inked lines, the plate was inked in relief roll on the surface only. The blue coloration serves as an atmospheric setting but, more important, it functions to allow the plant forms to survive in ghostly white lines below the black trees imprinted above them. They are the survivors, the historical evidence, the tracks of the past now vital to Dine's requirements for the printed image.

During the years with Friedman and in the years since then, Dine has worked with printers in an unusual diversity of locales. Aldo Crommelynck in Paris has been a major figure in Dine's career since 1977. But before turning to his role in Dine's printmaking and portraiture, a brief survey of Dine's other past and present associations illuminates the variety of Dine's printshop experiences. From 1979 to 1981, Dine worked at the Burston Graphic Center in Jerusalem, where he produced several portrait series and where "everything was at my disposal, without the vanity of American print shops. . . . I like a printer who feels he is a tool for me, feels that he is the ink and the press. The ideal printer is an extension of me and the press."[16] The sense of partnership he felt for Ami Rosenberg and Keren Ronin at Burston (and when they worked in New York in 1980) existed for Dine in working with his young cousin, Jeffrey Berman, in 1980. Dine learned new lithographic transfer techniques in 1980–82 with Maurice Sanchez in New York, produced the magisterial group of *Tree* etchings in 1981 with young printers at the Palm Press in Tampa,[17] and in 1983, renewed his associations at USF Graphicstudio II, Tampa, working with students under Saff's supervision.[18] Also in 1983, Dine formed a relationship with Toby Michel in Los Angeles where he continues to produce lithographs, woodcuts, and monotypes when he is living on the West Coast. Dine regards Michel's lithography "as good as you're going to get in America.

I love Toby. He's a loyal, loyal worker. I like that kind of collaboration." Since 1978, Dine has also printed in New England with Robert Townsend who offers Dine a huge press (70 × 100 inches) for printing etchings and woodcuts. An experienced printer, Townsend makes a conscious effort when working with Dine to be flexible in his methods, warmer than usual in his inking, and less concerned with consistency of editioning in response to Dine's preference for the edition's "ebb and flow." Townsend is sensitive to the delicacy of copper surfaces worked with sanding and abrading tools (they must be steel-faced daily during editioning), and sums up what he sees as his priority in the collaborative endeavor: "You want to make sure you're giving Jim everything that can be gotten off the surface of the plate."

Dine's need to take control and to be challenged in return can be seen in his relationship with Aldo Crommelynck, the legendary French printer. Renowned for his technical perfection, Crommelynck offered another set of ingredients, distinct from Friedman's contributions, for Dine's new approaches to etching. After working with Crommelynck on the *Paris Smiles* and *Mabel* images, published in 1976 and 1977, Dine resumed his relationship in 1977 when he began *Nancy Outside in July,* the first of what was to become twenty-five portraits. These portraits, continuing until 1981, consolidated not only his collaboration with a master who "is so much greater than any other in the world that to call him Printer is all that is necessary,"[19] but also his allegiances to the European printmaking traditions represented by the Frenchman. At the age of seventeen, Crommelynck began his training as a printer of reproductive *estampes,* becoming expert in line and tonal techniques (especially soft-ground and aquatint) to translate artist's drawings into prints. His collaboration with Picasso, with whom he worked for twenty years, resulted in the editioning by Crommelynck of nearly half of Picasso's graphic work.[20] The presence of the past is palpable in his atelier located on the ground floor above the presses and printers working below. For those who print with him (including David Hockney, Richard Hamilton, and Jasper Johns), Crommelynck reserves the privacy of his immaculately equipped shop and is ready to proof for hours into the night after the printers have gone home.

The atelier serves Dine as both classroom and skirmishing ground. He credits Crommelynck with many revelations in his exploration of soft-ground etching and of aquatint as a painterly medium as well as in their shared interest in searching out unusual papers. Crommelynck's vast repertory of tools (as still life in the shop, they are represented in Dine's 1984 series, Nos. 171–75) includes the French equivalent of the Dremel and flexible-shaft tools which he found for Dine in a hobby shop in Paris. Crommelynck speaks of Dine as unusual among painters who have come to him because he was "fully conversant" with intaglio methods from the beginning. He draws comparisons between Dine's "impetuous" working methods and Picasso's practice of working on plates in the printshop while Crommelynck was proofing others, and then saving them up before

editioning as many as fifty prints at one time. Crommelynck describes his relationship with Dine as one in which he will suggest a technique and type of paper, or initiate an idea, but "Jim takes it much further. Jim is always changing. It is impossible to keep track of what he does to a plate. Editioning comes only after many stages of work."

Crommelynck's experience and responsiveness animate Dine: "Every time we do a project I change something that has to do with Aldo's training and frustrate him and excite him too." Dine is spurred for contest in part because there is some ambiguity about his attachment to what he describes as a "super-elegant" workshop where "everything has to be perfect." Needing its history and ambience and admiring of Crommelynck's mastery, Dine is wholly irreverent about procedure. "I use the mezzotint rocker sometimes with a chisel or with a hammer. I push it like that and it raises this huge burr. Aldo just can't get over it." He scrapes plates on the floor for tone or pours and splashes acid on his plates to give his aquatint a more personal signature than Crommelynck's flawless handling: "It's just a mess. I'm on the edge always of dying from the fumes or burning my hands. But I seem to try and pull it together." When using electric tools for his *Desire in Primary Colors* (120), Dine recalls that he "shot copper all over the place—good stuff." As he recently told Pat Gilmour, who was working on a comparative study of Hamilton's and Dine's associations with the French printer, "I like to have Aldo's depth of history. . . . [he] had so much to teach me, and I had so many rules to break there, which is what I love doing. . . . His is very dry and precise classic French printing. I've tried to break all those habits there, not to change him, but to use him to work off of."[21]

Crommelynck's technical resources and his readiness to initiate or respond to imaginative solutions helped to focus Dine's work on several of the most important sequences of the artist's career. This is no better exemplified than in the collaboration from 1977 to 1981 when Dine worked primarily with Crommelynck on the series of twenty-five prints, *Nancy Outside in July*. At intervals during the five-year period, Dine repeatedly scrutinized his wife as model, producing transformations in her portrait beyond the scope of any he had worked thus far. These prints synthesize much of what Dine had learned since 1974 as well as his on-going discoveries in his encounters with Crommelynck. As the most sustained of Dine's explorations in the printed portrait, they also represent many of the recurring concerns in his printmaking today.

The first five etchings of Nancy, published in 1978 (18–22), progress from clarity of contour to darkened environment, with additions of color printing and hand-painted elements, and then return to the simplicity of the original image. But by the third state, lilies appear in the foreground flattened against the woman's chest. In 1979, Dine's single etching of Nancy (61) luxuriates with the flowers now enclosing her face. The seventh through eleventh versions of 1980 (68–72) portray flowers burgeoning, transformed into tulips obscuring Nancy's figure, and then

reduced to pentimenti. By the fourth image in this cycle, *Nancy Outside in July X,* the woman assumes an altered presence; the eyes and body confront the viewer more directly and the marks on her face suggest inner tension. This image is the key for the final group of fourteen prints, produced in a sustained burst of activity in 1981 (93–106). Mutations in plant forms appear and disappear; surroundings are darkened or the figure brightened with colors; the face expresses anxiety or withdrawal; the portrait becomes, in several instances, unrecognizable, even unpleasant. Again, as with the first five prints, this final group is circular in sequence. It ends with *Nancy Outside in July XXV,* a recollection of *Nancy X.* But now the graphic means are simpler, the image more muted in tonality and assertiveness than the flowers drawn on the lower margin.

How are we to read this extraordinary record of a single woman's personality? Perhaps something of Dine's intent may be suggested by the decisions he made as he constructed the series. He used at least sixteen plates, several of them going through numerous states. These are introduced, altered in surface and printing sequence, used, discarded, and retrieved. But the key plate remains as the leitmotif. It commences the series as a soft-ground contour, enters its ninth state by the tenth print, and after serving as the basis for subsequent impressions in photogravure or remaining unused, it is recalled again in the last two prints. By the end, the plate is exhausted; it yields a faint image as if, metaphorically, it parallels the aging process of Nancy herself during her engagement with the portrait. As the main survivor, it is the symbolic structure upon which the sequences depend as they circle back to recall earlier motifs or introduce new elements.

Similarly, traces of the flowers from *Nancy VII* are barely visible in *Nancy XXV.* They have multiplied, been replaced, and finally diminished to fragments as new plants appear in charcoal on the sheet. More concretely than the hearts (which may be seen as stand-ins for Nancy as are the robes for Dine), flowers are Nancy's primary attribute. Since their appearance in Dine's early prints of Nancy, they have testified to her love for gardening which now extends to an expertise in botanical exotica and book illustration (177). Through his alterations to the flowers and introduction of new plant forms (tulips, vines, trees, irises), Dine enriches the dimensions of Nancy's portraits. Her changing environments suggest both the passage of time and the regeneration of organic growth.

Nancy has speculated about the complex relationships between the artist who observes and the model who sits "to be looked at" in referring to the women in the portraits of Cezanne, Matisse, Picasso, and Giacometti.[22] These artists, and undoubtedly Nancy herself, are sources of inspiration. But, in terms of Dine's experimentation as a printmaker-portraitist, it is the German Expressionists who are the closest references for his fertility of technical invention. Like Kirchner, Pechstein, and Nolde, Dine uses complex methods of corrosion and wholly unconventional means of working the copper. Almost every known form

of aquatint appears in *Nancy Outside in July*—as flat field, with open-bite and spit-bite, in lift-ground by brush or filtered through a screen, with grease-crayon resist, or scraped down like mezzotint. Reminiscent of the idiosyncratic tonal methods adopted by the Brücke artists, Dine's method is to exploit surfaces for chance markings or to work with unusual implements, such as wire brushes and nails. Similarly, he frequently circumvents specific definitions of either drypoint or engraving techniques through his facility in combining the functions of tools. Although there may have been precedent in the use of a mechanical burnisher by Kirchner, and Dine is not alone among printmakers who use electric tools today,[23] he has no peer in his ability to manipulate power tools to lift delicate burr or plow incisions into the plate, achieving variations in line and tone. Just as much of his work with and without acid escapes traditional description, so no one medium is sacrosanct. Like the Expressionists, Dine often subverts the purity of etching (as well as lithography and woodcut) by nonprinted means, applying paint to plate or sheet, with additions in oil, pastel, watercolor, and charcoal.

Dine's investigation of Nancy in print closely parallels in time and method his encounters with his own face in the mirror. He printed his first self-portraits, the drypoint series, in 1971, the first year that he etched Nancy on copper. The first etched self-portraits of 1973, including *Self-Portrait in a Flat Cap* (Figs. 3 and 4), were produced at the same time as the three states of his *Nancy* etchings, including *Begonia* (Fig. 6), his earliest sequence of portraits of his wife. The simplified line etching on the face and figure of Nancy in this series is almost unchanged; additions to the plate consist of paintbrushes and, in the third state, begonias. But what is curious about the face of Nancy here is the fact that Dine appropriated her features to replace his own in the third and fourth states of his 1973 *Self-Portrait in a Flat Cap,* published in 1974. With this odd transference, Dine merges his wife's image with his own to suggest, perhaps, the look-alike resemblance of the proverbial couple in a long-lasting marriage. Since portraiture in Dine's prints is primarily that of the artist and his wife, speculation about their marriage is inevitable. Their relationship is, indeed, a close one. For twenty-five years, Nancy Dine has been the artist's most familiar model and he has called her, on more than one occasion, his "muse."

The correspondences in printmaking techniques between the portraits of artist and wife are too numerous to cite. But one hitherto unmentioned aspect of Dine's prints is significant as it applies to the portrait. Dine painted the sheet black and inked the plate in white for *Nancy Outside in July XIX* (100) to produce a negative image in the whitened face against a dark ground. This relates the portrait to the negative imagery with which Dine had experimented in lithography as early as 1964 and in intaglio in his 1975 *Self-Portrait as a Negative.* In their reversal of tones and their transparency, the portraits are analogous to that preliminary stage in the photographic process when the image awaits its final form. The viewer of the negative is required to make mental transpositions from

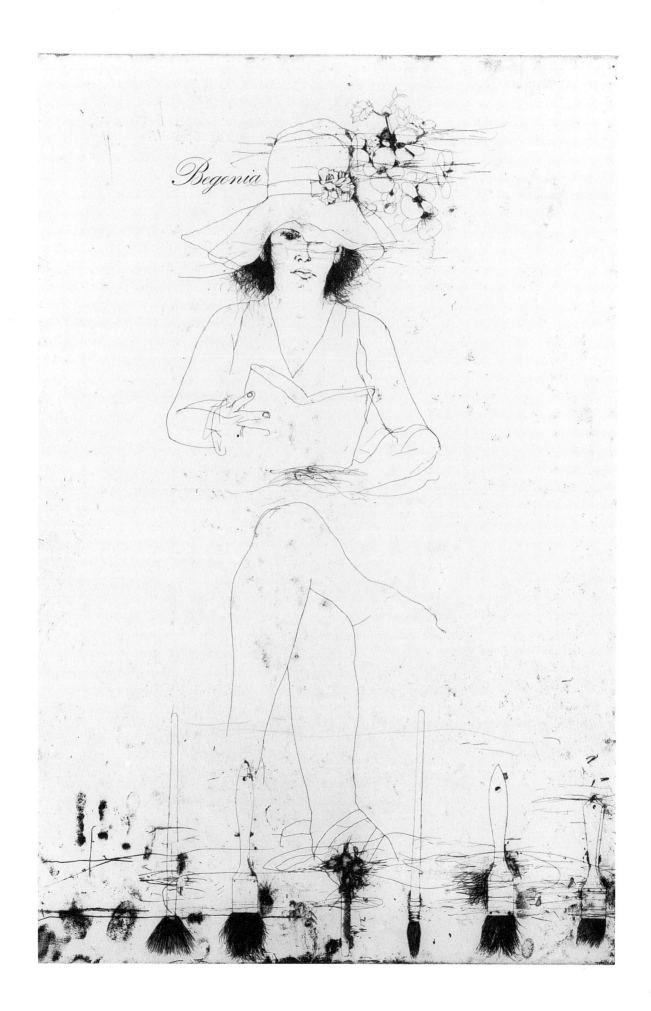

Begonia

Fig. 6. *Begonia,* 1974, etching and hand coloring.

an incompleted process to the final stage of normal seeing. For Dine, this visual activity or participation inherent in looking at negative images represents what printmaking, as opposed to painting and drawing, is all about: "It's a most obvious thing to do. It has to do with my romance, the magic of the process, the idea that you can switch over the ink color and make a wholly different print. It charges me up, the creative idea. It's the same image but it isn't the same image."

Something of this interplay between printed imagery and the spectator's active engagement with its process is suggested in the five prints of Nancy and the nine self-portraits made at the Burston Graphic Center in Jerusalem in 1979 (42–55). After working the initial lithographic sketch for *Nancy in Jerusalem* and its three successive variants, Dine hand painted the fifth state and radically reduced its format to focus on the face (55). Dine's nine states of his *Self-Portrait* similarly begin with the figure at nearly half-length and, after sequential reduction, end with the hand painted close-up (50). The Jerusalem portraits continue Dine's ideas about progression of viewing in a temporal sequence. But, rather than maintaining the size of the plate and playing variations within its borders, as with the Crommelynck *Nancys,* Dine explores psychological responses to changes in scale. The viewer is required to maintain a distance from the large images and then to alter position to move in for a closer inspection of the last states. By ending both sequences with the portraits in dense coloration and drastic reduction, following the more expansive linear description of the earlier states, the artist invites altered forms of interpretation. But the expectation of greater intimacy in viewing the close-up is thwarted by the extreme compression of the image and the expressions on the faces, especially Dine's, of anxiety and withdrawal. In fact almost nothing remains of his image but the brow furrowed with lines and the tensed features in the center of the face. As the portrait becomes increasingly compressed and the margins correspondingly larger in relationship to the plate, the viewer's perceptions shift with the near and far view. The face within the plate-mark, finally, appears to retreat behind the barrier of a window set into the sheet.

Dine's approach to pendant or serial portraiture is allied to his intense examination of trees and plants. The tree as an isolated theme first appeared in Dine's paintings in 1980 and in the five intaglio prints made in Tampa in 1981 (79–84). Anthropomorphism is the evident characteristic of the swelling contours and swaying limbs of these female forms in the guise of trees. The plates undergo strenuous attack from deep gouging of electric tools and acid biting; off-spectrum colors and off-registration contribute to the sense that the trees vibrate in muscular or sinewy agitation. Like the *Nancy Outside in July* sequence, changes to the plates and inking evoke a shift in mood as the trees comply with their environment in bright or somber coloration. By pairing two trees in *Blue* and *Swaying in the Florida Night* (89, 143), Dine offers images that, although they are not the same, raise questions about correspondence. Dine's figurative work includes one print that may be seen as a double

13

portrait of himself and his wife: *Two Figures Linked by Pre-Verbal Feelings,* 1976. But we may speculate that Dine suggests human pairing in some of his prints of doubled hearts, robes, trees, Venuses, shells, and plants. Paired images appear among four of the eight *Jerusalem Plant* prints made at ULAE over a period of three years from 1982 to 1984. These pairs are at their most effusive in the two largest lithographs of the series: *Jerusalem Plant #6* (136), printed from a single plate, and *Jerusalem Plant #7* (148), printed from the same plate but also incorporating printings from stones used in earlier states. In these examples of his recent lithography, Dine gave his hand and arm latitude to work the images of paired Dracena plants with rubbing stick and liquid tusche in spatter, long strokes, dragging, and dabbing patterns. Much as Dine describes the lithographic materials as having a life of their own—"my biggest problem, as is my biggest problem in life, is staying within the borders"—so the plants generate an inner vitality as they appear to press against the confines of their sheet.

Two sets of pairs in the series, *Jerusalem Plant #2* and *#3,* 1982 (132, 133), are woodcuts. These represent Dine's new self-confidence in a medium which he has reinterpreted for some of his most innovative recent work. Again, as with the etchings of the mid-1970s, Dine worked in portraiture and figurative subjects as he developed a new language for a diversity of themes. But it was not until 1982 and 1983 in the *Apocalypse* self-portrait and the Aspen *Nancys,* that Dine fully adopted woodcut for his portraiture. Working with single and paired blocks, Dine reexamined the portrait in this most venerable of printmaker's mediums.

As early as 1954, Dine made his first figurative woodcuts as a student at Ohio University and printed them in black enamel paint—"I was thinking about Hyman Bloom and Jewish expressionism." In common with most of his contemporaries, he rarely used relief surfaces in his 1960s prints.[24] In 1974, Dine retrieved the medium of woodcut by carving a group of self-portraits with Hartmut Freilinghaus in London and having them printed by hand-rubbing with a spoon. These portraits (never published) and his first published woodcut, *The Woodcut Bathrobe,* 1975, were directly inspired by Dine's visit in 1973 to the Munch Museum in Oslo. In technique, the *Bathrobe* is, in effect, a tribute to Munch's innovations in emphasizing the texture of wood grain, in jigsawing, inking, and reassembling color elements before printing, and in incorporating lithography in the image.[25] Although the *Bathrobe* marks an exploratory step for Dine, it was one of the earliest woodcuts by a leading artist to presage the widespread interest in the medium among American and European painters today.[26]

When Dine renewed his interest in woodcut in the early 1980s, part of its appeal was its relative simplicity of means. Dine traveled frequently and found that he could work on wood at odd moments in Putney, in such varied locations as London and Jerusalem, or in workshops while waiting for other work in progress. The block was adaptable to being printed by

hand rubbing or on presses where he was accustomed to working in etching or lithography. The critical factor in Dine's adoption of woodcut, however, was his discovery that he could work in large scale on sheets of plywood because of his familiarity with power-driven tools. Having begun to use the electric Dremel (Fig. 7) on copper in 1980 for the *Strelitzia* series (73–78), Dine found it invaluable as a partner of hand gouges, chisels, and knives for delicate work on the image. At the same time, he established his expertise in the use of a flexible-shaft tool with a chisel or gouge attached to the end (Fig. 8), enabling him to go through large areas of wood "like butter." Something of Dine's response to the physicality of carving is revealed in his recent statement about woodcuts:

I don't really cut them spontaneously, I make elaborate drawings and follow the drawings exactly. I take a brush and use India ink or something like that and I draw on the wood and let it dry. And then I spend days and weeks sitting with the wood on my lap (or on sawhorses) using the Dremel, following it exactly. And it's so soothing. It's like you put yourself into another state. You think about a lot of other things but you are also inventing as you go along. Because the Dremel is not exact and you can never find the exact thing you want. It pisses me off a lot. Because I think I got it down and suddenly that part of the wood won't work or the Dremel itself goes very dull. The glue in the plywood makes the Dremel dull. You still don't know why it isn't working for you, so you must invent to produce your line. So the invention takes place sometimes within a square inch. You start to invent and that gets really exciting and engrossing and you forget where you are.[27]

Dine's innovations with power tools freed him to conceive of woodcut as an extension of his ideas in painting while also relating it to the roughness of materials and scale of the large bronze sculpture which preoccupied

him at about the same time in 1982–83. An example of the radical change in his approach to woodcut is the *Fourteen Color Woodcut Bathrobe,* 1982 (112). Like his earlier mixed-media *Woodcut Bathrobe,* the block was jigsawed before printing, reassembled, and inked for exposure of the wood grain. Entirely different in concept, however, is the image's second printing from another woodblock which impresses its black design onto the color. The second block serves two visually contradictory functions. In the modern woodcut tradition, it reveals its woody substance in the inking of the gouge marks surviving from the sunken or negative areas of the block. The same block also asserts the presence of freely handled and aggressive brushstrokes carved over its surface. In gestural immediacy, these are worked to resemble the effect of a brush loaded with black paint or dragged dry across the paper's surface. The impulse to read these black marks as hand-applied paint is denied by the evidence of the gouge, reminding the viewer that the strokes are carved in relief. Their ambiguity or illusionism in relation to the known woodiness of their material is Dine's expression of irreverence about the shibboleths of the medium's integrity. He intentionally confounds our conventional expectations and experiments with woodcut as a painterly process.

Dine was to alter his approach to color from relief surfaces just as he used a diversity of techniques for the black and white woodcuts of the same period. In 1981 he exploited incised white line and negative imagery to dramatize the lunar light in the *Big Black and White Woodcut Tree* (85). The curving, white forms in the *Jerusalem Plant* woodcuts, 1982, play off against the vertical textures in the black backgrounds. The pronounced wood grain in these prints was enforced by imprinting the blocks on soft Japanese papers. A coloristic *tour de force* is the triptych *The Three Sydney Close Woodcuts,* 1983 (147). Dine carved these surfaces to yield up

smudged and blotted tones as well as areas of sharp distinction between black and white.

Nearly contemporary with this painterly woodcut are Dine's most conventional works in the medium: the twenty-seven prints made for the Arion Press *Apocalypse,* 1982 (141). To associate these images with historic woodcut prototypes in Biblical illustration (Dürer was not the first to illustrate the theme in woodcut), Dine simplified his carving to work his oak blocks for strong graphic contrasts in black and white. The self-portrait frontispiece, *The Artist as Narrator* (141a), is characteristic of the group as a whole. Dine cut into and sliced the block with manual and electric tools to express the angularity and ruggedness inherent in carving an image in relief from wood. Although Dine's pose is frontal and the background patterned, the portrait's economy and chiseled black line closely relate it to Max Beckmann's woodcut *Self-Portrait* of 1922, itself a paraphrase of the German woodcut tradition.

With the *Venus* images of 1983–85, Dine was to take further liberties in allying the woodcut with other media and recycling and manipulating its elements. Returning to images of Nancy, the black and white woodcuts and their multicolor variations made in Aspen in 1983, Dine extended his experimentation into the most monumental of his portraits to date. The huge head and shoulder portrait in the *Black and White Nancy* woodcuts (152, 153) fills the shallow foreground space; the latticed pattern behind her, as in many of the woodcuts, indicates a landscape setting. To heighten the physicality of the woman's presence, Dine presents her at nearly life-scale and emphasizes the prominence of her large, slightly off-kilter eyes and the swirling lines of her hair. Hand and power tools carve a tapestry of chisel marks, staccato line, and pitted and cross-hatched areas. In the first version particularly, Dine expresses the figure's three-dimensionality by following the curves of her form with chisel marks and by patterning the surface to capture reflected light in the shadows of her face. Distinct from his more schematic *Apocalypse* self-portrait, Dine's *Nancy* woodcuts explore the pictorial boundaries of what is possible to achieve on the surface of a single plywood block.

Unlike copper, the woodblock has a limited capacity for tonal modulation or progressive revisions. Effects which the artist may extract from the intaglio surface with acid biting, burnishing, and variant inking may be simulated to a degree in woodcut by sanding or scratching on the existing relief surface. More drastic revisions can be effected by introducing sawn elements in different color printings or in the reduction of areas of the block's surface. But what was first cut away cannot be replaced with new work. Woodcut, therefore, presents challenges for an artist like Dine who draws by rubbing out and building upon past traces. Dine circumvented these limitations by taking a new approach to the succeeding two woodcuts in the series. For the third version, *The Hand Painted Nancy* (154), he first coated the sheet to seal it in color and then painted the first version block with hot pinks, cerises, blues, whites, and blacks before

printing it by hand rubbing. This was repeated and followed by painting on the sheet until it became impastoed with oil paint. Finally, in *A Double Feature* (155), Dine printed the two blocks side by side and then imprinted both images with the first version block, again adding hand applied color to block and sheet. As with similar processes used by late nineteenth- and early twentieth-century woodcut artists, the print thus becomes a unique object—a hybrid of relief carving, printed in multiple colors, and of hand coloring. The paired portraits, layered with accretions of print and paint, offer two variant observations of the sitter for viewing at a single instant of time.

Dine's most recent etching of Nancy, *12 Rue Jacob* (190), is a single print without a sequel. Its experimental aquatint technique, however, associates it with several other prints made with Aldo Crommelynck at the same time (188, 189, 195). Like these, *12 Rue Jacob* is pulled from darkness into light, exploiting in the tonal range between black and white a wide spectrum of coloristic possibilities. As the portrait's evident traces of revisions indicate, it is an image with a past. In fact it is the second state of *The Channel* (189), a luminous image of a skull floating before a modulated black ground. After *The Channel* was editioned, Dine burnished down the plate and began to work a negative variant. This was obliterated and, in its place, Dine constructed Nancy's portrait on the plate's reduced, nearly square format. The woman's face emerges from the upper part of the burnished skull, which survives in raised white traces and as a ghost image around the right side of her head. These traces and the pentimenti of lines about the head and chin contribute to the sense of the sitter's vitality. But her gaze is inward and like several of the *Nancy Outside in July* portraits, she is insubstantial and nearly weightless among the relics of the imagery that preceded her presence on the plate.

With the exception of a handful of works of the past ten years, Dine has limited the subjects of his printed portraits to himself and his wife. Through his investigation of change in the two faces most familiar to him, Dine finds inexhaustible resources for discovering something new to say in one of the oldest forms of depiction in Western art. With his increasing discipline as a draftsman, Dine struggles to deal with both verisimilitude and the layers of human personality while holding in check its overtly subjective aspects of expression. His figures confront the viewer in full face and in close physical proximity to the picture plane. Their forms are neither distorted nor, excepting the last states of the Jerusalem portraits, unusually cropped. Gesture is condensed to the set of the shoulders and the turn of the head.

Despite their similarities of presentation, the self-investigations and Nancy Dine's portraits are, by their nature, different in approach. The etching and woodcut self-portraits remain elusive of access. The artist's eyes are frequently averted or narrowed and the features are set in severe lines and compressed. Although the disturbing self-obliterations of the early

1970s portraits are, in recent years, no longer evident, Dine sees in the mirror an image of anxiety and tension. In this sense of himself as an artist and in the sheer numbers of his drawn and printed self-portraits, Dine allies himself with European painter-printmakers (Munch, Beckmann, Kollwitz, for instance). More important to our understanding of these prints, however, is their relationship to a long tradition of imagery in which the artist has attempted to peel away the mask and deal with the self-consciousness inherent in the tradition of self-portraiture. Dine wrestles with this dilemma, finding a resonance between his guarded view of himself and the medium in which it is executed—particularly in etching with its capacity for self-revelation. Perhaps Dine most fully reveals his own autobiography in the portraits of his wife. Not since Picasso's *Vollard Suite* has a woman's face been so pervasive a part of the investigation of a printmaker. With these portraits, Dine offers a human landscape in celebration of change and the passage of time. They are images as diverse in etching and woodcut technique as they are sensuous in coloration and the physical beauty of the woman's presence.

Dine makes portraits that are about the pictorial language of printmaking. He has left few methods unexplored in his images of himself and his wife. These studies present a survey of Dine's procedures of the past ten years as they exist in a pure state and as they cross over and adulterate clear distinctions between media and between the printed and hand-made. His prints repeatedly reinforce the notion of process. By giving us the evidence of their making—their history—Dine gives us access to the printmaker's sequence of ideas. The viewer's share in this process is Dine's delight. For, as his wife says of him: "If he could do nothing else, he would be perfectly happy making prints."

NOTES

1 The two earlier catalogue raisonnés of Dine's prints, published in 1970 and 1977 (see the Bibliography for full citations of references in the Notes) number the prints from 1–77 and 1–236 respectively. Excluding the posters and related designs listed in the 1970 catalogue, but including all the prints listed under a single number for series or portfolios in the two volumes, Dine's total production from 1960 until early in 1977 comes to about 340 published prints. By the same reckoning, the present catalogue lists over 260 individual prints. For a case study of Dine's cross-references between painting, sculpture, and printmaking in his recent *Venus* images, see Jean E. Feinberg's essay in this publication.

2 These primary themes are discussed by many authors cited in the Bibliography; especially useful are the recent books by Beal, 1984, and Glenn, 1985.

3 Unless otherwise cited, quotations from the artist are taken from interviews granted the authors of the present catalogue on six occasions in Putney and New York during 1984 and 1985. Several are also cited from among the four videotapes made by Nancy Dine in 1983 and 1984. These show the artist at the Atelier Crommelynck, Paris, in his London studio, and at work on prints for the Angeles Press, Los Angeles.

4 Dine's statements about his debt to de Kooning and the Abstract Expressionists, together with his sense of belonging to the European tradition, are expressed in books by Beal and Glenn and, among other sources, in interviews with Ackley, Duffy, Gruen, Krens, and Stayton.

5 The *Five Paintbrushes* and its states are discussed by Goldman in the exhibition catalogue for the Whitney Museum, 1981, pp. 70–77, when they were exhibited together with the *Strelitzia* series (73–79). For Dine's place in the etching revival of the late 1960s and early 1970s, see Field's *Recent American Etching,* 1975. Field's emphasis on the pared down or minimal use of etching by artists such as Johns, LeWitt, Mangold, and Motherwell applies to his discussion of Dine's relatively reductive use of etched line in the early 1970s.

6 Although he had done some etching at Ohio University, Dine states that he learned the basics primarily from Jules Heller, *Printmaking Today: An Introduction to the Graphic Arts* (New York: Holt, Rinehart & Winston, 1958). Dine describes the well-illustrated book as "a hobbyist's guide for all-purpose amateurs."

7 Quotations from Friedman and others cited below (Townsend and Crommelynck) who have printed with Dine are from interviews held in 1984.

8 A useful guide to the full range of printing techniques is Saff and Sacilotto's *Printmaking,* 1978, which also includes discussions of several of Dine's prints, pp. 79–80, 117, 141, 159, 348.

9 Its bed measuring 25 × 50 inches proved to be too small for Dine, as Friedman had predicted, and it was replaced. In his London studio, Dine prints etchings and monotypes on a large press which he bought from Petersburg and had motorized.

10 Quoted in Glenn, 1979, p. 15; see her recent study, 1985, for a full discussion of Dine as a draftsman.

11 Quoted in Ackley interview, 1983, p. 3; see also Hennessy, pp. 171–72. For discussions with Dine about his approaches to drawing and recurring references to building up a history of marks, see those authors as well as Glenn's studies and Krens' interview in the Dine catalogue, 1977, pp. 28–32. Alan B. Eaker, Director, USF Graphicstudio II, kindly loaned the authors a videotape made in 1983 in which Dine discusses his new confidence in drawing and its effect on the physicality of his etching.

12 For Dine's discussions of these and other artists, see the authors cited above, Gruen, p. 42, and Kitaj's description in the 1977 Waddington catalogue of his visit with Dine to see a Van Gogh exhibition in 1974.

13 Quoted in Krens' interview, p. 32. As opposed to the rarity of figurative works before 1970, seventy-two prints in the 1977 Dine catalogue, nearly a third of his graphic work of this period, are figural.

14 Dine also suggests tangential references to Rembrandt with the title of his *Three Trees in the Shadow of Mt. Zion* (108) and in his shell images, particularly *Lost Shells* (187).

15 See Saff and Sacilotto, p. 348, for a discussion of an early example of Dine's combination of monotype with drypoint, *Rimbaud, 1975.* See also Ives et al., *The Painterly Print,* p. 252. An insight into Dine's monotype techniques is gained from the videotape made by Nancy Dine in December 1983 while Dine worked with Toby Michel at Angeles Press.

16 Quoted in Smilansky, p. 56.

17 See the 1980 interview by Susie Hennessy, one of Dine's printers at the Palm Press.

18 Gene Baro, *Graphicstudio USF,* sheds light on Dine's earlier work in the printshop. Alan B. Eaker's videotape of Dine (see note 11) shows the artist at work on his 1983 USF prints.

19 Quoted in Ackley, *Nancy Outside in July* (unpaginated), a book devoted to the series and illustrated with color reproductions.

20 Gilmour, p. 195.

21 Quoted in *ibid.,* p. 196.

22 See Nancy Dine's essay, "Sitting," and Ackley's discussion of etched portraiture in Ackley, *Nancy Outside in July.*

23 The possibility that Kirchner used a mechanical burnisher is suggested in Frances Carey and Antony Griffiths, *The Print in Germany 1880–1933* (London: British Museum, 1984), p. 36. Michael Mazur, with whom Dine made monotypes in 1978, uses the electric needle extensively in his prints; see Frank Robinson, *Michael Mazur, Vision of a Draughtsman* (Brockton, Mass.: Brockton Art Center, 1983), passim.

24 Dine also worked in woodcut when studying with Ture Bengtz in the Boston Museum School (one of his themes was the *Seven Deadly Sins*). Describing himself as a "country and western artist from Ohio," he was impressed by the techniques of Leonard Baskin, Jacob Landau, and the British wood engraver, Peter Blake. Bengtz assisted in the production of Paul Sachs, *Modern Prints and Drawing* (New York: Alfred A. Knopf, 1954) (See Plates 211–22.) Sachs' book was extremely influential on Dine's understanding of late nineteenth- and early twentieth-century European art, especially the drawings of Van Gogh and the prints of the German Expressionists. Several of his student woodcuts ("not worth cataloguing") appeared on the market recently at Christie's, 7 November 1984. In 1967 Dine used a rubber stamp for *Broken Heart* and in 1968, a woodblock for the key image in *Bleeding Heart* which, prophetically, he carved to resemble strokes of paint.

25 Munch's methods, inspired by Gauguin, are analyzed by Elizabeth Prelinger, *Edvard Munch, Master Printmaker* (New York: W. W. Norton and Company, 1983). Saff and Sacilotto illustrate the printing of jigsawed elements of Dine's *Woodcut Bathrobe,* pp. 79–80.

26 A useful study is Field's "On Recent Woodcuts," 1982. Preceding Dine's renewed work in woodcut were the ULAE publications of Helen Frankenthaler's *East and Beyond,* 1973, from eight blocks, and her *Savage Breeze,* 1974.

27 Dine prefers standard plywood to plywood veneer or oak blocks and contemplates a visit to Japan to find interesting woods. For the influence of his innovative carving on plywood, see Jacqueline Brody, "Roger Herman: A New Expressionist?," *Print Collector's Newsletter* 15 (January–February 1985): 200.

"NOT MARBLE"
JIM DINE TRANSFORMS THE VENUS

Jean E. Feinberg

For the past twenty-five years, Jim Dine has dedicated himself to the art of printmaking. The creation of etchings, lithographs, and more recently woodcuts, has been ongoing, an activity he has consistently pursued. At this advanced stage in his development, yet at the artistically youthful age of fifty, he merits the title master printmaker. Dine has recognized that printmaking offers the artist a process and presents aesthetic opportunities distinguished from those of the other mediums. Because most artists produce only small numbers of prints, as an activity that augments but does not equal their other artistic endeavors, they rarely reach the stage where they comprehend the medium in depth and are able to explore the full range of its potential. Dine, in contrast, has understood that printmaking can yield a unique result; therefore, he has approached it with full conviction, always as a primary, never a secondary, activity.

Dine, like most of the great printmakers throughout history, is not exclusively a printmaker. He has produced large numbers of paintings, drawings, and, most recently, sculptures. A discussion with Dine about the difference between the mediums sheds light on key thinking in his creative process. Dine refuses to place his art activities in a hierarchical order or even to isolate one medium from the next. Certainly each form has its compelling characteristics that attract the artist and leads to particular formal investigations and results. Nevertheless, the artist's recognition of certain working distinctions has not led him to see one medium as unrelated to the next. At different times during the last quarter century, Dine's emphasis has been on one process or another. He has allocated large blocks of time to one project, often owing to the technical and physical requirements of the process involved. Nevertheless, it is important when we consider Dine's prints to remember his equal dedication to painting, sculpture, and drawing. By examining the movement of Dine's creative energy from one art-making process to the next, we can see an overall picture that does not isolate his work by method but views all his work as part of a continuous flow of creative thinking and productivity. This approach provides an understanding that parallels the artist's creative process. The result is that we gain a comprehension of Dine's prints more in keeping with the artist's own vision, rather than the isolated perspective created by the categories of documentation.

The past ten years have been the artist's most productive, offering major bodies of work in painting, sculpture, drawing, mixed media on paper, and monoprinting. The attempt to chart Dine's activities day by day, month by month, frustrates even the most careful biographer. This volume alone catalogues over two hundred prints. Examining only the

years presented in this publication, when the artist maintained a home base of operation in Putney, Vermont, reveals that Dine's style of living and working is characterized by continual change. Since their three sons reached their teenage years, Jim and Nancy Dine have led a peripatetic existence, constantly changing their workplace, permitting rapid movement from one venture to the next. Dine is far different from artist-printmakers who over a twenty-year period have had, perhaps, three painting studios and have frequented the same two or three printshops—switching only according to whether they intended to pursue lithography, screenprinting, or intaglio. Since 1977, Dine has produced paintings and sculptures in Putney, Los Angeles, Chicago, Walla Walla, London, and Humlebaek, and has set up temporary headquarters in dozens of hotel rooms to make drawings, to work on woodblocks, or to revise aluminum plates. He has had editions printed in workshops in New York, Cambridge, Tampa, Los Angeles, Aspen, Putney, Hanover, West Islip, London, and Paris. This way of living, which others might find disorienting, suits the high energy and diverse interests of the Dines and has propelled Jim Dine's creative output.

No better image presents itself to illustrate the complicated process of cross-fertilization than Dine's new subject, the Venus. The web of events surrounding the body of work that utilizes this image provides a perfect case study and an opportunity to see the results of Dine's printmaking philosophy, as well as his nonhierarchical and energetic working methods. The *Venus* prints bring to light general characteristics of Dine's recent printmaking, in addition to revealing what is newest about his efforts in the field. In exactly the period covered by this catalogue, 1977 to mid-1985, Dine has brought the Venus to light in painting, mixed media on paper, sculpture, *and* woodcut, lithography, intaglio, screenprinting, and monoprinting. The *Venus* prints, examined in detail, permit a close look at the network of activities that engage Dine. Their study indicates a working pace involving frequent change from one project to the next and the return to unfinished projects, often left in abeyance due to technical necessity. Dine's working methods result in an interaction and carrying over of ideas and goals from activity to activity. Unraveling this method provides a unique view into the artist's creative thinking.[1]

During 1977 and 1978, in his Putney studio, Dine created a group of still life paintings.[2] These works present a dazzling display of everyday objects bathed in mysterious, fluctuating light. The assortment first appears to line a long tabletop. However, because the physical environment remains undefined, the viewer is left with the impression of a silent landscape rather than a domestic interior. The crowded compositions are dominated by glass objects (empty bottles, pitchers, and vases) and a smattering of solid forms. The contrast between the transparency of the glass and the opacit of the other shapes spotlights the latter. Among the disarray in *The Studio Near the Connecticut River,* 1977, one sees a skull, a plaster hand, a palette, and empty jars of red paint. In *Night Forces Painterliness to Show Itself in a Different Way,* 1978, there are several small

flowers, a reproduction of an Egyptian statue and a large shell, and in *My Studio #1; The Vagaries of Painting: These are Sadder Pictures,* 1978, the skull reappears with the plaster hand, several random vegetables and a small plaster reproduction of the Venus de Milo.[3]

Primary to Dine's aesthetic, to his work in all mediums, is his belief in the power of objects.[4] He has always invested objects with meaning beyond their literal or descriptive function. This use of objects as symbols or metaphors has at times been pursued to the level of animism, the objects taking on a life and breath of their own. With the still life series, Dine developed a different composition, format, and painting style that took his veneration of the object to new heights. He introduced a new vocabulary of images, including our subject here, a plaster cast of the Venus de Milo, the Hellenistic marble figure that has been a presence in the Louvre since 1820.

One is led to speculate why Dine purchased the miniature Venus statue and in 1977 placed the small plaster cast in amongst the myriad objects that make up his still life compositions. Dine is helpful and specific regarding this question. The Venus is "a link to art history . . . and is about the relationship of art and the history of art to objects." Dine's original intention was to make a respectful reference to and establish a link with his great artistic predecessors.

As a young artist in the late fifties and early sixties, Dine took an iconoclastic stance towards content and its form of presentation.[5] Eventually, however, his dissatisfaction with the New York scene took him, in 1967, to Europe where he immersed himself in art history. From that time onward he has continually studied great painting, sculpture, and drawing as well as the decorative arts, citing over the years a variety of influences and preferences.

As he matured as an artist, Dine became less interested in seeing himself in relation to his contemporaries, and adopted a stance of veneration for the past, placing himself within the larger continuum of art history. The Venus de Milo, one of our age's most identifiable symbols of the history of western culture, offered itself as an appropriate image for this notion. In preparing for the still lifes, which by nature are pregnant with art historical reference, Dine included the Venus, as well as the Egyptian statue and the skull to "set the tone or mood for the studio."

Dine has on occasion turned to sculpture. His work in three dimensions includes a group of aluminum objects from the mid-sixties, the *Nancy and I in Ithaca* series from later in that decade, and several 1976 busts of Nancy. But it is with his recent endeavors in this medium, a large number of works in bronze, that he has established himself as a formidable sculptor. Within the context of this undertaking, beginning in mid-1982, Dine adopted the Venus image full force, with emphasis on the creation of what would be, by the end of 1983, a group of slightly larger than life

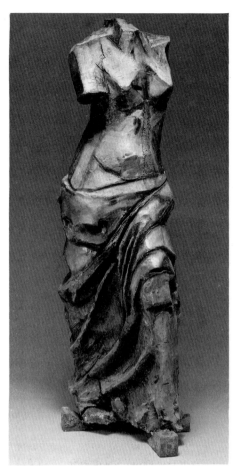

Fig. 9. *Venus in Black and Gray,* 1983, bronze, 64 × 23 × 25″, edition of 6.

statues of single and paired Venuses, as well as several small study versions.[6] Paralleling the bronze Venus figures are the two-dimensional Venuses fashioned on copper plates, woodblocks, screens, and aluminum plates, as etchings, woodcuts, screenprints, and lithographs. By late 1984 and early 1985 the printed versions of this new subject number twenty-three editions.

Dine began the sculpture project by buying a souvenir figurine of the Venus de Milo, an item widely available in art stores and tourist shops. He had it enlarged in clay while working in his two home bases of this period, London and Los Angeles. Dine reworked the pointed up versions in a process that is about learning a new image. "The clay versions were quite crude, but the proportions were correct . . . I kept throwing clay at it and slicing it off." He refers to his working method while creating *Venus in Black and Gray* (Fig. 9), one of the slightly larger than life statues that he produced. All are notable for their corporeality and this version, in particular, for its aggressive stance. Broad shoulders and pointed cubist breasts characterize her upper torso. The viewer's eye moves downward past a thick waist by means of vertical incisions that mar her bare flesh. The drapery is bulky, falling in awkward gathers over her hips and legs. The balanced, centrifugal force that characterizes the closed movement of the second century B.C. original is broken here by the angularity of many features and the forward thrust of the right leg. Through a working process that involved remodeling and alterations, and the creation of not one, but several versions, Dine transformed a popular icon of western culture. By putting his own stamp on this historic work, Dine began the process of incorporating a public symbol into the lexicon of his personal images.

The first stage in the complex process that resulted in the *Venus* prints began when the cast sculpture *Venus in Black and Gray* was delivered from the foundry to the artist's London studio. It was Dine's practice to have the bronze versions delivered there, for further study and completion. This finishing involved hand painting with oils.[7] At this time, early fall 1983, Nancy Dine took a studio shot, a black and white photograph that showed a close-up of the sculpture against the general disarray of the small workroom. This photograph was given to the London printer Christopher Betambeau. Through a posterization process, Betambeau, at Advanced Graphics, produced approximately 100 screenprints from the photograph (Fig. 10). Through this procedure, the 8 × 10 inch photograph was substantially blown up and translated into four tones of gray. The Betambeau screenprints were not released as an edition but were kept by Dine and at this time some were drawn on or served as models, acting as a reminder of the sculpture, *Venus in Black and Gray,* when it was not available for direct study.

A characteristic of Dine's working method is the use of a template as a reference or starting point. While exceptions can be found, in most cases, Dine's initial work on the plate, block, or stone is dependent on

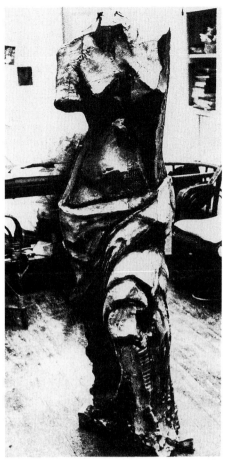

Fig. 10. Screenprint of *Venus in Black and Gray,* derived from Nancy Dine photograph.

preparatory or advanced information. The method of preparation and the nature of the external reference is varied. At times Dine draws from life, but more often traces previous drawings or transfers them through photogravure. A strong case can be made that with many prints, the artist's most familiar images, i.e., the heart and the robe, function as the template. The shape of the heart and the contours of the robe serve as the familiar structures that Dine intuitively begins with. They are points of reference to be abstractly reinterpreted.

When Dine began his exploration of the Venus, he used the original Venus de Milo, or rather a plaster cast, as his reference. With the prints, he did not want to return to the cast because his goal is to personalize the universal and reinvent the familiar. Dine needed to use the first-stage alteration, his sculptures, and not the statute in the Louvre, as his visual aid. Nancy Dine's photograph of the studio, turned into a screenprint, would serve this function many times in the development of the *Venus* prints.

Once Dine decided that the first screenprint of the *Venus in Black and Gray* would not be issued as an edition, he turned to woodcut.[8] He did not, however, discard the entire screenprint project, but began a group of *Venus* woodcuts and lithographs by having two of the four screens used in the original posterization process printed onto a mahogany veneer plywood block. Thus, Dine utilized a component of one activity to initiate another. The image screened on the block served as his new template. In London, during the next two months the artist cut on the block in a slow, painstaking process. Dine used the screenprint image as his guide, yet he happily admits that the wood's resistance demanded that he "reinvent" as he worked. This turned what could have been a rather arduous and boring task into a creative one that assisted Dine in his efforts at learning the landscape of his new muse.

Dine's earlier use of the woodblock in 1968 for *Bleeding Heart with Ribbons and A Movie Star,* and in 1975 for *The Woodcut Bathrobe,* employed the block as a stamp for wood grain texture. It was in 1981 that Dine began seriously printing woodblocks and cutting a relief design into their surfaces. Dine took up power tools in keeping with the working methods that he had adopted for other surfaces. By late 1983, Dine had mastered the power tools that he used to cut this first *Venus* woodblock: the power gouge of many sizes, attached to a flexible shaft, and the Dremel, a hand-held hobbyist's tool that takes a variety of small abrasive bits (Figs. 8 and 11). Since Dine began editioning woodcuts in 1981 all of his blocks have been cut with one or both of these power instruments. A chronological examination of the blocks reveals his increasing knowledge and exploitation of their potential. His facility with the Dremel was also sharpened by using it frequently on copper. Just at this time, Dine had completed the twenty-eight plates used for the illustrated botanical publication *The Temple of Flora* (177). All of the plates were engraved with the Dremel and this bound volume is, in effect, a

Fig. 11. Attachments for electric drill and Dremel.

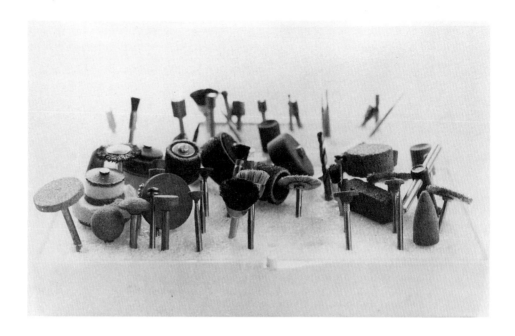

dictionary of marks made possible by the imaginative and controlled use of this tool.

With the exception of some of the small blocks cut for the *Apocalypse* (141), Dine's large woodblock prints do not have the primitive raw look associated with many artists' initial woodcuts. Dine worked his plywood surfaces to create a relief that goes beyond conventional woodcut marks. The artist has reproduced in wood several types of gestures and tones, each serving specific formal ends. His working of the block never simply exposes, in a traditional manner, "the inherent nature of the material." Dine, an expressive artist by his own definition, does not follow a method of working the wood which, in keeping with the material's supposed integrity, has led to the contemporary deluge of raw expressionistic prints. He is now creating a new vocabulary of gouged and engraved marks that is redefining the discipline. From the sweeping gestures of the *Rancho Woodcut Heart* (142), to the tangled linear and dot patterns that define Nancy's portrait (152–55), to the tonal modeling of the *Venus* (160), Dine has with each block addressed specific aesthetic intentions. When Dine took up the woodblock, he approached it with the same kind of insistent experimentation that characterizes all his printmaking and thus bypassed the standard practice that disallowed inventive interpretation.

The first two prints that Dine editioned in late 1983 at Angeles Press from the *Venus* block are *Black Venus in the Wood* (160) and *The Yellow Venus* (163). The black version is a simple print, a single black image that provides a clear vision of the block as Dine cut it before it was altered and wonderfully complicated with colored inks, multiple printings, and handcoloring. The Venus figure is distinctly silhouetted against its background. All the detail work done with the Dremel, for the upper torso and the fall of the drapery over the hips and the legs, serves to create a believable volume. Every mark on the body has a descriptive

function that gives the female form specific physical definition. The black Venus is illusionistically depicted as a three-dimensional mass, like its original sculpted source. The background, cut with the power gouge, is a flat, diagonal grid that contrasts with the figure's realistic definition.

Before Dine printed *The Yellow Venus* he had the mahogany block cut into two parts: the central Venus figure which Dine refers to as the *key block* and the background. A sheet of pine plywood was also cut into two pieces identical in shape to those in mahogany. The pine sections were used to print flat color or to brace the original block in the press when only one of the mahogany sections was being printed.[9] *The Yellow Venus* was made with three passes through the press: first a flat blue for the background and a flat yellow for the center printed from the pine sheet; then, an orange printing of the mahogany background; and finally, a black printing from the entire mahogany block. The volumetric quality of the Venus in this version is emphasized by the interaction of the black, the overprinting that provides the female form with her physicality, with the lively yellow beneath. The darkness of the grid-filled sides juxtaposed to the flat yellow, as well as the emphasis on the torso as a silhouette, increases the play on three-dimensionality.

Even though this woodblock is cut with the same tools as those preceding it, there is a difference in the way Dine worked this surface and thus in the impressions taken from it. This difference distinguishes this block and its subsequent editions from Dine's earlier 1981–83 woodcuts, with the exception of the two blocks used for the Aspen portraits of Nancy Dine. The two large heads of Nancy had been cut and printed just prior to the beginning of the *Venus* series. This proximity as well as their similar form of template, a screenprinting onto the block, explains, in part, their similarity.

The change in approach to the block had to do with the template Dine cut from and its relationship to the artist's other art-making activities of this period. As stated above, the *Venus* block's immediate derivation was a screenprint. As Dine meticulously followed the screened-on design with the Dremel, the screen's tonal pattern affected the cutting and appears to some extent in the print. The second and more significant level of derivation was the subject of Nancy Dine's photograph, that is, the artist's own sculpture. Nancy Dine's photograph is of a three dimensional object. In this manner, even in its two dimensional translation (through photography, screenprinting and woodblock printing), Dine's current preoccupation with sculpture as a solid form has been maintained. Consequently, Dine worked the printed torso with the Dremel in a manner that preserved and perhaps accentuated the plasticity of the original sculpted form.

A comparison of these first two *Venus* woodcuts with earlier woodcut prints, for example *A Night Woodcut* (140) and *A Sunny Woodcut* (139)— two heart prints that use similar though not identical methods of inking

and printing—illustrates how differently the *Venus* prints were conceived. All four of these prints are of a single image against a grid-filled field. However, the heart is a flat shape chiefly defined by its outline. The sweeping gestures in the heart's interior have no descriptive function the way the marks do within the body of the Venus. In the 1982 prints the relief pattern functions abstractly, as painterly gesture. The heart is a flat shape that is not in conflict with the inherent two-dimensionality of the sheet of paper and complements Dine's approach to painting, which is essentially an abstract, nonillusionistic style that uses forms which emphasize rather than break with the flatness of the canvas. *A Night Woodcut* and *A Sunny Woodcut,* as well as others of the period such as *Rancho Woodcut Heart* (142) and *Fourteen Color Woodcut Bathrobe* (112), derive from brushed on India ink drawings that Dine painted on the block and then cut around, or out. Their bravado translates as expressive content. Dine worked the blocks to create painterly interiors within and around his hearts and robes. With the Venus, Dine approached the block from a different vantage point. The nondescriptive areas of the block were confined to the background grid. The key area, the Venus herself, was rendered with an eye toward physical description. Thus Dine's concurrent fascination with sculpture was expressed in the illusion of three-dimensionality and volume that he achieved in the *Venus* woodblock and its imprints.

The next phase in the *Venus* print narrative involved the introduction of lithography into the repertoire of methods that now surrounded the image's development. Before Dine had the mahogany *Venus* block jigsawed, Toby Michel, director of Angeles Press, took three transfers from it. One was subsequently fixed to an aluminum lithographic plate and used to edition *The Sky* (164). The others were trimmed, and together transferred to a single lithographic plate used in creating *Handmade Double Venus* (165). *The Sky's* woodcut transfer was substantially altered with brushed on diluted tusche and lithographic rubbing stick, so that the woodcut quality was largely obliterated before the plate was printed in transparent black. Two other plates with additional brush applied tusche were dropped on, in light and dark blue, followed by a black plate with minor drawn, rather than brushed, marks. Finally, the center of the jigsawed woodblock, i.e., the key block, was printed over the lithograph, in effect, bringing back the woodcut image that Dine camouflaged with four lithographic runs. This sandwiching of images in combination with the use of transparent black ink and the printing of light blue over dark blue, yielded a luminosity that enhances the figure's physical presence.

Frequently, when Dine talks about the procedure he follows to create an image in any medium, he emphasizes his penchant for overworking to the point of destruction, followed by actions that bring back some of the original. "I like it when things overdo, then I like to correct through that, rather than underdo." *The Sky,* a combined lithograph-woodcut, exemplifies this working principle. The transfer is used merely as a starting point, on the principle of the template. In this case the template is

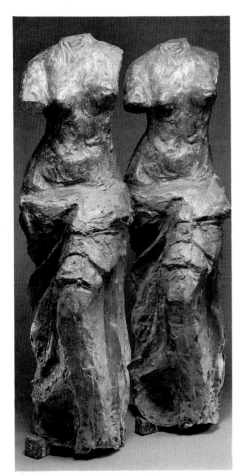

Fig. 12. *Double Venus,* 1983, bronze, 64 × 45 × 23″, edition of 3.

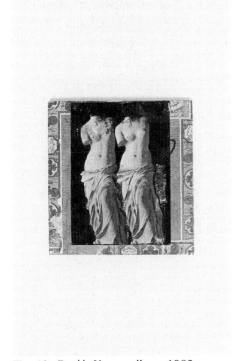

Fig. 13. *Double Venus* collage, 1982, mixed media, 5½ × 5″.

the memory of a just completed project serving as the point of initiation for the next. The three lithographic runs over the transfer weaken the key image's characteristics, which Dine brings back by overprinting the original woodcut block. With this final step, the strong central image is retrieved.

The next print that utilized the mahogany block in the late 1983 Angeles Press *Venuses* is the *Handmade Double Venus.* This print, composed of two transfers from the woodblock printed in white on a black field with some handwork after editioning, displays two compositional devices that Dine has used throughout his twenty-five years of printmaking: the negative image and doubling.[10] Dine has stated that his interest in negative images and other means of reversal are an indication of his continual "romance with the process," for it produces "the same image but not the same image." This condition of one impression resembling another but not being a mere carbon copy, also underlies the formal device of repetition. The second image is not identical to the first and as each plays off the other, both are strengthened. Negative images and repetition also poke fun at the idea of printmaking being a reproductive process—an *a priori* fact of the medium that Dine has frequently defied. As stated above, his fascination with printmaking lies in what the process permits *through* the act of printing, and not with its reproductive capabilities.

A recapitulation of the scenario behind the *Handmade Double Venus* reinforces the working principle of a complicated network of cross fertilization underlying each work before it reaches completion. *Handmade Double Venus* is a double, white on black image; technically it is a lithograph derived from a woodcut through the transfer process. The woodcut is based on a four-color silkscreen of a documentary photograph of the artist's sculpture, a contemporary interpretation of a second century B.C. marble statue. The freedom Dine permits himself in combining processes, continually violating the sanctity of traditional concepts of what each medium is supposed to look like has been forcefully illustrated by *Handmade Double Venus* and the other three *Venus* prints editioned up to this point in the *Venus* chronology.

The final print that Dine made in late 1983 at the Angeles Press relates to a group of woodcuts that the artist had printed earlier that fall with Jack Shirreff in London. The English prints and the final Angeles Press print, *Double Venus in the Sky at Night* (166), relate to a different sculpture, *Double Venus* (Fig 12) and thus have a lineage independent of the prints just discussed. Nevertheless, work on the two groups of prints, as this continuing discussion of the *Venus* editions indicates, did overlap.

In the spring of 1982, Dine bought several postcards of the Venus de Milo and pinned them to the wall of his London studio. In the fall, at the same time that he slashed away at the clay Venus to model *Venus in Black and Gray,* he modeled a softer, more graceful, double version, titled the *Double Venus.* During this intense period of focusing on sculpture, Dine used two of the postcards to create a small (5½ × 5″) collage (Fig. 13).

Fig. 14. *Double Venus,* 1983, soft-ground etching, unique impression.

Dine painted the cards with India ink, blotting out the background and eliminating the heads. After cutting the cards down, he glued them side by side to the lid of a cigar box.[11] At the same time that the artist gave his wife's photograph to Christopher Betambeau, he gave him this collage, which like the photograph was made into a screenprint. Dine's intention at this time was to create a combined screenprint-intaglio edition. He did etch a soft-ground drawing of the two Venuses (Fig. 14) which was dropped over the screenprint. Owing to technical problems regarding the ink's resistance to the surface of the thick screenprint, this project was put aside.[12]

When Dine went to Los Angeles in late 1983, he took with him approximately seventy of the *Double Venus* screenprints. These became the basis for *Double Venus in the Sky at Night.* At Angeles Press, Dine printed over the screenprint two aluminum plates: first, a background wash from diluted tusche applied with a brush printed in greenish blue, and second, a linear and tonal drawing from lithographic crayon and rubbing stick printed in black. The drawing enhances the sensual figure's sculptural definition. The painterly blue background implies a twilight sky. The screenprint's eight shades of black and brown shine through the lithographic overlays. This print is an extraordinary example of how Dine utilizes a flat, lifeless screenprint as a starting point and through daring additions creates an elegant image that differs from all others in his growing number of *Venus* prints.

Dine's next body of work in printmaking began in early October 1984 at the Atelier Crommelynck. During several weeks of daily working sessions and a return visit over the Christmas holidays, Dine produced the final proofs for thirteen editions that would be printed and subsequently published in mid-1985. Among this group were four *Venuses.*

Three of these prints are from a single unchanged copper plate. Dine drew through a sheet of paper on the plate which had been prepared with a soft ground. As he worked, the Betambeau silkscreen of *Venus in Black and Gray* hung on the wall of the Atelier, serving as the artist's guiding reference. At the artist's request, the ground was deeply bitten. After a first proofing, Dine added further soft-ground drawing and considerably strengthened and heightened the figure with the Dremel and an electric drill with grinding wheel and wire brush attachments.

Dine did print this plate, once in black, as the uncolored part of the edition *Venus at Sea* (192). These versions on delicate Chiri paper and Rives beige provide us with the opportunity to see, without the later additions that camouflage the pure plate work, the sensuous soft-ground drawing with electric tool accents. It was through his work with Aldo Crommelynck that Dine mastered the use of soft ground, frequently employing it as his starting point. In the past it had been common procedure to combine this with hard-ground etching and aquatint, frequently printing the aquatint plate in color to simulate watercolor.

Lately, however, Dine has been replacing hard-ground etching with electric tools and in these editions he used washes of hand coloring rather than colored aquatint printing.

The preparation of the paper with flesh and sea-blue acrylic for the bulk of the edition *Venus at Sea* adds to the illusion and the reference to the nude goddess emerging from the water, near the isle of Cypress. For *The French Watercolor Venus* (194), after the plate was printed in black, Dine covered the entire sheet with a rainbow wash of color, emphasizing the central portion. In the third published version (193), Dine experimented with negative imagery. A white Venus looms in the night sky. The artist added to this iridescent image a line of Sappho's poetry—"Love shakes my heart again an inescapable bitter-sweet thing." Rubber stamps made from Dine's own lettering are hand stamped around the hips and thighs.

In comparison to the aggressive visual impact of the *Venus* woodcuts, the first intaglio versions read as restrained. This is not to suggest that they lack visual force. Rather, their aesthetic is associated with Dine's early-seventies printmaking, particularly the tool print editions done with Petersburg Press. For these early prints and the first three Crommelynck editions, the white of the sheet is allowed to serve as part of the composition and the etching functions basically as drawing. Dine has also used rainbow washes in hand coloring, as well as including lettering within the composition, since he began making prints.

It is tempting at this point to conjecture about the influence of workshop environments on Dine's printmaking. Perhaps the Atelier Crommelynck, with the aura of printmaking tradition that surrounds it, drew Dine to his more tranquil earlier style. There are similarities in the way the Los Angeles series and the Crommelynck prints were approached, such as the single black printing of the plate followed by colored versions, and the experimentation with negative images—all done without plate alteration. Nevertheless, the interpretation of the subject and the expressive results of these two groups are very different. And it is not merely the change of technique—from woodcut and lithography to the intaglio process—that brought about this difference. The Paris editions are uncomplicated prints that utilize to full advantage what the atelier has to offer. It would be hasty, however, to suggest that this workshop restricts Dine, for as the next print indicates, Dine is able to move ahead and integrate his newer working methods and stylistic goals within a traditional framework. He pushes Crommelynck in the area of his expertise. Dine can be seen as having been influenced by the shop, because he skillfully channels his experimentation toward the Atelier's area of strength. The result is a modification of the shop's strongest qualities.

The fourth Venus print proofed in Paris during this period is *Black and White Cubist Venus* (195). Dine drew directly on the plate with Magic Marker which was then bitten with spit-bite aquatint. The working proof at this point read as white, ropey lines, the Magic Marker having

functioned as a resist, in a brushy aquatint field. Dine then attacked the plate. Using a rotary sander (Dine found one in Paris that had a Velcro pad so that he could easily change the grade of the sanding paper) and the Dremel, Dine substantially altered the position of the upper torso and gave bulk and volume to all parts of the body and drapery. This print illustrates Dine's method of overdoing and modifying, arriving at the final form through a series of corrections. In what could be called an electric version of mezzotint, Dine brings out tone and even restores dark areas to full white in a process that reflects his corrective approach. *Black and White Cubist Venus* illustrates how far removed Dine now is from the process of gradual additions and state editioning with hard-ground etching that characterize much of his earlier intaglio work. Now, in the most rational of all European ateliers, Dine is able to produce a print that combines the most beautiful qualites of intaglio printing with a new vocabulary of linear and painterly marks that he has mastered through the use of electric tools. This image is a *tour de force* of contemporary printmaking and one that could only be identified with the working methods of Jim Dine and the plate quality of Atelier Crommelynck.

The *Venus* prints, and all the works in other mediums devoted to this theme (monoprints, mixed media drawings, and sculptures), should be seen in the larger context of Dine's exploration of new subjects. The extreme popularity of the heart and robe prints, augmented by the major body of paintings that complement them, has created an incorrect impression regarding the range of his subjects. In fact, an investigation of new subjects has characterized the last fifteen years and is partially illustrated by the other editions produced in late 1984 while at Crommelynck: *Lost Shells* (186), *The Channel* (189), *The Channel, My Heart, A Hand* (188), *12 Rue Jacob* (190), and *Wallpaper in Paris* (187). This group includes further exploration of the shell and the skull, subjects introduced, like the Venus, with the still life paintings. Dine editioned four shell prints prior to 1984, but *Lost Shells* is surely his most masterful. A large Jamaican conch shell is described with a subtle combination of traditional intaglio processes (open-bite, soft-ground etching, and drypoint) and a tempered use of electric tools. A pair of shells is transformed into an erotic landscape, highlighted with sensual pink and flesh tones. Dine's study of the skull in print began with his illustrations for the *Apocalypse.* Like the Venus, the skull is a subject rich with art historical reference. *12 Rue Jacob* is a portrait of Nancy Dine, named after the Paris address where she sat for the print's germinating drawing. Nancy Dine has figured prominently in her husband's printmaking since 1973.[13] *Wallpaper in Paris* takes the iron entry gate of the Atelier as its subject. The artist had used this form four previous times in printmaking, with three examples in 1982 and one in 1983. As with the *Lost Shells,* the newest version is Dine's most loving interpretation. A French-blue background is overlaid with a yellow-gold floral pattern. With this and soft-ground texture as its surrounding atmosphere, the gate is transformed into a sensuous pattern of dark arabesques. *Wallpaper in Paris,* through its subject, coloration, and *tour de force* technique, pays homage to the French

tradition that has played so prominent a position in Dine's printmaking since the mid-seventies.[14]

The most recent chapter in the history of the *Venus* prints occurred in December 1984, when Dine returned for two weeks to the Angeles Press. The result of this visit was the series *Nine Views of Winter* (197–205). For these prints the *Black Venus in the Wood* mahogany block was trimmed at the top and bottom. The block had previously been sawn into two parts, and the trimming resulted in its separation into three parts, a central Venus shape and two separate side or background pieces. Toby Michel has stated that because of the manner in which this series was worked and the way the block aged, he no longer thought of these new prints as coming from a single sawn block, but from three separate blocks, each with a character of its own that, as a master printer, he was forced to contend with through the long editioning process.[15] By trimming the block, cutting the neck and lower drapery, the Venus no longer stands as a complete figure, i.e., a statue with space all around, but is compressed. As with the just completed Paris editions, the torso is concentrated. Because the figure is scaled down and its length shortened, the image's three-dimensionality is partially reduced.

The procedures that determined *Nine Views of Winter* are lengthy and varied. The series is characterized by variation in the initial preparation of the paper. This was accomplished with a flat roll of color from a stainless steel plate or part of the sawn plywood sheet. The paper was on occasion prepared with French floral rollers. This preparation was followed by a printing from all or part of the original mahogany block and each sheet was altered with substantial handwork. Previously, Dine had expanded the function of hand painting from the subtle addition of pastel tones to the use of color as a major element of the composition. With this series the artist took its function still further, expanding it to a primary procedure that determines each print. Now the handwork is not only about the addition of color, but involves substantial alteration of the image. Dine not only adds, he uses handwork to modify and subtract. Solvents obscure previous work and blur the edges of the jigsawed boundaries. Charcoal and oil stick not only heighten but are used to draw on top of flat color. Scraping was employed to remove overprinting before the black ink dried, revealing the color beneath.

In addition to the prominent role of handwork, these nine prints are visually startling for their wide range of colors and their use of patterning. Hand applied and printed color ranges from soft grays, white, and transparent blacks, to bright greens, blues, yellows, and reds. With the silhouettes created by the jigsawing, colors are often juxtaposed to startle the eye, adjacent shapes vibrantly contrasting. The role of patterning is initially present in the printed cross-hatching that characterizes the side sections. The puzzle quality of the jigsawing, a pattern in itself, creates the look of assembly. Patterning is taken further in this series by means of two devices that create all-over repetitive forms;

the floral roller and the wood-graining device. In several prints, Dine uses one or more rollers to convert the sheet into wallpaper. In another, a woodgrainer is dragged through wet latex leaving its track in the thick paint. Both techniques look printed and play with the viewer's ability to decipher what is actual woodblock printing and what is achieved through other means.

Given the fact that *Nine Views of Winter* was created as a series, it is worth looking at Dine's history with this method. Since his first prints in 1960, Dine has worked with different types of series. The earliest groupings were of related images of one subject from different surfaces (*The Toothbrushes* I–IV, 1962). Another group used a stone in one state for several editions, in combination with other stones or different inkings (*Self-Portrait, The Landscape, Red Bathrobe,* and *Night Portrait,* 1969). Most notably through the seventies, one plate is editioned in several states (*Five Paint Brushes* 1–6, 1973). Dine has also grouped different yet thematically related prints in suites or portfolios (*A Tool Box,* 1966, through the *Temple of Flora,* 1984). In the recent past, Dine fully explored seriality with the use of multiple plates and techniques to produce the twenty-five prints for *Nancy Outside in July.*

The *Venus* prints are based on different principles of seriality. The working premise that underlies this series has to do with the sequencing and selection of activities. The ordering and combining of events is extremely important. Which surface or section of that surface is printed first, second or third and how these decisions are integrated with hand painting or patterning are major factors. The block from which the series is germinated is fully cut, the printed image established at the outset. The matrix, that is the relief surface, remains essentially unchanged and is only one element among the many that determine the final look of each edition. The ordering of the procedures, the prepared papers, colored inks, and extensive handwork that contribute to this series, have a more prominent visual impact than that of the printed matrix. It is not surprising that this means of working a series never leads to repetition. Dine's sequencing and multiple activities yield prints of great diversity. In fact, *Nine Views of Winter* exhibits variety far greater than that of the traditional state sequence, where the first, second, and third states reveal a gradual process and the filling out of one composition, rather than the creation of three unique images. Here, a single woodcut surface is used to produce nine prints that are widely dissimilar. It is not the change in matrix or the use of several matrixes in combination that yields the series variety. Rather, it is the ordering of printing and variety of nonprinting activities that creates the visual diversity in the group of prints. The vigorous working process that the *Venus* woodcuts required—combining, recombining, altering, adding, and subtracting with a wide range of materials and surfaces—embodies Dine's desire to incorporate the Venus into his printmaking vocabulary. It has never been through repetition, but always by means of in-depth exploration yielding variation, that Dine has

adapted each of his images, thereby stripping known symbols of their previous association and redefining them as his own.

In February and December of 1983 Dine produced monoprints at the Angeles Press, creating groups of related prints during several hectic sessions. What is significant about the time he spent making monoprints with Toby Michel is that the working method developed for producing serial monoprints was carried over into Dine's subsequent use of this workshop. Traditional monoprints are made by drawing or painting on a flat surface and transferring that image to paper. When Dine works on the monoprints he combines printing with every form of hand painting. Dine paints on the plate, prints it, pins the print to the wall, alters the image by hand, paints on the plate again, prints it again, prints the shadow of what remains on the plate on another sheet, pins that to the wall, and so forth. The result is that Dine has half a dozen monoprints in process simultaneously. They are created with a series of acts that, according to Toby Michel, utilize the complete arsenal of materials found around the shop. This process was carried over to the printing and hand painting of the *Nine Views of Winter*.[16]

Once the Venus shifted from being a plaster cast that Dine represented in oil to being a life-size sculpture that he fashioned into his own form and made the subject of large-scale prints, its meaning expanded. The association to art history is immediate, particularly with each viewer's initial exposure. With stated "awe for the greatness of the original," which Dine revisited at the Louvre in late 1984, the artist clarified his lack of interest in simply copying a masterpiece. With his adaption of the Venus as a single form to be explored in depth, Dine maintains his art historical connection and then adds his own personal meaning. Through numerous variations he subverts the viewer's initial association and arrives at a new, less loaded image. Then he proceeds to integrate it into his own vocabulary by investing it with his own second layer of intent. This process, without demeaning the original, removes it from its pedestal, so to speak, as Dine declares that nothing is sacred, beyond or above contemporary usage.

Surprisingly, when Dine is questioned about why, of all the famous sculptures to choose from for this still-evolving series, he selected the Venus, he avoids a direct answer. He has given a practical explanation, that the Venus plasters are widely available in art supply stores, yet he will not be pinned down regarding specific reasons for his attraction to this particular work of art and what the meanings are that he has, through variation, attributed to it. Even so, several probable explanations present themselves.

The first layer of meaning is the literal one: Dine's Venus is a modern representation of Aphrodite, the goddess of love and beauty. Homeric verse describes her as emerging from the foam of the sea to become the goddess of spring. Later she would become the lover of Adonis, the wife

of Vulcan, the mother of Aeneas and Cupid, and, as the recipient of the golden apple awarded to the fairest woman in the world, a key figure in the legends surrounding the Trojan War. Whatever aspect of the myth comes to mind, our primary response to this statue is grounded in a fundamental vision of a graceful, curvaceous figure, the embodiment of female sexuality.

The next layer of meaning and amplification of Dine's intent is disclosed through comparison with another of the artist's subjects—the robe. Dine's adaption of the robe began in 1964, in printmaking and painting, and has been sporadically pursued ever since. From the start, Dine stated through the titles he gave to the prints that the robe was a self-portrait. However, toward the late seventies, with major bodies of work in both mediums, this specificity of reference changed. The robe became iconic, spiritual, and expressive, more a general vehicle than a specific symbol. Dine's robes have always occupied the center of the composition, filling the entire sheet or canvas. The robe is always empty, neither head atop the shoulder nor hands emerging from the sleeves. No body fills the garment, so that the attributes of the robe, not the person wearing it, became Dine's purveyor of content. Despite the consistency in formal presentation, Dine has never created two robe prints that are alike. Every print or painting is a further development of the symbol.

With Venus, Dine has succeeded in finding a female counterpart to the robe. The very first thing he did to the Venus de Milo was remove her head, disallowing reference to a specific person. This opened her up to the multiple interpretations that were to follow. The Venus however is not an outer skin, like the robe. Dine has taken full advantage of the volumetric in describing a voluptuous female form. The drapery hangs off her full hips and hugs the thighs. Her scant costume provides the identical formal device that the folds of the robe offer. Certainly, just as the robe is both Dine himself and a generalized male image, the *Venus* could be Nancy Dine as well as female sexuality. When Dine desires specificity and intense psychic interpretation he turns to portraiture—to images of himself and his wife. When he explores full-length figures, male and female physical forms, he turns to the robe and now to the Venus.

NOTES

The title of the essay is from William Shakespeare's fifty-fifth sonnet, which begins "Not marble, nor the gilded monuments/ Of princes, shall outlive this powerful rhyme."

1 All quotations from the artist are taken from interviews granted the authors of the present catalogue during 1984–85 or from videotapes made in 1983–84 by Nancy Dine.

2 The 1977 still life paintings were exhibited at The Pace Gallery, New York, April 29–June 9, 1978. A catalogue for this exhibition was published by the gallery. Two still life paintings from the summer of 1978 were illustrated in the catalogue for Dine's next exhibition at Pace, January 11–February 9, 1980, although they were not exhibited at that time. The 1980 exhibition featured robe paintings done during the summer of 1979 in Jerusalem.

3 A precedent for Dine's use of the still life landscape theme as a metaphor for the art-making process can be seen in *The Studio Landscape,* 1963, oil on canvas with objects, 60 × 108". This is a six-panel painting (each panel refers to a different weather condition or type of landscape) with a small shelf, on which sits bottles, cups, glasses, and an ashtray.

4 The relationship between Jim Dine's art and that of mid-seventies and eighties *image* painting and sculpture has yet to be properly addressed or documented. Dine should be viewed as a senior member of this movement, one who is still working and strongly influencing the younger generation, rather than a distant "pop art" influence upon it. Such a study might focus on Dine's relationship to the current interest in isolating objects from logical narratives or descriptive contexts and then relocating them in nonspecific or imaginary situations, in addition to addressing the significance of the abstract-painterly environments in which the latter occurs. Richard Marshall has credited Dine and Johns in *New Image Painting* (New York: Whitney Museum of American Art, 1978) with a "precursory affiliation in style to the later generation of image painters."

5 For an excellent listing of Dine's early activities see the Chronology compiled by Susan J. Cooke in Barbara Haskell's *Blam!, The Explosion of Pop, Minimalism, and Performance 1958–1964* (New York: W. W. Norton and Company and Whitney Museum of American Art, 1984).

6 The *Venus* sculptures along with other sculptures of columns, tables, shells, hearts, busts of Nancy, and a gate, were exhibited for the first time at The Pace Gallery, New York, February 17–March 30, 1984 and at the Waddington Gallery, London, March 7–31, 1984. Pace published a catalogue with an informative essay by Michael Edward Shapiro, that places the *Venus* sculptures within the context of Dine's larger body of work in that medium.

7 In light of this essay's interest in the interaction of mediums, it is worth noting that Dine's attitude toward the addition of color to a bronze statue relates directly to his printmaking. Rather than applying a patina, Dine hand paints the bronze, each sculpture being cast in a small edition.

8 Dine has never been attracted to the quality of screenprinting and has gone so far as to repudiate his mid-sixties work in the medium. Currently he relegates screenprinting to the role of background, suitable for overprinting with other mediums.

9 This is not the case with all the Angeles Press editions. In certain instances, Toby Michel prints part of the jigsawed block with nothing in the press to brace it. All the Angeles Press woodcuts were printed on a lithography press.

10 *White Teeth,* 1963 and *Night Palette,* 1965 are early examples of white printings on black paper. *Double Palette with Gingham,* 1965, is the first double image on a single sheet of paper.

11 The process of producing the collage relates directly to the procedure Dine followed just a few months later in creating *Handmade Double Venus.* That is, two images, in this case transfers, were cut down and placed side by side on a plate.

12 A unique impression of the soft-ground plate and one with this over-printed on the screenprint are in the Davison Art Center Collection.

13 See essay by Ellen G. D'Oench in this volume.

14 It is worth noting that the first prints Dine editioned in Paris are of the Eiffel Tower, the archetypical symbol of that city.

15 Numbers 1–7 and 5 AP's of all nine editions that comprise *Nine Views of Winter* were printed in December 1984. The rest of the editions were printed in March 1985.

16 The video tape of December 1983 that shows Dine working on the *Heart* monotypes and the tape of December 1984, made when he was working on *Nine Views of Winter (3),* provide documentary evidence of this similarity.

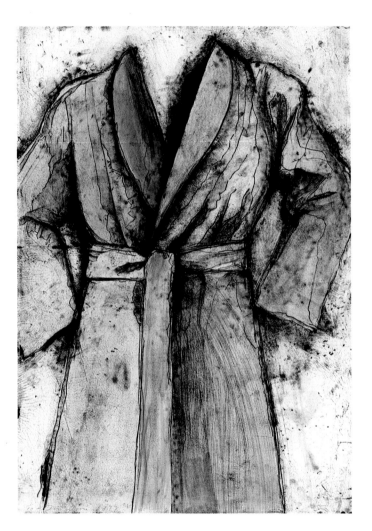

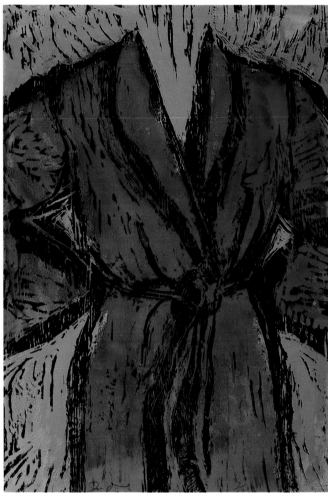

5. **Multi Colored Robe** 156. **Cooper Street Robe**

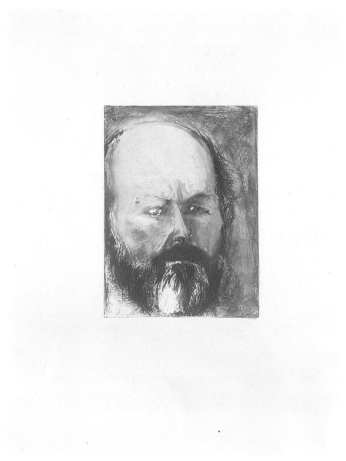

28. Self-Portrait with Oil Paint

47. Me in Horn-Rimmed Glasses

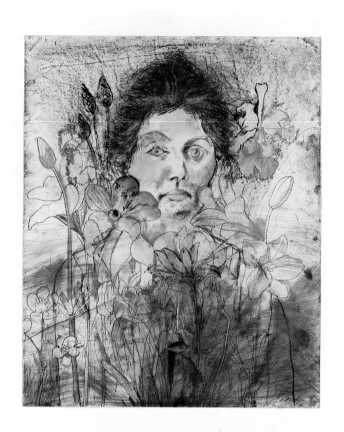

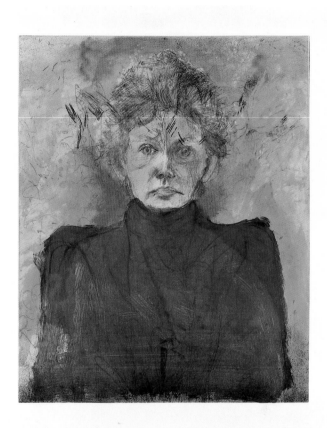

68. Nancy Outside in July VII

72. Nancy Outside in July XI

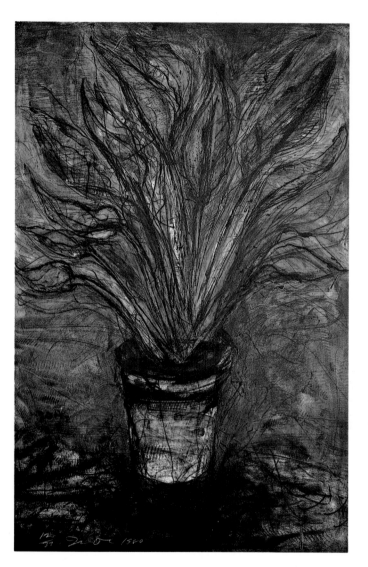

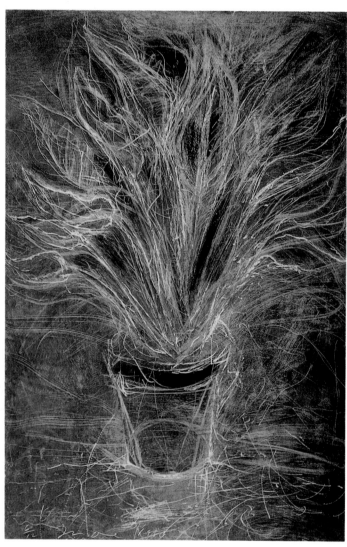

73. A Well

77. Pink Strelitzia

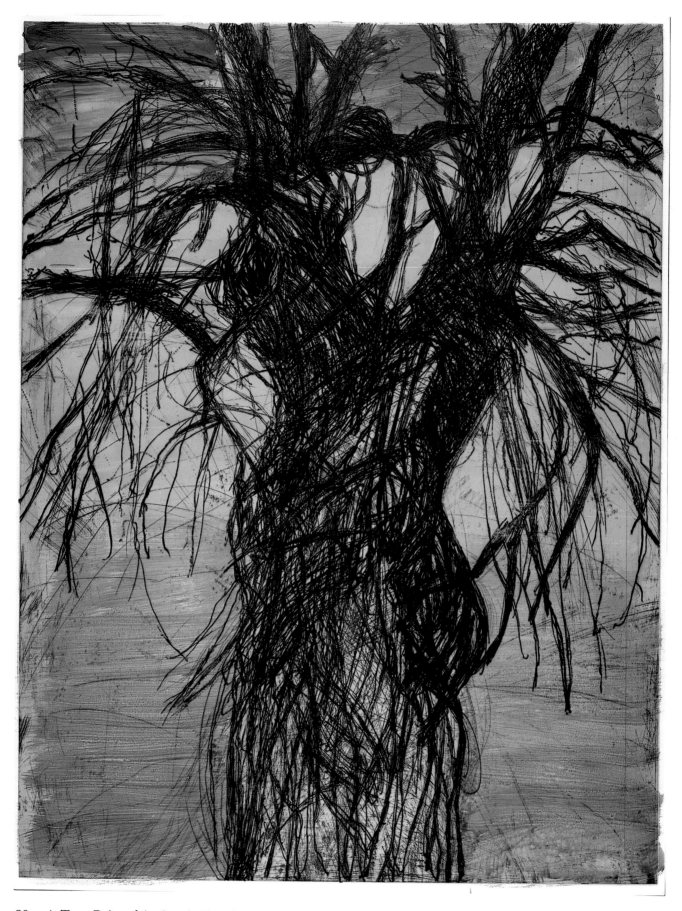

80. A Tree Painted in South Florida

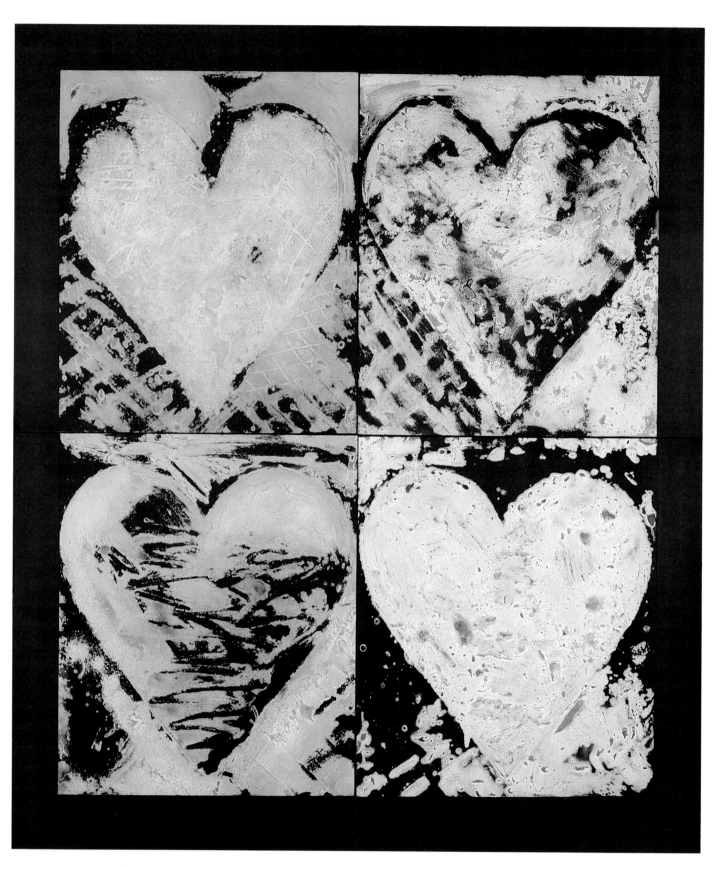

117. Winter Windows on Chapel Street

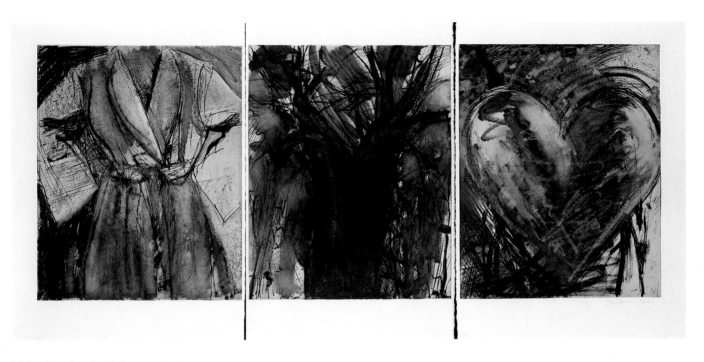

120. Desire in Primary Colors

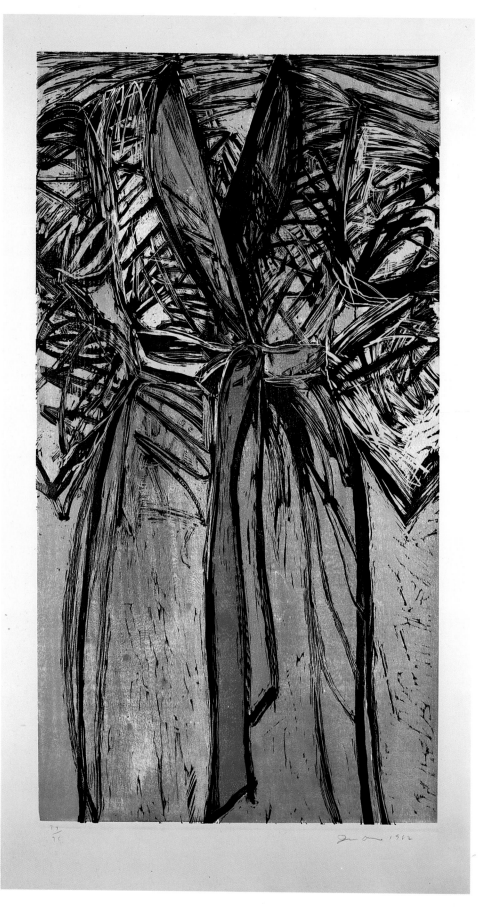

112. Fourteen Color Woodcut Bathrobe

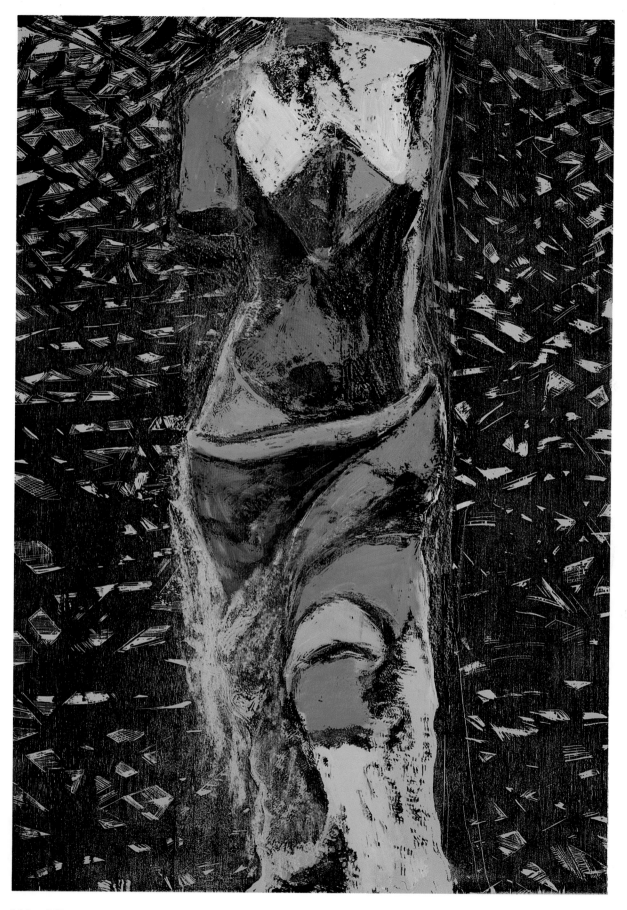

199. Nine Views of Winter (3)

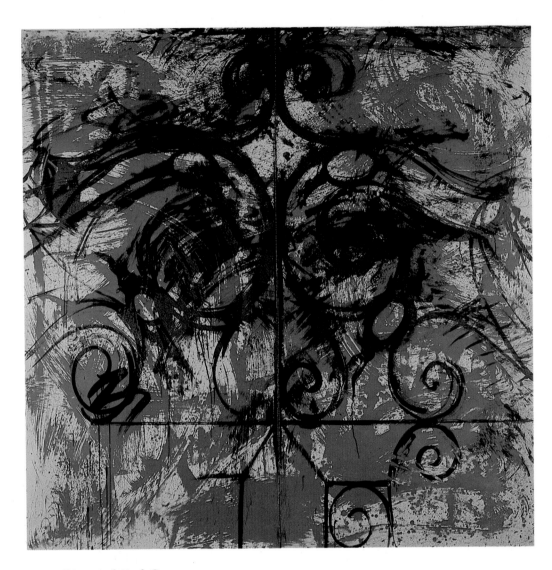

113. Blue and Red Gate

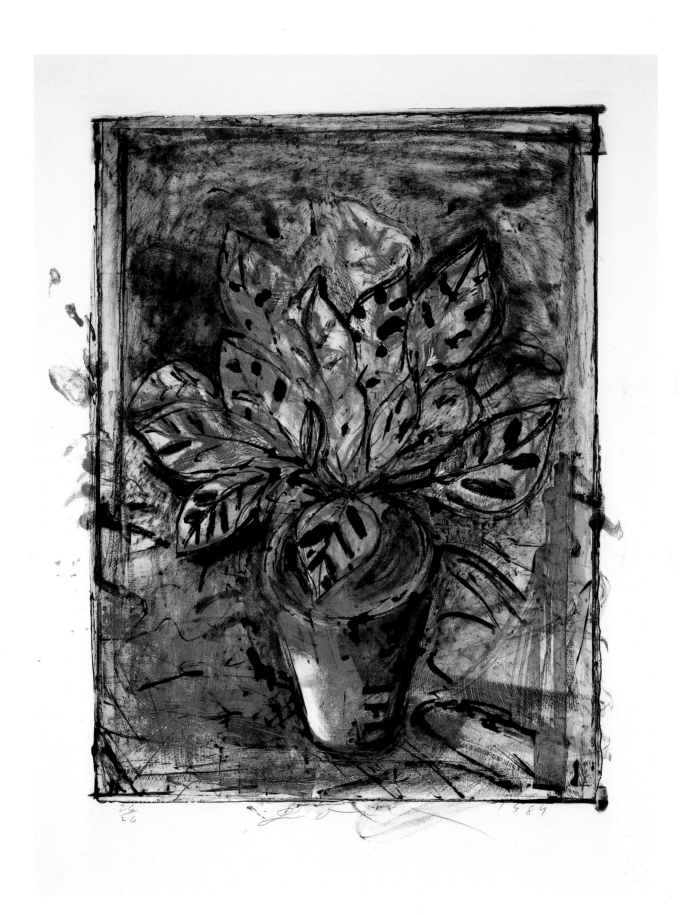

176. **The Jerusalem Plant #8**

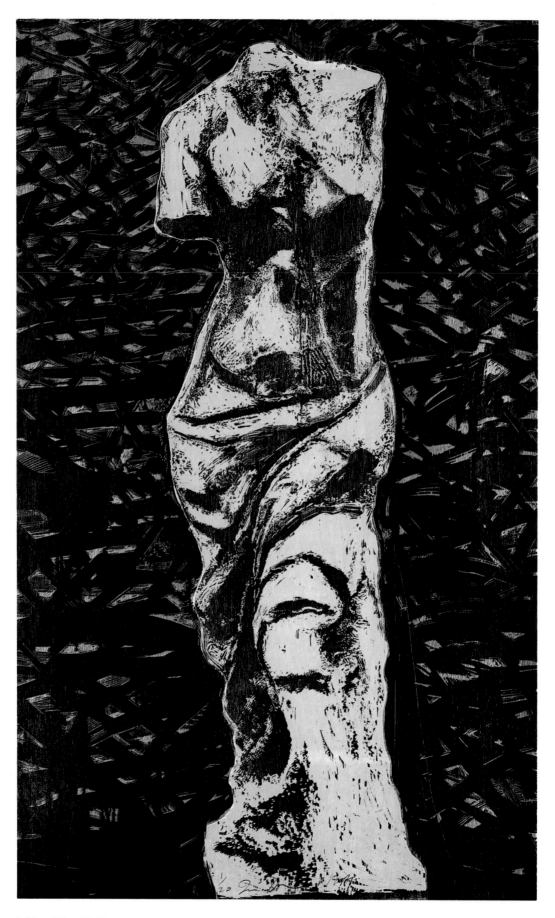

163. The Yellow Venus

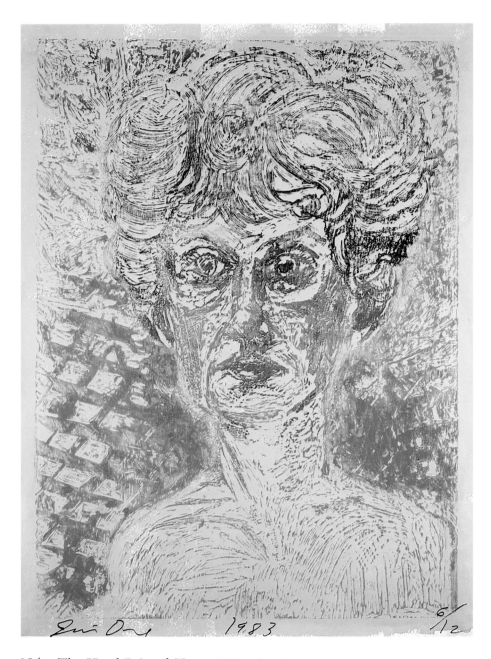

154. The Hand Painted Nancy (Woodcut)

194. The French Watercolor Venus

186. Lost Shells

187. Wallpaper in Paris

91. A Heart on the Rue de Grenelle

CATALOGUE RAISONNÉ

Chronology

This catalogue raisonné lists the prints of Jim Dine from early in 1977 through the end of 1985. The prints are listed according to their year of publication. The ordering within each year follows the sequence of Dine's printmaking activities as closely as possible. An exception to this procedure occurs when the date of publication falls in the year after the print's completion. In that case, the placement of the print in our chronology reflects the date the edition was released rather than when Dine completed it. Prints which were editioned but not released for publication are listed in the Appendix. This publication supplements the two earlier catalogue raisonnés: *Jim Dine: Complete Graphics,* Berlin: Galerie Mikro, 1970, and Thomas Krens, ed., *Jim Dine Prints: 1970–1977,* New York: Harper & Row in association with Williams College, 1977.

Media

The technical information for the listings and the descriptive texts were compiled by the authors with the assistance of the printers, the publishers, and the artist, and are as accurate as possible. In entries for prints worked in combinations of intaglio, relief, and planographic processes, media are listed in the order of their printing. The term *hand painting* signifies work by the artist. Because Dine frequently employs unconventional methods and tools, several standard printmaking terms require amplification.

Intaglio

ETCHING: The term indicates hard-ground etching as distinct from soft-ground etching.

AQUATINT: Occasionally Dine places the plate in an acid bath to bite an even aquatint field. More frequently the term is used to indicate the spit-bite method. With this technique, the artist paints on the rosin-grounded plate with a brush dipped in acid, mixing it with saliva so that the acid will adhere to the surface without shrinking. Less frequently Dine uses a sugar solution for lift-ground aquatint or splatters and pours acid directly on the rosin-grounded plate. Dine, in recent years, has used the grease resist method with hand scraping and electric burnishing of the aquatint.

ENGRAVING: Dine seldom uses the burin to incise the design into the plate; rather he uses it to score the surface. The mezzotint rocker, on occasion, is used to gouge areas of the plate and excavate the metal.

DRYPOINT: The term indicates the use of needle, scraper, sandpaper, nails, roulette, and mezzotint rocker to roughen the surface of the plate and raise a burr.

ELECTRIC TOOLS: The term indicates the use of a variety of power-driven hand tools: the die-grinder with rotary sanders or wire brush attachments, the electric drill with grinding wheels and router bits, the Dremel with a variety of small abrasive bits, a German vibrating needle, and other rotary or oscillating implements. Because Dine uses these tools to excavate metal and to raise a burr, he has referred to his power-driven techniques as "drypoint-engraving." Most of his marks made by electric tools are unique and do not look precisely like traditional drypoint or engraving. Dine's practice puts into question the traditional terminology of intaglio printmaking.

Relief

WOODCUT: The term incorporates the use of handwork as well as electric tools such as a flexible-shaft power tool with different sized gouge and chisel attachments and the Dremel with its variety of abrasive bits.

Planographic

LITHOGRAPHY: The term indicates standard lithographic techniques using crayon and tusche. Dine also occasionally works the surface with electric rotary sanding discs.

Dimensions and Paper

Measurements are given in inches followed by centimeters in parentheses; height precedes width. With intaglio prints, dimensions are those of the plate-mark. With relief and planographic prints, dimensions are those of the stone, plate, or block only when the image has distinct margins. All paper is described by sheet dimensions and manufacture. The description of a print as a diptych, triptych, four-part image, and so on, indicates that it was printed on two or more sheets of paper, not subsequently joined.

Documentation and Editions

Because Dine works with numerous printers, documentation varies in its comprehensiveness and terminology but is as complete as possible at the present writing. Abbreviations are as follows:

EDITION	Prints numbered in sequence in the regular published edition
AP	Artist's Proofs, pulled outside the edition but equal to it in quality
PP	Printer's Proof, pulled outside the edition and given to the printer
WP/TP	Working Proof/Trial Proof, pulled during the process of work on a print but before the final editioning
BAT	*Bon à tirer,* the exemplar print serving as the model for the edition

Printers and Publishers

All entries are listed with their printers and publishers, with inventory numbers when applicable. Frequently cited printshops are abbreviated as follows: Angeles Press, Los Angeles (Angeles Press); Atelier Crommelynck, Paris (Atelier Crommelynck); Burston Graphic Center, Jerusalem (Burston Graphic Center); Derriere l'Etoile Studios, New York (Derriere l'Etoile Studios); Palm Press, Ltd., Tampa (Palm Press); Putney Fine Arts, Putney (Putney Fine Arts); Universal Limited Art Editions, West Islip, New York (ULAE); and University of South Florida Graphicstudio II, Tampa (USF Graphicstudio II). Dine's principal publisher is Pace Editions, Inc., New York (Pace). Others with whom Dine has published recently are Universal Limited Art Editions, West Islip, New York (ULAE) and the Atelier Crommelynck, Paris (Crommelynck).

Signatures

All editioned prints are signed in pencil by the artist with the date and edition number, usually along the lower margin of the print. Signatures are noted here only if inscribed in a medium other than pencil or in an unusual place within the image.

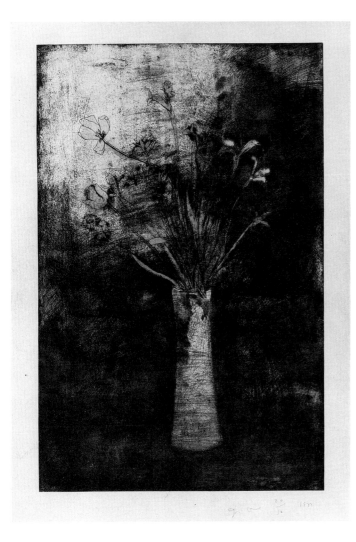

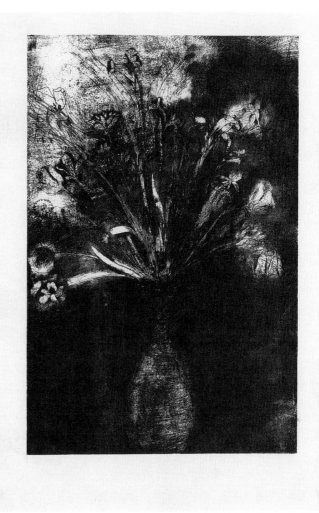

1. Hand Colored Flowers 1977

Etching, soft-ground etching, aquatint, drypoint, engraving, and electric tools from one 35½ × 23¼ (90.2 × 59.1) plumber's copper plate
Printed in black with hand painting in blue, 2 shades of pink, yellow, violet, and green watercolor after editioning
Paper: 41½ × 29½ (105.4 × 75) Copperplate Deluxe
Edition: 50, plus 8 AP; 16 lettered A through P without color
Printed by Mitchell Friedman, assisted by Jeremy Dine, New York; published by Pace (193-13)

Dine used a single plate, a randomly scratched sheet of plumber's copper, for three prints: *Hand Colored Flowers, Black and White Flowers,* and *Red Ochre Flowers* (1, 2, 8). The plate was heavily worked with a complete range of intaglio techniques: soft-ground etching, hard-ground etching, aquatint, and drypoint, in addition to using the mezzotint rocker to raise burr and as an engraving tool. The plate was cut down for the second state (2) and again for the third (8), with the die-grinder used as an electric burnisher to change the shape of the vase and the details of each bouquet. The working of the entire surface and heavy inking is characteristic of the prints editioned with Mitchell Friedman, Dine's primary printer in the United States from

1975 to 1979. In the three flower prints, the tonal variation and rich inking was augmented through retroussage, followed by careful wiping of each flower head. Two charcoal, ink, and crayon drawings of 1976 relate to these prints (Glenn 1979, 33 and 34).

2. Black and White Flowers 1977

Etching, soft-ground etching, aquatint, drypoint, engraving, and electric tools from one 29⅜ × 19¾ (74.7 × 50.2) plumber's copper plate
Printed in black
Paper: 39 × 27½ (99.1 × 69.9) Fabriano Rosaspina
Edition: 50, plus 12 AP
Printed by Mitchell Friedman, assisted by Jeremy Dine, New York; published by Pace (193-14)

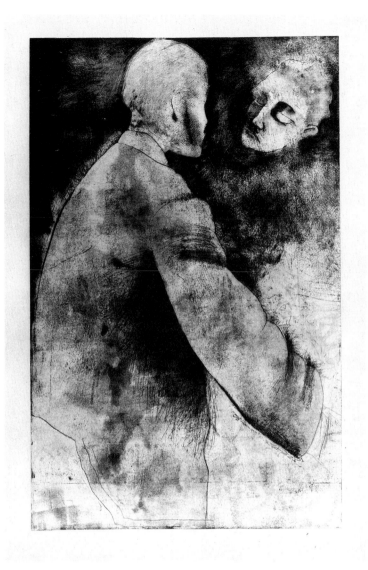

3. The Brown Coat 1977

Etching, soft-ground etching, aquatint, drypoint, and electric tools from two 35⅝ × 23½ (90.2 × 59.6) plumber's copper plates
Printed once in black and once in brown
Paper: 41⅞ × 29⅜ (106.2 × 74.8) Copperplate Deluxe
Edition: 50, plus 13 AP
Printed by Mitchell Friedman, assisted by Jeremy Dine, New York; published by Pace (193-15)

The print is related to *Man in a Brown Coat Visiting the Sick,* 1976, charcoal and pastel (Glenn 1979, 21), based on a collage made from two photographs. Dine sketched the figures' contours on a sheet of newsprint laid over the soft-grounded plate, used the die-grinder to erase and rework areas of the image, and incorporated mezzotint and deliberate foul-biting for tone. The second plate, printed in brown for the man's coat, was first grounded with aquatint rosin fused to the surface by the heat of a propane torch. When the plate cooled, Dine painted on it with nitric acid mixed with saliva (spit-bite) to achieve tonal gradations similar to watercolor.

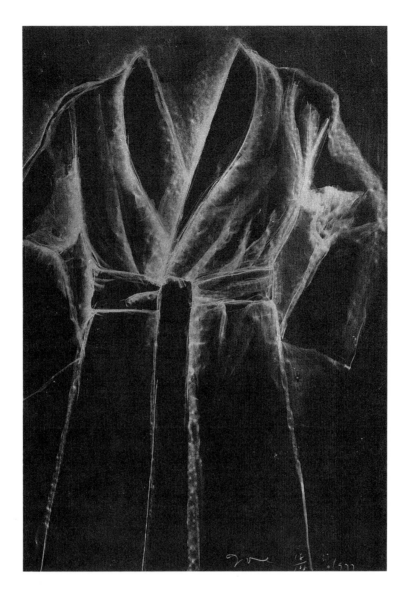

In 1977, Dine was commissioned to create a poster for the 15th New York Film Festival. The lithograph he submitted was of a black robe with red lettering on gray Rives paper. When the zinc plate with the robe drawing was being printed on a commercial offset press, Dine obtained two other runs for his own use: one in white ink on just over 100 sheets of Fabriano black and one in black of a similar number of Arches Cover buff. The former became the *White Robe on Black Paper* (4) and was sent for benefit sale to the Israel Museum. The latter became the basis for the *Multi Colored Robe,* the *Spray Painted Robe,* and the *Black and White Robe* (5–7). Dine worked a plate with a similar combination of techniques and tools including a wirebrush, steel wool, the mezzotint rocker, and the die-grinder that characterize the three states of the flower plate during this same period. A group of the lithographs on Arches were hand painted with several colors of oil paint and then printed with this plate to yield *Multi Colored Robe* (5). The plate was reworked, another group of lithographs prepared

with spray paint, and then the second state plate dropped onto it, producing *Spray Painted Robe* (6). For the third print in this group, *Black and White Robe* (7), the second state of the plate was printed over the lithograph without hand painting. There is great diversity in editions Nos. 5 and 6 because Dine did not seek consistency in hand painting and the ink resisted the enamel surface of the sprayed version, making uniform printing difficult. See No. 87 for later use of the copper plate.

4. White Robe on Black Paper 1977

Offset lithograph from one zinc plate
Printed three times in white
Paper: 41⅜ × 29½ (105.1 × 75) Fabriano black
Edition: 100, plus 10 AP
Printed by Deli Sacilotto, New York; published by the American Friends of the Israel Museum (Pace 193-80)

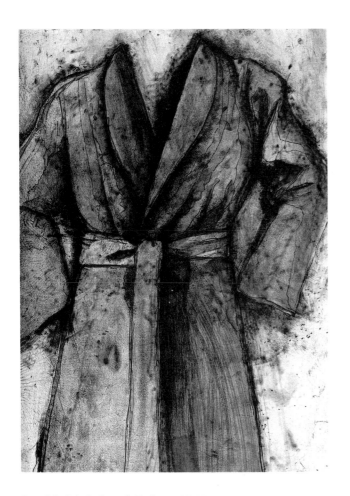

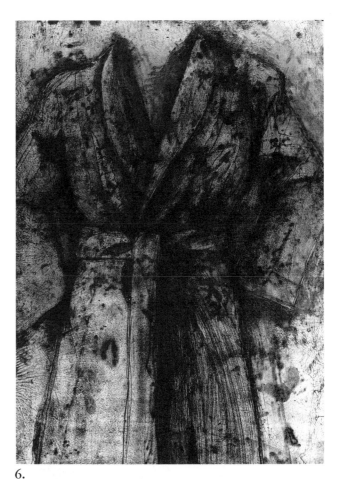

6.

5. Multi Colored Robe 1977

Offset lithograph from one zinc plate; etching, soft-ground
etching, drypoint, and electric tools from one copper plate larger
than sheet size
Printed twice in black with hand painting in green, pink, yellow,
and blue oil between printings
Paper: 41⅜ × 29½ (105.1 × 75) Arches Cover buff
Edition: 10, plus 3 AP
Lithograph printed by Deli Sacilotto, New York; intaglio printed
by Mitchell Friedman, assisted by Jeremy Dine, Dartmouth;
published by Pace (193-17)

6. Spray Painted Robe 1977

Offset lithograph from one zinc plate; etching, soft-ground
etching, drypoint, and electric tools from one copper plate larger
than sheet size
Printed twice in black with hand painting in red and blue spray
enamel between printings
Paper: 41⅜ × 29½ (105.1 × 75) Arches Cover buff
Edition: 27, plus 6 AP
Lithograph printed by Deli Sacilotto, New York; intaglio printed
by Mitchell Friedman, assisted by Jeremy Dine, Dartmouth;
published by Pace (193-18)
Signed in white pencil

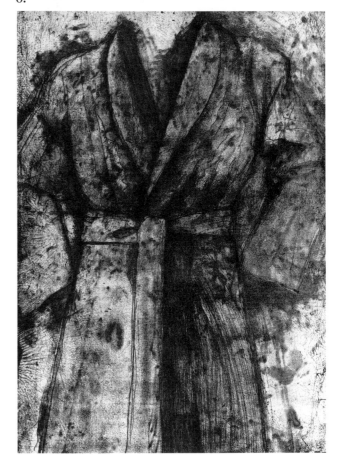

7.

64

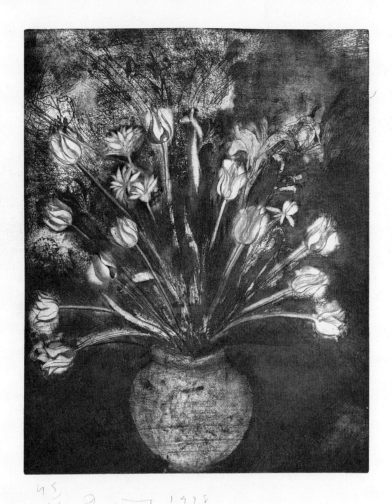

8.

7. Black and White Robe 1977

Offset lithograph from one zinc plate; etching, soft-ground etching, drypoint, and electric tools from one copper plate larger than sheet size
Printed twice in black
Paper: 41⅜ × 29½ (105.1 × 75) Arches Cover buff
Edition: 12, plus 3 AP
Lithograph printed by Deli Sacilotto, New York; intaglio printed by Mitchell Friedman, assisted by Jeremy Dine, Dartmouth; published by Pace (193-19)
Signed in white pencil

8. Red Ochre Flowers 1978

Etching, soft-ground etching, aquatint, drypoint, engraving, and electric tools from one 24⅝ × 19¾ (62.6 × 50.2) plumber's copper plate
Printed in red-ochre
Paper: 39¼ × 27⅝ (99.7 × 70.2) Fabriano Classico
Edition: 45, plus 11 AP, 1 TP printed in green on John Koller HMP pink paper
Printed by Mitchell Friedman, New York; published by Pace (193-32)

The plate for *Red Ochre Flowers* (8) is the third state of the plate used for *Hand Colored Flowers* and *Black and White Flowers* (1, 2).

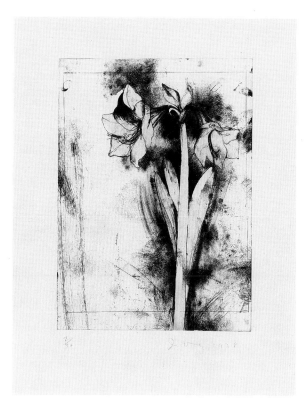

9. Amaryllis 1978

Hand painting in pink and green

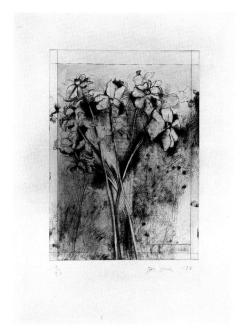

10. Anemones 1978

Hand painting in green

The *Temple of Flora* portfolio (9–17) began in 1977 as nine mylar drawings that were transferred to plates through photogravure. Each plate was worked with hard and soft-ground etching, drypoint needle, mezzotint rocker used as a drypoint tool, and the die-grinder used as an electric sander for light plate tone. After editioning, all the prints were delicately highlighted with watercolor. This series emphasizes Dine's superb draftsmanship, a skill that he perfected during the mid-seventies by constant exercise, including frequent sessions of drawing from the model. *A Temple of Flora* was issued as a portfolio with a cover sheet for numbers I–X, while numbers 1–30 were released as individual prints. The tulip drawing (17) was used for the Ojai Festival poster, May 1978. Dine issued a second, bound *Temple of Flora* in 1984 (177).

9–17. A Temple of Flora 1978

9 prints: etching, soft-ground etching, drypoint, photogravure, and electric tools from nine 23¾ × 17¾ (60.3 × 45.1) copper plates
Printed in black with hand painting in watercolor after editioning
Paper: 39 × 27⅝ (99.1 × 70) Fabriano Rosaspina
Edition: 10 (I–X), 30 (1–30), plus 10 AP (11 AP for *Strelitzia*, No. 12), and 2 WP
Printed by Mitchell Friedman, assisted by Sally Sturman, New York; photogravure by Deli Sacilotto, New York; published by Pace (193-21-I-X; 193-22-1-10)

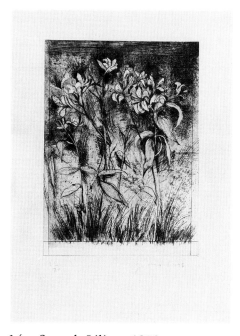

14. Superb Lilies 1978

Hand painting in green and yellow

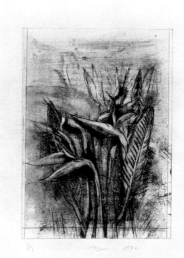

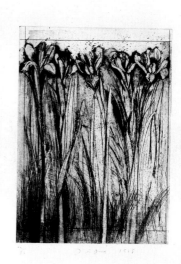

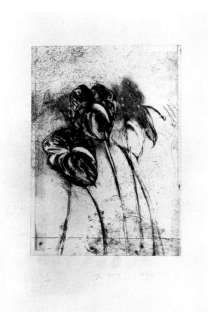

11. Anthurium 1978

Hand painting in green, pink, red, yellow, and orange

12. Strelitzia 1978

Hand painting in green and two shades of pink

13. Iris 1978

Hand painting in green, yellow, and violet

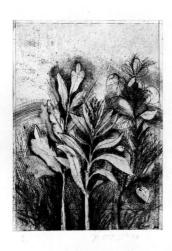

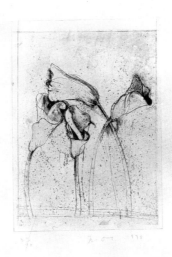

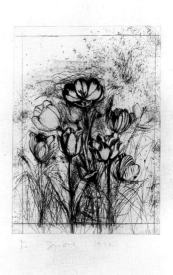

15. Tropical Succulents 1978

Hand painting in green and pink

16. Yellow Calla Lilies 1978

Hand painting in yellow and green

17. Tulips 1978

Hand painting in yellow, green, and two shades of pink

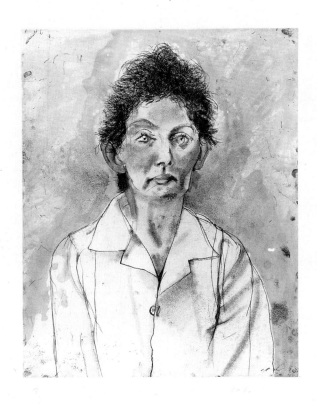

18.

In July 1977 Dine began work on the first plate of the twenty-five print series, *Nancy Outside in July,* which was to be the focus of the next four years of work at the Atelier Crommelynck until 1981. These portraits are variations on or developments of the first state (18), which was drawn from life on a sheet of paper laid on the soft-grounded plate. During the four years, Nancy Dine posed frequently and therefore the series reflects changes in her hair and clothing as well as in mood and setting. Dine brought to these images a vast diversity of techniques to effect their subtle and, at times, dramatic alterations. The series is discussed in Ellen G. D'Oench's essay in the present catalogue and was the subject of Clifford Ackley's *Nancy Outside in July,* 1983. The prints are listed in their chronological order as Nos. 18–22, 61, 68–72, 93–106.

18. Nancy Outside in July I 1978

Etching, soft-ground etching, and aquatint from three 23 × 19½ (58.4 × 49.6) copper plates
Printed once in green, once in flesh, and once in black with hand painting in pink and blue watercolor after editioning
Paper: 35⅝ × 24⅞ (90.5 × 63.2) Arches
Edition: 60, plus 13 AP
Proofed by Aldo Crommelynck, printed at Atelier Crommelynck; published by Crommelynck (Pace 193-25)

19. Nancy Outside in July II 1978

Etching and soft-ground etching from one 23 × 19½ (58.4 × 49.6) copper plate
Printed in black
Paper: 35⅝ × 24⅛ (90.5 × 61.3) Kozo cream
Edition: 9, plus 4 AP
Proofed by Aldo Crommelynck, printed at Atelier Crommelynck; published by Crommelynck (Pace 193-36)

The Japanese (Kozo) paper introduced sufficient change in the print to warrant Dine's editioning of a second version using the key plate only.

20. Nancy Outside in July III 1978

Etching, soft-ground etching, aquatint, drypoint, and electric tools from two 23 × 19½ (58.4 × 49.6) copper plates
Printed twice in black
Paper: 41½ × 29½ (105.4 × 74.9) Rives BFK
Edition: 60, plus 10 AP
Proofed by Aldo Crommelynck, printed at Atelier Crommelynck; published by Crommelynck (Pace 193-37)

The flowers added to the key plate were designed after a watercolor by an unknown artist which Dine found in a shop in Paris.

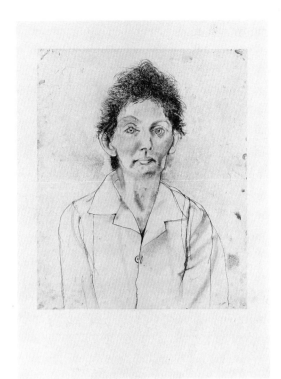

19.

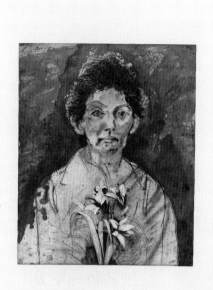

20.

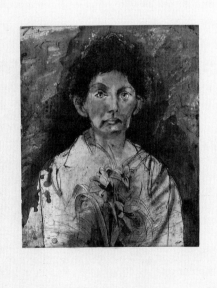

21.

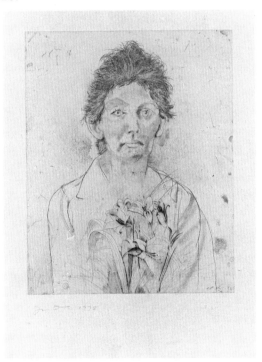

22.

21. Nancy Outside in July IV 1978

Etching, soft-ground etching, aquatint, drypoint, and electric tools
from three 23´ × 19½ (58.4 × 49.6) copper plates
Printed three times in three shades of black, with hand painting in
orange, flesh, and pink oil before the third printing
Paper: 41½ × 29⅞ (105.4 × 75.9) Rives BFK
Edition: 15, plus 10 AP
Proofed by Aldo Crommelynck, printed at Atelier Crommelynck;
published by Crommelynck (Pace 193-38)

22. Nancy Outside in July V 1978

Etching, soft-ground etching, drypoint, and electric tools from one
23 × 19½ (58.4 × 49.6) copper plate
Printed in red-brown
Paper: 35¾ × 24 (90.8 × 61) Kozo cream
Edition: 25, plus 10 AP
Proofed by Aldo Crommelynck, printed at Atelier Crommelynck;
published by Crommelynck (Pace 193-39)
Inscribed with edition numbering by Aldo Crommelynck

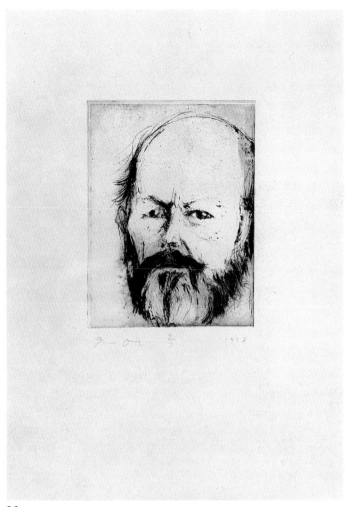

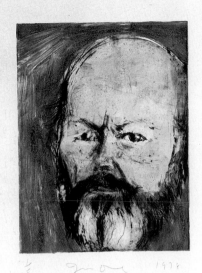

23.

24.

While Dine was a guest artist at Harvard in the fall of 1978, he began work on a series of self-portraits originating from a single drawing on transparent acetate. The drawing was transferred by photogravure to a plate which Dine brought to Harvard for work in intaglio techniques and monoprinting. Three states of the print, showing the artist facing to the left (23–25) were pulled from this plate. In its third state, the plate was reduced in size. After returning to New York, Dine produced three additional prints for the series (26–28). These began with a tracing made from No. 23, which reversed the image and therefore show the artist facing to the right. The three states of this image (26–28) incorporate a lithographic plate. It was based on the key image (23) and had been intended, originally, for use as a color element in a poster for Dine's exhibition at the Museum of Modern Art in 1978.

23. Harvard Self-Portrait without Glasses 1978

Etching, drypoint, and photogravure from one 11¾ × 8⅞ (29.9 × 22.6) copper plate
Printed in black
Paper: 26¾ × 20 (68 × 50.8) Copperplate
Edition: 7, plus 3 AP, 1 unique AP printed on Arches Aquarelle paper
Printed by Mitchell Friedman, Cambridge; photogravure by Deli Sacilotto, New York; published by Pace (193-24)

24. Harvard Self-Portrait with Paint 1978

Etching, soft-ground etching, drypoint, photogravure, and monoprinting from one 11¾ × 8⅞ (29.9 × 22.6) copper plate
Printed twice in black with monoprinting in green, orange, and flesh oil on the plate with second printing
Paper: 26¾ × 20 (68 × 50.8) Arches
Edition: 5, plus 2 AP, 2 AP with green monoprint only
Printed by Mitchell Friedman, Cambridge; photogravure by Deli Sacilotto, New York; published by Pace (193-26)

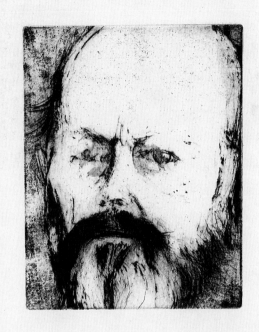

25. Harvard Self-Portrait with Glasses in Sepia 1978

Etching, soft-ground etching, drypoint, and photogravure from
one 9½ × 7⅝ (24.2 × 19.4) copper plate
Printed in red-brown
Paper: 25⅞ × 19¾ (65.7 × 50.2) Richard de Bas Narcissus
Edition: 10, plus 4 AP
Proofed by Mitchell Friedman, Cambridge, printed in New York;
photogravure by Deli Sacilotto, New York; published by Pace
(193-23)

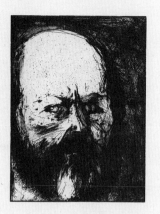

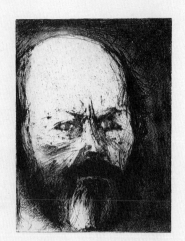

26. Self-Portrait without Glasses 1978

Lithograph from one aluminum plate; etching, soft-ground
etching, and drypoint from one 11¾ × 8⅞ (29.9 × 22.6) copper
plate
Printed twice in black
Paper: 29¾ × 20⅞ (75.6 × 53) Copperplate Deluxe
Edition: 9, plus 3 AP
Lithograph printed by Stuart Allen, New York; intaglio proofed
by Mitchell Friedman, printed by Jeremy Dine, New York;
published by Pace (193-30)

27. Self-Portrait with Blue Tint 1978

Lithograph from one aluminum plate; etching, soft-ground
etching, and drypoint from one 11¾ × 8⅞ (29.9 × 22.6) copper
plate
Printed once in red and once in blue-green
Paper: 25¾ × 19¾ (65.4 × 50.2) Arches Cover cream
Edition: 15, plus 6 AP
Lithograph printed by Stuart Allen, New York; intaglio proofed
by Mitchell Friedman, printed by Jeremy Dine, New York;
published by Pace (193-28)

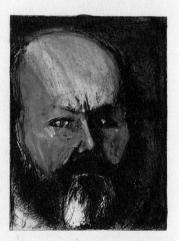

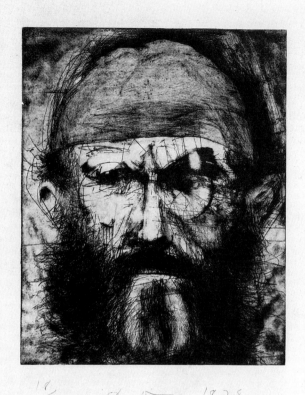

29.

28. Self-Portrait with Oil Paint 1978

Lithograph from one aluminum plate; etching, soft-ground
etching, and drypoint from one 11¾ × 8⅞ (29.9 × 22.6) copper
plate
Printed once in red and once in black with hand painting in blue,
white, and flesh oil after editioning
Paper: 25¾ × 19¾ (65.4 × 50.2) Arches Cover
Edition: 16, plus 6 AP
Lithograph printed by Stuart Allen, New York; intaglio proofed
by Mitchell Friedman, printed by Jeremy Dine, New York;
published by Pace (193-27)

29. Self-Portrait on J.D. Paper 1978

Etching, soft-ground etching, aquatint, drypoint, and electric tools
from one 12⅝ × 10⅜ (32.1 × 26.4)) copper plate
Printed in black
Paper: 25⅞ × 19⅜ (65.8 × 49.3) handmade linen with J.D.
watermark
Edition: 23, plus 8 AP
Proofed by Mitchell Friedman, printed by Jeremy Dine, New
York; published by Pace (193-29)

The *Self-Portrait on J.D. Paper* (29) is a greatly reduced
second state of *Dark Blue Self-Portrait with White Crayon,*
1976. After Dine reworked the plate with etching, the
scraper, and die-grinder, it was printed on paper bearing a
watermark of the artist's initials.

Men and plants

30. Men and Plants 1978

Etching, soft-ground etching, aquatint, drypoint, and electric tools
from one 27½ × 22⅝ (69.9 × 57.5) copper plate, and one 1⅜
× 11¾ (3.5 × 29.9) lead relief block
Printed twice in black
Paper: 40½ × 31 (102.9 × 78.8) John Koller HMP Sagittarius
dyed gray
Edition: 40, plus 9 AP
Intaglio printed by Mitchell Friedman, New York; relief block
pressure-printed by Donald J. Saff, New York; published by Pace
(193-33)

Men and Plants (30) is from the second state of the plate
for *Two Figures Linked by Pre-Verbal Feelings,* 1976. The
earlier print is based on a drawing of a clothed man and a
nude woman. In the 1978 edition, the identities of the two
figures have been obscured through heavy plate work that
results in the addition of flowers in the foreground, a
device that Dine used previously in three states of
Self-Portrait with a Ski Cap, 1974, and explores in depth in
Nancy Outside in July, 1978–81. The dark and mysterious
quality of this richly inked print is complemented by a gray,
deckle-edged paper.

31. The Pine in a Storm of Aquatint 1978

Etching, aquatint, and drypoint from one 57½ × 31¾ (146 × 80.7) heavy gauge copper plate
Printed in black
Paper: 65½ × 39¾ (166.4 × 101) Rives rolled
Edition: 45, plus 11 AP, 1 PP
Proofed by Mitchell Friedman, assisted by Jeremy Dine, Dartmouth, printed by R. E. Townsend, Inc., Boston; published by Pace (193-34)

The plate for *The Pine in a Storm of Aquatint* (31) is larger than any Dine had previously used and forecasts the increase in scale that will characterize his printmaking of the eighties. Its size presented a technical problem in terms of achieving an even aquatint. In order to adhere the rosin particles to the plate's surface, it was heated from behind with a propane torch, section by section. The result, a varied, mottled aquatint texture, illustrates how Dine's open-minded attitude towards process permitted him to turn the unexpected consequences of technical difficulties into imaginative imagery.

32. Roses 1978

Drypoint from one 11¾ × 11⅞ (30 × 30.2) copper plate
Printed in black
Paper: 24 × 20 (61 × 50.8) John Koller HMP Lexington
Edition: 40, plus 10 AP, 4 unique proofs dated 1975
Proofed by Mitchell Friedman, printed by Jeremy Dine, New
York; published by Pace (193-31)

Roses (32) was delicately drawn with a drypoint needle and
a scraper was used for gray tone. Several unique proofs
with hand painting, signed and dated 1975, are in the
artist's possession.

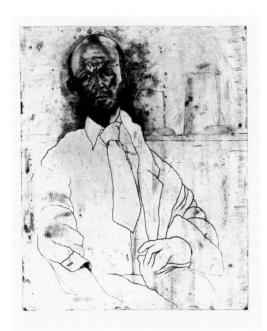

33.

For the suite of eight hand colored etchings of 1979 (33–40), Dine returned to the plates used for his *Eight Sheets from an Undefined Novel,* 1976. The earlier prints were based on charcoal figure studies drawn in 1975 (Glenn 1979, 1–8). After erasing and adding areas of tone with the die-grinder and making alterations to the images, especially to the faces, Dine changed the identities of some of the characters. For the 1976 *Eight Sheets,* Dine painted in watercolor on the paper after editioning; with the second states, he painted in oil on the paper between double printings. Because roofer's copper tends to flatten in the printing process, Dine intentionally exploited off-register printing to suggest the revisions and pentimenti of his drawings.

33–40. Eight Sheets from an Undefined Novel, State II 1979

8 prints: etching, soft-ground etching, aquatint, and electric tools from eight 23¾ × 19½ (60.3 × 49.6) unpolished roofer's copper plates
Printed twice in black with hand painting in oil between printings
Paper: 29¾ × 22 (75.6 × 55.9) Rives BFK
Edition: 35, plus 9 AP (10 AP for *Self-Portrait as a Diemaker,* No. 33)
Proofed by Mitchell Friedman, printed by Jeremy Dine, New York; published by Pace (193-41-48)

33. Self-Portrait as a Diemaker 1979

Hand painting in yellow and flesh

34. Akhmatova, The Russian Poetess 1979

Hand painting in yellow, pink, and green

35. The Cellist Against Blue 1979

Hand painting in red and blue

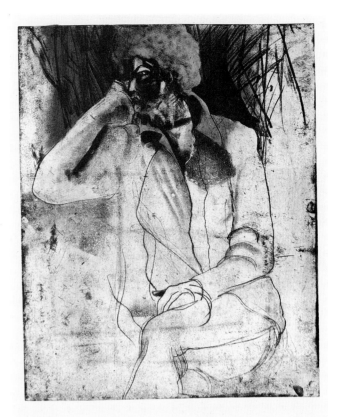

34.

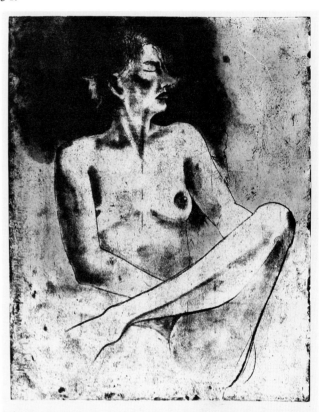

35.

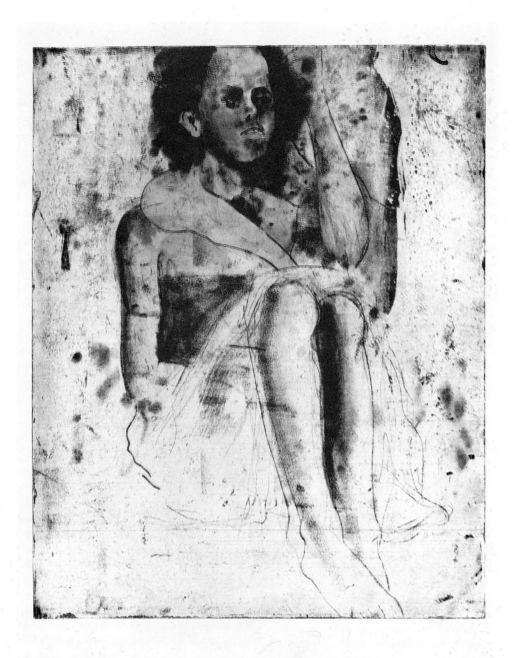

37.

36. Our Nurse at Home 1979

Hand painting in green, orange, flesh, and red

37. A Little Girl 1979

Hand painting in yellow and pink

38. Summer (A Swimmer) 1979

Hand painting in yellow, blue, and flesh

39. Etching Lesson 1979

Hand painting in yellow and flesh

40. The Leaning Man 1979

Hand painting in yellow, pink, and flesh

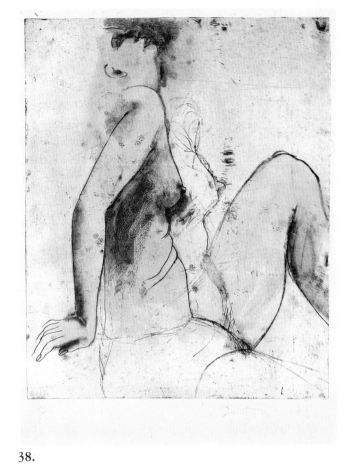

36.

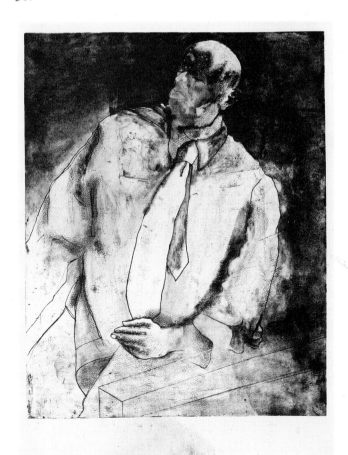

38.

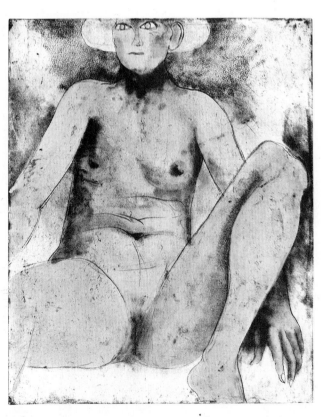

39.

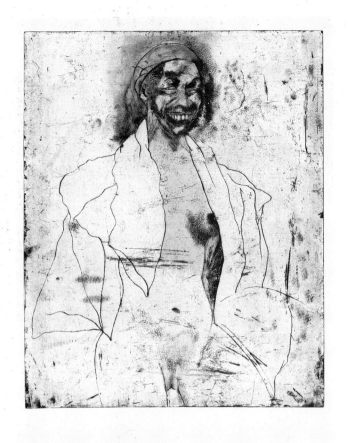

40.

41. Rachel Cohen's Flags, State I 1979

Drypoint from six 15¾ × 21¾ (40 × 55.3) copper plates
Each sheet printed twice in black with hand painting in blue,
green, and red oil between printings
Paper: six joined sheets, overall 17¾ × 138 (45.2 × 337.5)
Rives BFK
Edition: 15, plus 4 AP, 2 PP
Printed by Donald J. Saff, assisted by students at the University of
Hartford; sheets joined by Michelle Juristo, USF Graphicstudio II;
published by Pace (193-49)

This frieze of irises (41), which Dine began by drawing on
the plate with a Magic Marker from life, is named after the
artist's grandmother. The six drypoint plates were first
lightly printed, providing Dine with guides for hand
coloring. The blue oil paint is mixed with a generous
amount of turpentine for a wash of sky in the background.
A transparent green is used for the leaves and a delicate
red for the petals. A second printing darkened the fuzzy
drypoint lines. For a second state edition, see No. 90.

Dine's series of nine self-portraits, 1979 (42–50), eight of
them printed in Jerusalem and the final one in Paris,
consists of successive states of the original plate (42). The
prints combine etching with the use of needle, scraper, and
a vibrating electric tool manufactured in France. Most of
them are painted or hand colored between printings and
several are printed off-register. Dine gradually reduced the
plate in size, ultimately condensing the image, now worked
with a Dremel, on the central features of his face (50).

42. Self-Portrait 1979

Etching, drypoint, and electric tools from one 21¼ × 16⅞ (54 ×
42.9) copper plate
Printed twice in black with hand painting in blue, flesh, and pink
oil between printings
Paper: 41 × 29¼ (104.1 × 74.3) Rives BFK
Edition: 6, plus 2 AP, 1 PP, 1 WP, 1 without hand painting
Printed by Ami Rosenberg, Burston Graphic Center; published by
Pace (193-60)

43. Self-Portrait in Gray 1979

Etching, drypoint, and electric tools from one 18¼ × 15⅛ (46.4
× 38.4) copper plate
Printed twice in black and once in white (on head only) with
hand painting in gray oil between black printings
Paper: 29¾ × 22¼ (75.6 × 56.5) Rives BFK
Edition: 6, plus 2 AP, 1 PP, 1 TP without hand painting
Printed by Ami Rosenberg, Burston Graphic Center; published by
Pace (193-59)

44. The Hand Painted Portrait on Thin Fabriano 1979

Etching, drypoint, and electric tools from one 14⅜ × 13⅞ (36.6
× 35.3) copper plate
Printed once in brown and once in black with hand painting in
pink, blue, green, yellow, and flesh oil between printings and
white grease crayon after editioning
Paper: 30⅝ × 22⅞ (77.8 × 58.1) Fabriano CMF Tiepolo
Edition: 6, plus 3 AP, 1 PP
Printed by Ami Rosenberg, Burston Graphic Center; published by
Pace (193-61)

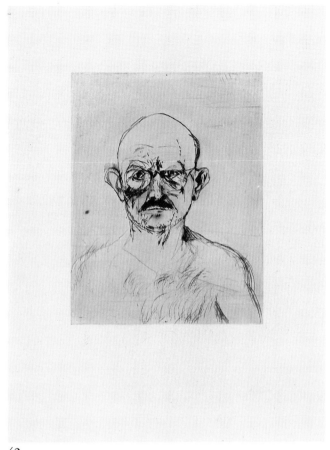

42.

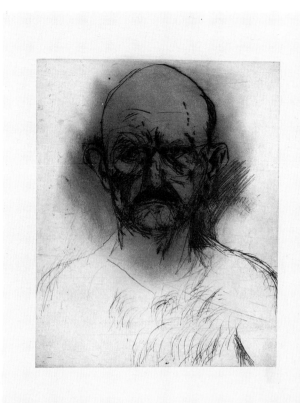

43.

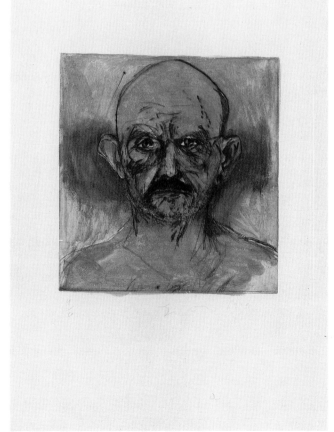

44.

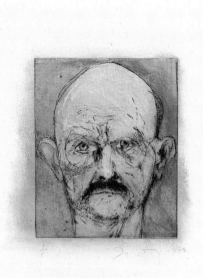

45.

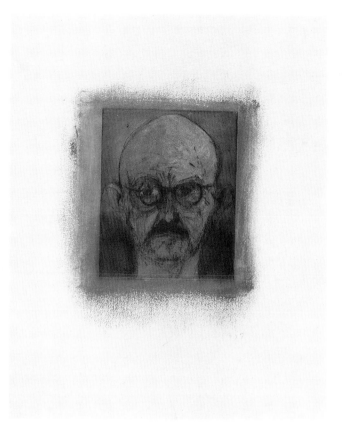

46.

47.

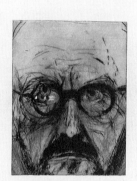

45. Unique Hand Painted Self-Portrait 1979

Etching, drypoint, and electric tools from one 11⅛ × 9¼ (28.3 × 23.5) copper plate
Printed twice in black with hand coloring in pink, blue, and yellow crayon, pastel, and fixative between printings
Paper: 29⅞ × 22½ (75.9 × 57.2) Arches Aquarelle 300 lb.
Edition: 4 unique prints, each colored differently and inscribed 1/1
Printed by Ami Rosenberg, Burston Graphic Center; published by Pace (193-62)

46. A Dark Portrait 1979

Etching, drypoint, and electric tools from one 11⅛ × 9¼ (28.3 × 23.5) copper plate
Printed twice in black with hand painting in blue, brown, flesh, and white oil between printings and with stop-out varnish after editioning
Paper: 30⅛ × 22½ (76.6 × 57.2) Arches Aquarelle 300 lb.
Edition: 3, plus 1 AP, 1 PP, 1 without hand painting
Printed by Ami Rosenberg, Burston Graphic Center; published by Pace (193-63)

47. Me in Horn-Rimmed Glasses 1979

Etching, drypoint, and electric tools from one 7¾ × 6 (19.7 × 15.2) copper plate
Printed twice in black with hand coloring in yellow, orange, black, and white pastel between printings
Paper: 25⅜ × 19⅝ (64.5 × 49.9) Canson Mi Fientes rust
Edition: 8, plus 2 AP, 1 PP, 2 unique impressions printed on Arches Aquarelle paper with hand coloring in flesh and black crayon after printing
Printed by Ami Rosenberg, Burston Graphic Center; published by Pace (193-58)

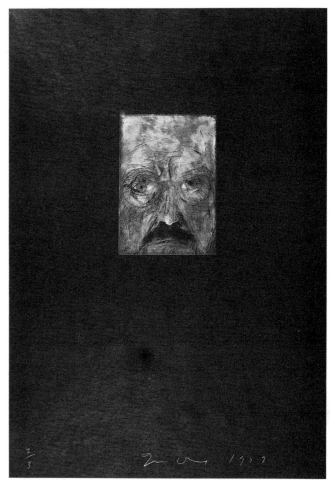

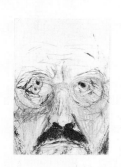

48.

48. Little Black and White Self-Portrait 1979

Etching, drypoint, and electric tools from one 7⅜ × 5⅜ (18.8 × 13.7) copper plate
Printed in black
Paper: 22⅜ × 18¾ (56.9 × 47.7) Arches 88
Edition: 4, plus 1 AP
Printed by Ami Rosenberg, Burston Graphic Center; published by Pace (193-70)

49.

50.

49. Self-Portrait on Black Paper 1979

Etching, drypoint, and electric tools from one 7⅜ × 5⅜ (18.8 × 13.7) copper plate
Printed once in white and once in black with hand coloring in flesh and white pastel between printings
Paper: 25⅛ × 18½ (63.8 × 47) Tumba black
Edition: 3, plus 1 AP, 1 PP, 1 unique impression printed in gray
Printed by Ami Rosenberg, Burston Graphic Center; published by Pace (193-71)
Signed in white pencil

50. Self-Portrait Hand Painted in Paris 1979

Etching, drypoint, and electric tools from one 6⅛ × 5⅜ (15.6 × 13.7) copper plate
Printed twice in black with hand painting in colored and clear acrylic between printings
Paper: 17¾ × 14⅞ (45.1 × 37.8) Arches Aquarelle 400 lb.
Edition: 25, plus 6 AP, 1 TP without hand coloring printed on Japon nacré
Proofed by Aldo Crommelynck, printed at Atelier Crommelynck; published by Pace (193-50)

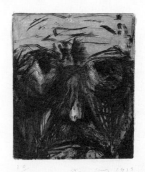

51.

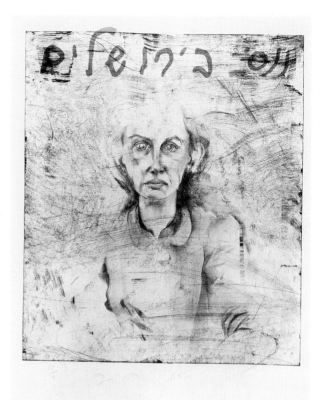

52.

For the series of five lithographic portraits of Nancy (51–55), printed in Jerusalem in 1979, Dine began with a crayon sketch on stone (51) which was overprinted with successive states of an etching plate (52, 53) and enriched with further drawing (54). In its third state (55), the lithographic image was cut down, printed off-register within an embossed plate-mark on chine collé, and hand painted. This variant lacks the Hebrew lettering of the title, *Nancy in Jerusalem,* which is printed from an aluminum plate in orange letters across the upper edge of Nos. 51–53 and below the image in No. 54.

51. Nancy in Jerusalem 1979

Lithograph from one 36 × 24 (91.4 × 61) stone and one aluminum plate
Printed once in black and once in orange
Paper: 41½ × 29½ (105.4 × 75) Rives BFK
Edition: 12, plus 3 AP, 2 PP
Printed by Yehuda Zion, Burston Graphic Center; published by Pace (193-73)

52. Nancy in Jerusalem (Through the Window) 1979

Lithograph from one 36 × 24 (91.4 × 61) stone and one aluminum plate; etching from one 28¾ × 25⅜ (73 × 64.5) copper plate
Printed twice in black and once in orange
Paper: 41 × 29¼ (104.1 × 74.3) Rives BFK
Edition: 12, plus 4 AP, 1 PP
Printed by Yehuda Zion and Ami Rosenberg, Burston Graphic Center; published by Pace (193-53)

53. Nancy in Jerusalem (Etching and Painting) 1979

Lithograph from one 36 × 24 (91.4 × 61) stone and one aluminum plate; etching from one 28¾ × 25⅜ (73 × 64.5) copper plate
Printed twice in black and once in orange with hand painting in pink, blue, and white oil between second and third printing
Paper: 41 × 29¼ (104.1 × 74.3) Rives BFK
Edition: 4, plus 1 AP, 1 PP
Printed by Yehuda Zion and Ami Rosenberg, Burston Graphic Center; published by Pace (193-72)

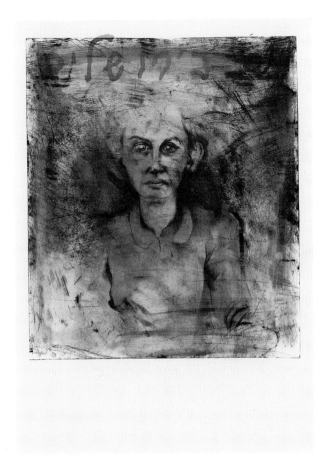

53.

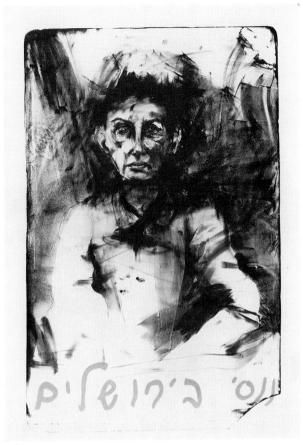

54.

54. Nancy in Jerusalem, Second State 1979

Lithograph from one 36 × 24 (91.4 × 61) stone and one
aluminum plate
Printed once in black and once in orange
Paper: 41¾ × 29½ (106 × 75) tea-dyed Arches Acquarelle
Edition: 15, plus 5 AP, 1 PP
Printed by Yehuda Zion, Burston Graphic Center; published by
Pace (193-52)

55. Hand Painted Head of Nancy 1979

Lithograph from one stone
Printed once in black and once in red with hand painting in pink
oil and black grease crayon after editioning
Paper: 12½ × 9⅞ (31.8 × 25.1) chine collé, within embossed
plate-mark, on 30⅜ × 22½ (77.1 × 57.3) Arches Aquarelle 300
lb.
Edition: 8, plus 3 AP, 1 PP
Printed by Yehuda Zion and Ami Rosenberg, Burston Graphic
Center; published by Pace (193-54)

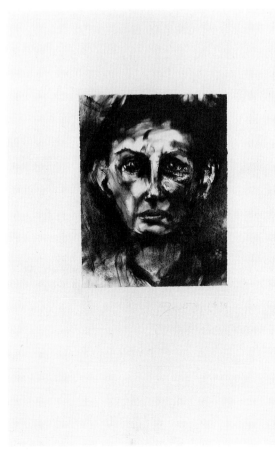

55.

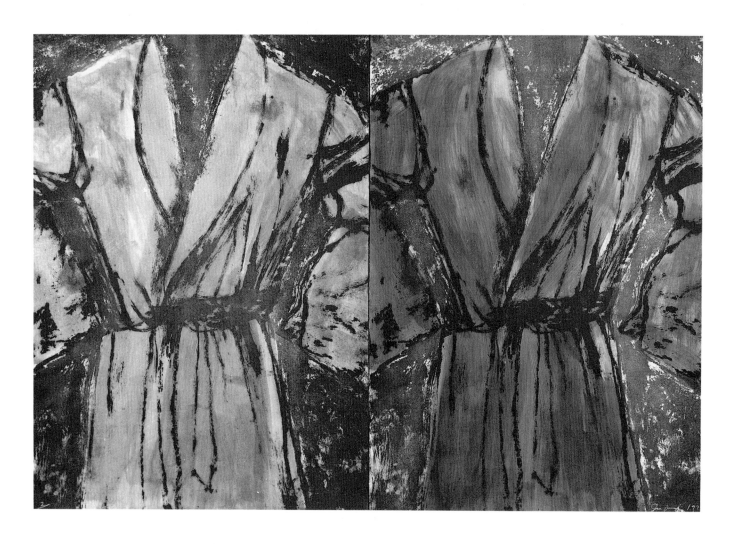

56. A Magenta Robe, A Rose Robe 1979

Diptych etching and aquatint from one copper plate larger than
sheet size
Each sheet printed in black with hand painting in magenta, pink,
and white oil after editioning
Paper: two sheets of 41 × 29¼ (104.1 × 74.3) Rives BFK
Edition: 16, plus 4 AP, 1 PP
Printed by Ami Rosenberg, Burston Graphic Center; published by
Pace (193-55)
Signed in white pencil

In working the single plate for this diptych (56), Dine used
the lift-ground technique for his aquatint. In this process,
the artist paints the design with a sugar solution on the
rosin-grounded plate. After the plate is covered with a
varnish-like ground, it is soaked in water which causes the
sugar solution to dissolve and to lift off the ground in the
image area. Because the plate is bitten in acid only where it
is painted, the result is a positive process recording, as
demonstrated here, the freely handled strokes of the brush.

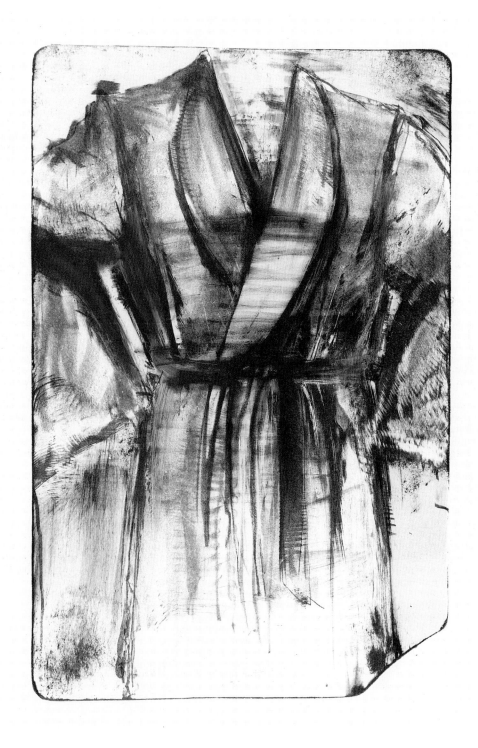

57. A Robe Against the Desert Sky 1979

Lithograph from one 36 × 24 (91.4 × 61) stone and one 36½ × 24 (92.7 × 61) aluminum plate; screenprint from two screens
Printed once in black, once in blue, once in gray, and once in white with hand wiping in solvent after screenprinting and before second lithographic printing
Paper: 41¾ × 29⅜ (106 × 74.6) Arches Aquarelle
Edition: 17, plus 4 AP, 1 PP
Lithograph printed by Yehuda Zion, screenprinting by Itzik Schwartz, Burston Graphic Center; published by Pace (193-56)

The first printing of No. 57 was in black from a stone (the same used in *Nancy in Jerusalem,* 51–55) which had been partially worked with a rotary disc sander. This was over-printed in gray and white with two screens. Before the fourth (blue) printing from a lithographic plate, Dine worked the sheet with a rag saturated in solvent. With this method of dragging light tones across the upper part of the robe, Dine increases the image's transparency and suggests his recollection of Jerusalem as "all white and gray."

58.

59.

The first state of the *Jerusalem Plant* series (58) is rendered with a needle, roulette, and scraper printed once in black. The image was slightly altered with an electric sander. For No. 59, the second state plate was printed in black and before the ink dried, Dine rubbed each sheet with turpentine, yielding a gray wash. Handwork in green and blue was added and then a concluding printing from the plate still in its second state. The third state (60) is two black runs from the further altered plate, with oil hand applied between them. A signed artist's proof of the fourth state with substantial additional drypoint (the plate was cut to 13¼ × 16¾ inches), printed once in black, is in the artist's possession. In 1982–84, an unrelated series of a different plant, yet also titled *The Jerusalem Plant,* was editioned at ULAE (see 131).

58. A Jerusalem Plant, State I 1979

Drypoint from one 23½ × 18 (59.7 × 45.8) copper plate
Printed in black
Paper: 41 × 29 (104.1 × 73.7) Rives BFK
Edition: 4, plus 2 AP, 1 PP
Printed by Ami Rosenberg, Burston Graphic Center; published by Pace (193-68)

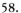

60.

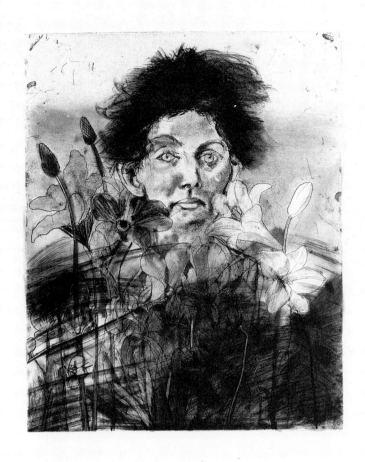

61.

59. A Jerusalem Plant, State II 1979

Drypoint and electric tools from one 23½ × 18 (59.7 × 45.8) copper plate
Printed twice in black with hand painting in blue and green oil between printings
Paper: 41 × 29 (104.1 × 73.7) Rives BFK
Edition: 8, plus 3 AP, 1 PP
Printed by Ami Rosenberg, Burston Graphic Center; published by Pace (193-69)

60. A Jerusalem Plant, State III 1979

Drypoint and electric tools from one 20¼ × 16¾ (51.5 × 42.6) copper plate
Printed twice in black with hand painting in blue spray and green, pink, and white oil between printings
Paper: 29¾ × 22 (75.5 × 55.9) Rives BFK
Edition: 3, plus 1 AP, 1 PP
Printed by Ami Rosenberg, Burston Graphic Center; published by Pace (193-57)

61. Nancy Outside in July VI, Flowers of the Holy Land 1979

Etching, soft-ground etching, drypoint, and electric tools from two 23 × 19½ (58.4 × 49.6) copper plates
Printed twice in black with hand painting in blue, pink, orange, green, white, and yellow enamel between printings
Paper: 35¾ × 24⅞ (90.8 × 63.2) Arches cream
Edition: 25, plus 6 AP, 4 unique proofs
Proofed by Aldo Crommelynck, printed at Atelier Crommelynck; published by Crommelynck (Pace 193-51)

Dine produced the sixth in the *Nancy Outside in July* series (18–22) in the Atelier Crommelynck at the same time that he printed the last state of his 1979 self-portrait series, begun at the Burston Graphic Center earlier in the year (50). In this image, he incorporates additional flowers in the foreground and burnishing for dark areas of tone in the hair and across the lower half of the composition.

62. Flowered Robe with Sky 1980

Lithograph from two aluminum plates
Printed once in red and twice in rust with hand painting in
ochre oil, blue spray, and charcoal between rust printings
Paper: 37½ × 29½ (95.2 × 75) Rives BFK newsprint gray
Edition: 31, plus 9 AP
Printed by Maurice Sanchez and Arnold Brooks,
Derriere L'Etoile Studios; published by Pace (193-64)

The four-print series of robes, printed at Derriere
L'Etoile Studios (62, 63, 150, 151), begins with
Flowered Robe with Sky (62), a two-plate lithograph
with extensive handwork. One plate, printed in
red, is of a robe and the other, printed twice in
rust, is of a floral pattern. The sky was sprayed in
blue. Hand painted ochre contributes to the sunlit
atmosphere and charcoal is used to give the robe
further definition. These two plates were used
again for *Red and Black Diptych Robe* (63), with
each sheet printed once from both plates in red for
the robe and rust for the flowers. Dine then drew
two new robes on proofs of No. 62. These
drawings were transferred to a third and fourth
plate. The third plate was printed on the left sheet
and the fourth on the right sheet, both in black, for
Red and Black Diptych Robe (63). This is, thus, a
four-plate, three-color lithograph with each sheet
using three plates. At the same time, two other
editions, originally titled *Black Diptych* and *Red
Diptych,* were printed from the third and fourth
plates. However, these editions were not released
until 1983, after Dine had them shipped to Aspen,
added hand coloring, and changed the titles to *Two
Robes with Watercolor* and *Two Hand Colored Colorado
Robes* respectively (150, 151).

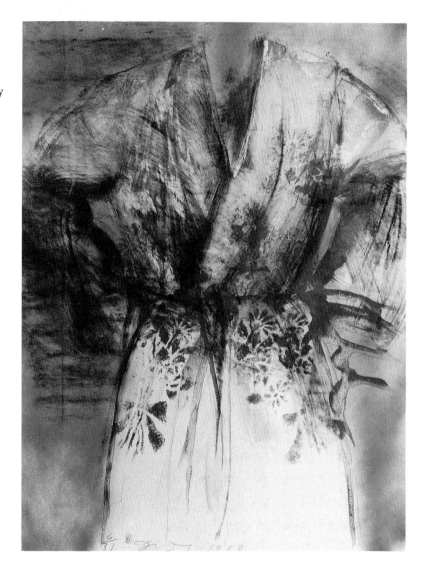

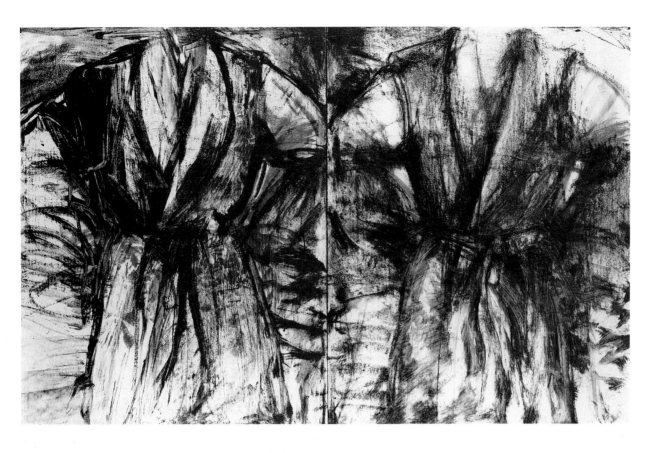

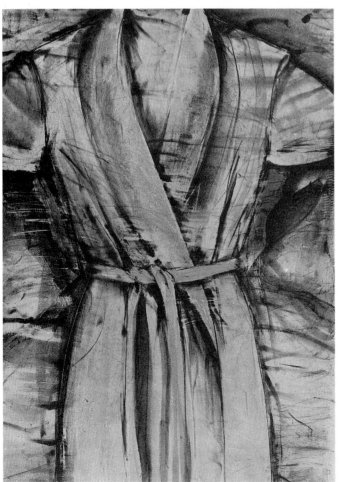

63. Red and Black Diptych Robe 1980

Diptych lithograph from four aluminum plates
Each sheet printed once in red, once in rust, and once in black
Paper: two sheets of 37⅝ × 29½ (95.6 × 75) Rives BFK newsprint gray
Edition: 20, plus 12 AP, 3 PP
Proofed by Maurice Sanchez, printed by Maurice Sanchez and John C. Erickson, Derriere L'Etoile Studios; published by Pace (193-76)

64. The Yellow Robe 1980

Lithograph from three stones
Printed once in black, once in yellow, and once in blue
Paper: 50 × 35 (127 × 88.9) Arches Aquarelle rolled
Edition: 40, plus 10 AP, 1 PP, 2 Landfall Press impressions, 1 BAT, 1 cancellation proof
Printed by Jack Lemon, assisted by Tom Blackman and Mary McDonald, Landfall Press Inc., Chicago (JD 80-771); published by Pace (193-75)

Dine's *Yellow Robe* (64) was printed from three large stones at Landfall Press. The two stones used for the yellow and blue printing were reused to print a group of second-state impressions in which the yellow robe is presented before a gray background. These were never editioned.

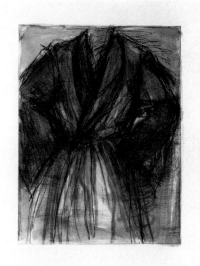 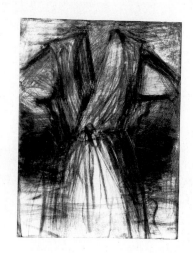 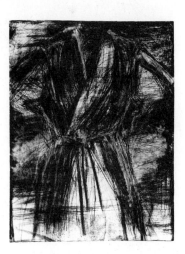

65. 66. 67.

The robe series, *Printing Outdoors, Winter,* and *Robe in a Furnace* (65–67), although produced in Mitchell Friedman's studio, was editioned by printers Dine had worked with at the Burston Graphic Center, Jerusalem. The same two plates were used for each print: in their first state for No. 65, their second for No. 66, and their third for No. 67.

65. Printing Outdoors 1980

Etching and electric tools from two 27¾ × 21⅝ (70.5 × 55) copper plates
Printed twice in red and once in black with hand painting in blue and green acrylic before printings
Paper: 42¼ × 29¾ (107.3 × 75.6) Copperplate Deluxe
Edition: 40, plus 10 AP
Printed by Ami Rosenberg and Keren Ronin, New York; published by Pace (193-65)

66. Winter 1980

Etching and electric tools from two 27¾ × 21⅝ (70.5 × 55) copper plates
Printed twice in black and once in white
Paper: 42¼ × 29¾ (107.3 × 75.6) Copperplate Deluxe
Edition: 40, plus 10 AP
Printed by Ami Rosenberg and Keren Ronin, New York; published by Pace (193-66)

67. Robe in a Furnace 1980

Etching and electric tools from two 27¾ × 21⅝ (70.5 × 55) copper plates
Printed once in red, once in dark blue, and once in black
Paper: 42¼ × 29¾ (107.3 × 75.6) Copperplate Deluxe
Edition: 31, plus 7 AP
Printed by Ami Rosenberg and Keren Ronin, New York; published by Pace (193-67)

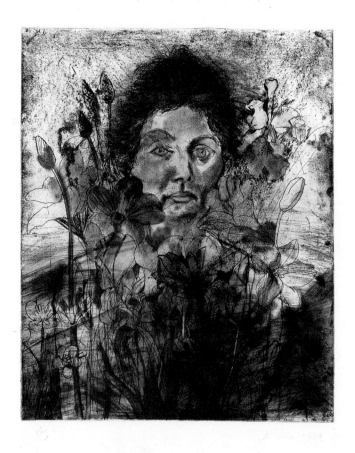

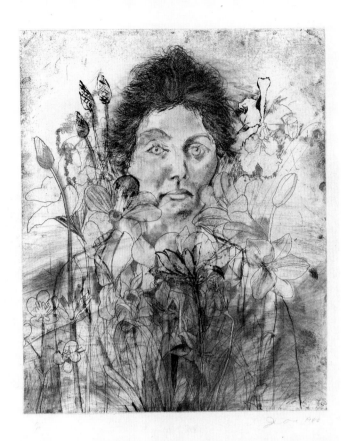

68.

69.

In 1980 Dine continued the *Nancy Outside in July* series (18–22, 61) with five new prints (68–72). Three of these (68–70) are from the sixth and seventh states of the first plate (18). Tulips, drawn in grease crayon on aquatint ground, almost entirely obliterate the figure in No. 70. Dine then retrieved the key image, burnished it, and added new drawing to several other plates, altering the features of his wife's face, her expression, and clothing for Nos. 71 and 72. These establish the key image for most of the later portraits in the series, completed in 1981 (93–106).

68. Nancy Outside in July VII 1980

Etching, soft-ground etching, drypoint, engraving, and electric tools from one 23 × 19½ (58.4 × 49.5) copper plate
Printed twice in black with hand painting in yellow, red, blue, green, and black watercolor and blue wax crayon between printings
Paper: 29¾ × 22¼ (75.6 × 56.5) Rives
Edition: 25, plus 6 AP, 1 WP
Proofed by Aldo Crommelynck, printed at Atelier Crommelynck; published by Crommelynck (Pace 193-79)
Inscribed with edition numbering by Aldo Crommelynck

69. Nancy Outside in July VIII 1980

Etching, soft-ground etching, drypoint, engraving, and electric tools from one 23 × 19½ (58.4 × 49.5) copper plate
Printed in black
Paper: 29¾ × 22¼ (75.6 × 56.5) Rives BFK gray
Edition: 14, plus 4 AP
Proofed by Aldo Crommelynck, printed at Atelier Crommelynck; published by Crommelynck (Pace 193-81)

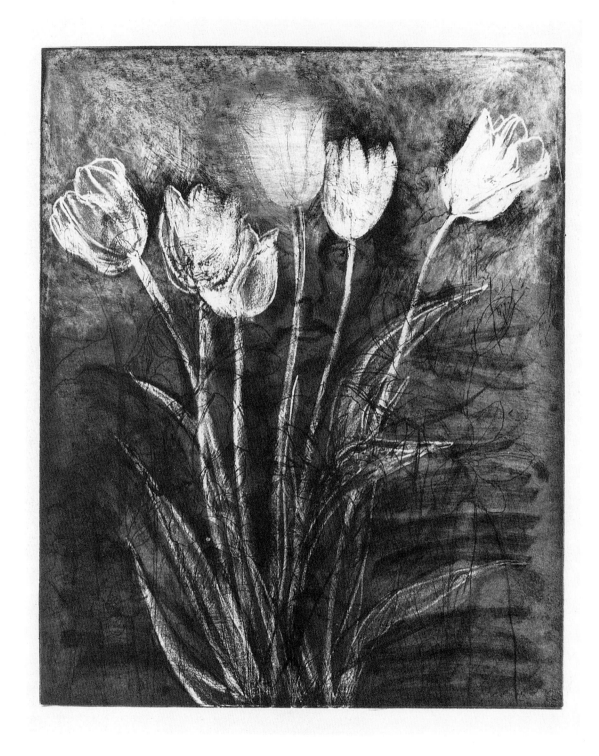

70. Nancy Outside in July IX: March in Paris (Tulips)
1980

Etching, soft-ground etching, drypoint, engraving, aquatint, and
electric tools from one 23 × 19½ (58.4 × 49.5) copper plate
Printed twice in black with hand coloring in pink oil pastel and
blue and green watercolor between printings
Paper: 29¾ × 22¼ (75.6 × 56.5) wove
Edition: 22, plus 6 AP
Proofed by Aldo Crommelynck, printed at Atelier Crommelynck;
published by Crommelynck (Pace 193-82)

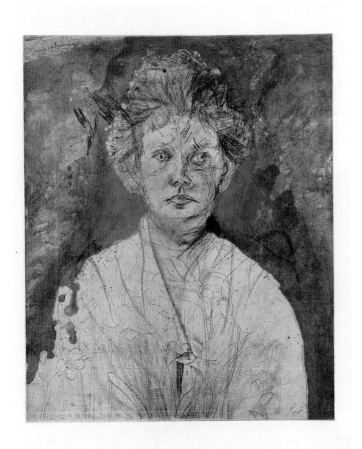 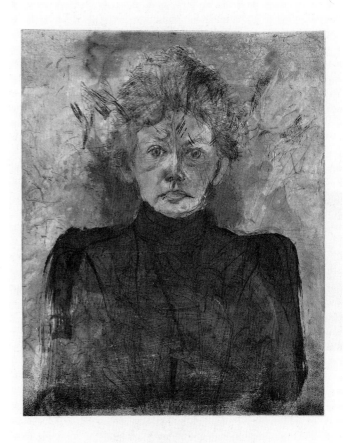

71. Nancy Outside in July X: Young and Blue 1980

Etching, soft-ground etching, drypoint, aquatint, and electric tools
from three 23 × 19½ (58.4 × 49.5) copper plates
Printed once in brown, once in rose, twice in blue-green, and
once in black with hand painting in blue-green and blue-white
after editioning
Paper: 30 × 22⅜ (76.2 × 56.8) Arches buff
Edition: 25, plus 7 AP
Proofed by Aldo Crommelynck, printed at Atelier Crommelynck;
published by Crommelynck (Pace 193-89)

72. Nancy Outside in July XI: Red Sweater in Paris
1980

Etching, soft-ground etching, drypoint, aquatint, and electric tools
from four 23 × 19½ (58.4 × 49.5) copper plates
Printed once in turquoise, once in buff, and three times in black
with hand painting in flesh, blue, red, and green acrylic between
third and fourth printings
Paper: 29¾ × 22⅛ (75.6 × 56.2) Rives
Edition: 25, plus 7 AP
Proofed by Aldo Crommelynck, printed at Atelier Crommelynck;
published by Crommelynck (Pace 193-90)

73. 74. 75.

One plate was used for the six *Strelitzia* prints (73–78). Dine began the series by printing approximately 100 sheets with the first state of the plate. This print is the basis for Nos. 73–76. Each of these prints was completed with an additional black printing from the plate's second state in combination with either monoprinting, hand painting, or additional second-state printings in colored inks. Minor changes were made to the plate, necessitated by the wear of four editions before the last two *Strelitzias* (77, 78) were printed. Both are on black paper with multiple third-state printings in white or pink. Dine made extensive use of the Dremel for the first time in working this plate through its three stages. The series was created in Putney during the summer of 1980 with the assistance of Dine's teenage cousin, Jeffrey Berman, who had been given a brief training with master printer, Donald J. Saff. The *Strelitzia* group illustrates the spirit of experimentation and inventiveness that Dine permitted himself in this informal workshop situation, skillfully incorporating and utilizing to creative advantage the results of uneven inkings, incomplete wiping, and slight off-registration. This plate was later used for *Blue* (89).

73. A Well Painted Strelitzia 1980

Etching and electric tools from one 35½ × 23¾ (90.2 × 60.4) copper plate
Printed four times in black with hand painting in blue, green, and red oil after first and second printings
Paper: 36¼ × 24¼ (92.1 × 61.6) Copperplate Deluxe
Edition: 33, plus 11 AP
Printed by Jeffrey Berman, assisted by Steven MacDonald and Kim Brandt, Putney Fine Arts; published by Pace (193-88)
Signed in white pencil

74. Strelitzia with Monotype 1980

Etching, electric tools, and monoprinting from one 35½ × 23¾ (90.2 × 60.4) copper plate
Printed twice in black with hand painting in pink and blue oil between printings and monoprinting in green after editioning
Paper: 36¼ × 24¼ (92.1 × 61.6) Copperplate Deluxe
Edition: 17, plus 6 AP
Printed by Jeffrey Berman, assisted by Steven MacDonald and Kim Brandt, Putney Fine Arts; published by Pace (193-86)
Signed in white pencil

75. Green-Gold Strelitzia 1980

Etching and electric tools from one 35½ × 23¾ (90.2 × 60.4) copper plate
Printed twice in black, once in green, and once in gold
Paper: 40½ × 28 (102.9 × 71.1) Rives BFK newsprint gray
Edition: 3, plus 3 AP
Printed by Jeffrey Berman, assisted by Steven MacDonald and Kim Brandt, Putney Fine Arts; published by Pace (193-83)
Signed in white pencil

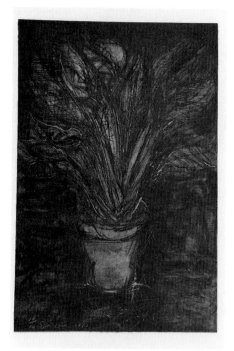

76.

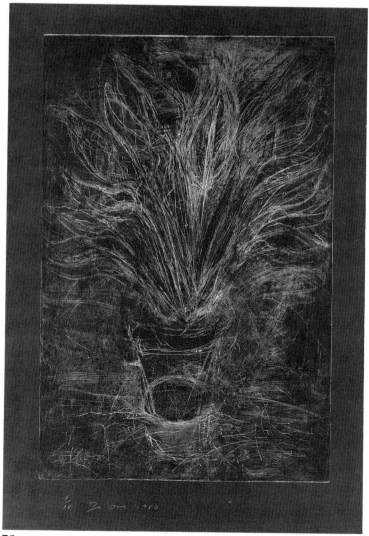

78.

77.

76. Green Etched Strelitzia 1980

Etching and electric tools from one 35½ × 23¾ (90.2 × 60.4) copper plate
Printed twice in black, once in yellow, and once in green
Paper: 40½ × 28 (102.9 × 71.1) Rives BFK newsprint gray
Edition: 10, plus 6 AP
Printed by Jeffrey Berman, assisted by Steven MacDonald and Kim Brandt, Putney Fine Arts; published by Pace (193-84)
Signed in white pencil

77. Pink Strelitzia 1980

Etching and electric tools from one 35½ × 23¾ (90.2 × 60.4) copper plate
Printed twice in pink and once in white
Paper: 35½ × 24 (90.2 × 61) Arches Cover black
Edition: 12, plus 6 AP
Printed by Jeffrey Berman, assisted by Steven MacDonald and Kim Brandt, Putney Fine Arts; published by Pace (193-85)
Signed in white pencil

78. White Strelitzia 1980

Etching and electric tools from one 35½ × 23¾ (90.2 × 60.4) copper plate
Printed twice in white and twice in black (once as surface roll)
Paper: 44 × 29⅞ (111.8 × 75.9) Arches Cover black
Edition: 18, plus 7 AP
Printed by Jeffrey Berman, assisted by Steven MacDonald and Kim Brandt, Putney Fine Arts; published by Pace (193-87)
Signed in white pencil

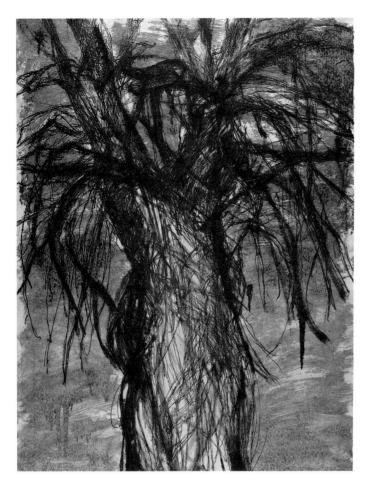

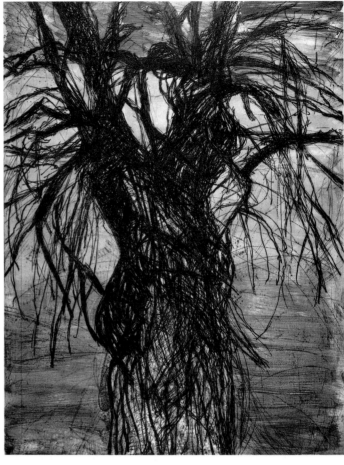

Dine's first series of *Tree* prints (79–84), produced in 1981 in Tampa, is based on a single drawing made on the plate with a Magic Marker and worked with etching and a Dremel with router attachments. These gouged deeply into the surface, producing lines raised in relief on the paper. The series becomes increasingly complex with further work on the plate for a second state (81) and third state (82), the use of a third plate worked with the die-grinder and sanding disc (81–84), and variations in monoprinting and hand painting. Before printing the image, all of the sheets, with the exception of No. 82, were first surface-roll printed in color from a blank copper plate. No. 81 is named for Karen McCready, formerly with Pace Editions. An unpublished variant set of *Tree* prints was used as the paper surface in printing *Nancy Outside in July XV* (96). The tree theme first appears in 1980 in Dine's paintings.

79. A Tree Curvaceous and Blue 1981

Etching, electric tools, and monoprinting from two 44¾ × 34½ (113.7 × 87.7) copper plates
Printed once in light yellow-green (surface roll), once in black, and once with monoprinting in blue, green, flesh, and black
Paper: 46¼ × 35⅞ (117.5 × 91.2) Arches rolled
Edition: 6, plus 3 AP
Printed by Betty Ann Lenahan, Susie Hennessy, and Stan Gregory, Palm Press; published by Pace (193-91)

80. A Tree Painted in South Florida 1981

Etching and electric tools from two 44¾ × 34½ (113.7 × 87.7) copper plates
Printed once in light yellow-green (surface roll) and twice in black with hand painting in brown, blue, and yellow acrylic before third printing
Paper: 46¼ × 35⅞ (117.5 × 91.2) Arches rolled
Edition: 15, plus 6 AP
Printed by Betty Ann Lenahan, Susie Hennessy, and Stan Gregory, Palm Press; published by Pace (193-92)
Signed in red pencil

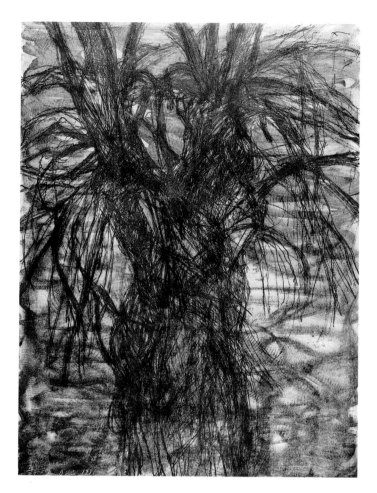

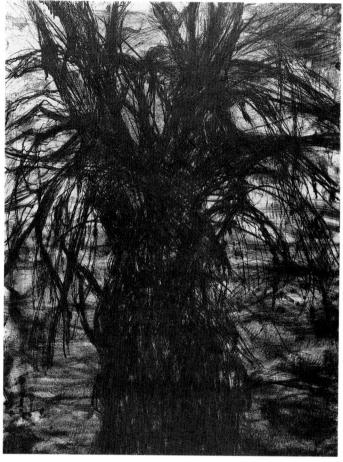

81. Tree (A Female Robe for Karen McCready) 1981

Etching and electric tools from three 44¾ × 34½ (113.7 × 87.7) copper plates
Printed once in light yellow-green (surface roll) and twice in black with hand painting in flesh and blue acrylic before third printing and in white acrylic after editioning
Paper: 46¼ × 35⅞ (117.5 × 91.2) Arches rolled
Edition: 23, plus 4 AP
Printed by Betty Ann Lenahan, Susie Hennessy, and Stan Gregory, Palm Press; published by Pace (193-93)
Signed in white pencil

82. The Tree in Soot 1981

Etching, soft-ground etching, electric tools, and monoprinting from two 44¾ × 34½ (113.7 × 87.7) copper plates
Printed once in black, once in brown, and once in dark green with monoprinting in green and blue acrylic before printings
Paper: 46¼ × 35⅞ (117.5 × 91.2) Arches rolled
Edition: 6, plus 3 AP
Printed by Betty Ann Lenahan, Susie Hennessy, and Stan Gregory, Palm Press; published by Pace (193-94)
Signed in multicolored pencil

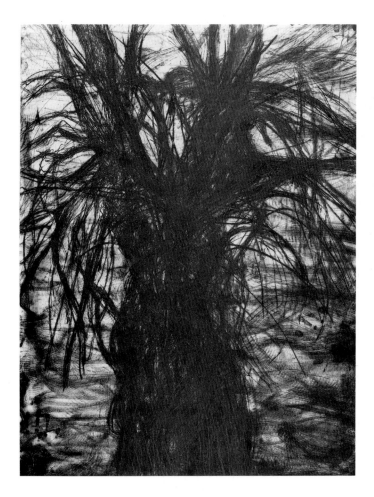 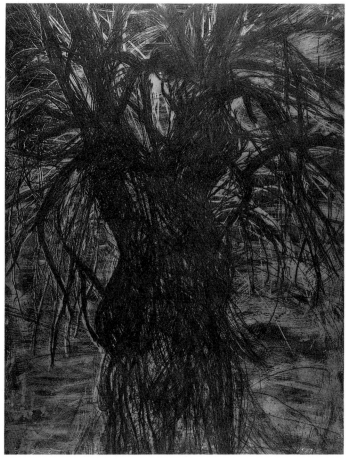

83. The Tree Covered with Rust 1981

Etching, soft-ground etching, and electric tools from two 44¾ ×
34½ (113.7 × 87.7) copper plates
Printed once in black, once in green, and once in red
Paper: 46¼ × 35⅞ (117.5 × 91.2) Arches rolled
Edition: 14, plus 6 AP
Printed by Betty Ann Lenahan, Susie Hennessy, and Stan
Gregory, Palm Press; published by Pace (193-95)
Signed in multicolored pencil

84. White Ground, Night Tree 1981

Etching, soft-ground etching, and electric tools from three 44¾ ×
34½ (113.7 × 87.7) copper plates
Printed once in black (surface roll), twice in white, and once in
black
Paper: 46¼ × 35⅞ (117.5 × 91.2) Arches rolled
Edition: 15, plus 6 AP
Printed by Betty Ann Lenahan, Susie Hennessy, and Stan
Gregory, Palm Press; published by Pace (193-96)
Signed in white pencil

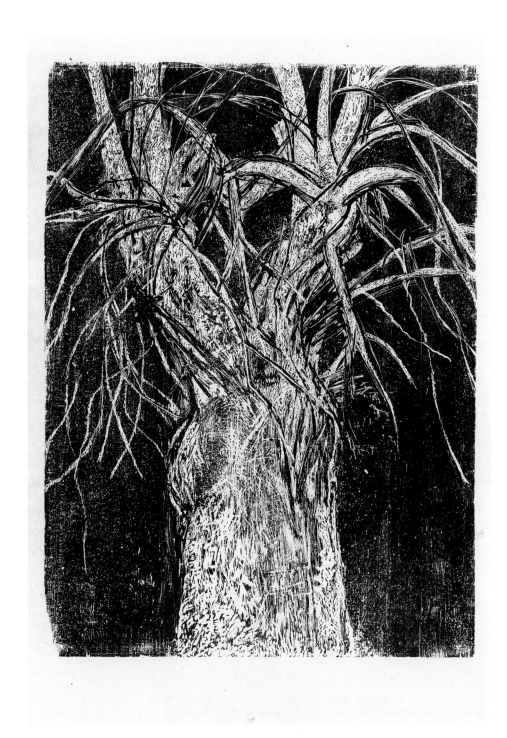

85. The Big Black and White Woodcut Tree 1981

Woodcut from one 48½ × 36½ (123.2 × 92.7) pine block
Printed in black
Paper: 58½ × 42½ (148.6 × 108) Japanese Toyoshi
Edition: 25, plus 6 AP, 2 PP
Printed by Keith Brintzenhofe, ULAE; published by ULAE (Pace 193-97)

The *Big Black and White Woodcut Tree* (85), a negative image, is Dine's first published woodcut since his *Woodcut Bathrobe,* 1975. He now works the medium by carving out large areas with a flexible-shaft chisel and more finely worked areas with the Dremel. The block used here was a varnished pine drafting table top which was pitted and scarred from use. The woodcut's embossment is the result of deep gouging with tools and its printing on a hand lithography press with the dampened paper placed under multiple layers of felt. Dine had intended to combine the woodcut with an intaglio image overprinted from a roofer's copper plate. At present, both the block and the unused plate are with ULAE.

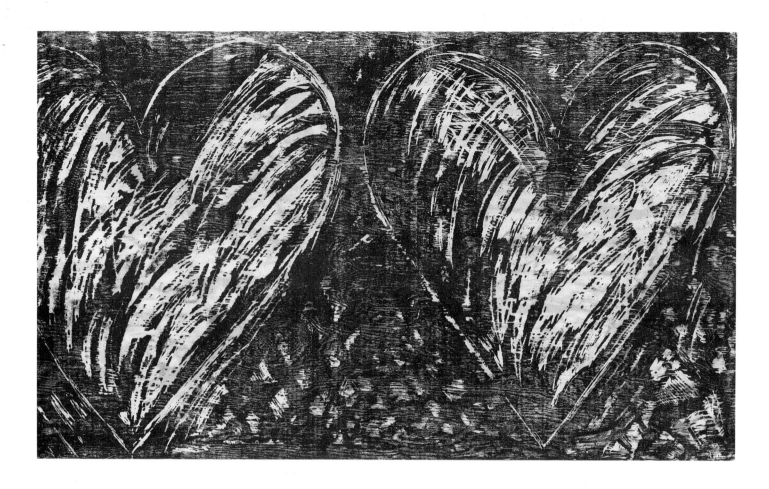

86. Two Hearts in the Forest 1981

Lithograph from three zinc plates; woodcut from one plywood block
Printed once in yellow and green, once in orange, once in pink, and once in black
Paper: 36 × 60½ (91.5 × 153.7) Arches rolled
Edition: 24, plus 5 AP, 2 PP
Lithograph printed by Julio Juristo, Topaz Editions, Tampa, woodcut printed by the artist, Putney; published by Pace (193-103)
Signed in white crayon

In 1981, Dine made a four-color lithograph from three zinc plates titled *Two Gulf Coast Hearts.* The edition printed by Julio Juristo in Tampa was shipped to Putney, where Dine decided he was not satisfied by the results. He cut a woodblock and printed it himself on half of the Juristo prints and titled this new edition *Two Hearts in the Forest* (86). Part of this block was reused for *A Woodcut in the Snow* (159). The other half of the Juristo edition is the basis for *Fortress of the Heart* (111). Drawings done in Putney on *Two Gulf Coast Hearts* were sent to Maurice Sanchez who transferred them to two aluminum plates. Both were printed in black on the remaining color lithographs, producing No. 111. The two black plates were also printed alone as a small edition (Appendix I), still in the artist's possession. This group of prints is related to the painting of the same period, *Painting for a Fortress of the Heart* (Graham Gund Collection).

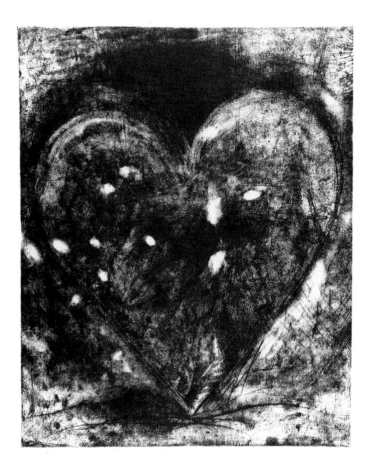

87. Etching Heart 1981

Etching, soft-ground etching, drypoint, and electric tools from one
34⅝ × 28½ (88 × 72.4) copper plate
Printed in black
Paper: 42⅛ × 29½ (107 × 75) Copperplate Deluxe
Edition: 42, plus 8 AP, 3 PP
Proofed by Mitchell Friedman, printed by Nicholas Dine, assisted
by Rebecca Gardener, Putney; published by Pace (193-105)

In the summer of 1981, Mitchell Friedman returned to
Putney to work with Dine on four editions (87–90). For
the *Etching Heart* (87), the copper plate used in the 1977
Robe series (4–7) was inverted and extensively reworked
with a die-grinder, in addition to hand scraping and
burnishing. The original robe is barely visible as a heart
now emerges out of heavy blackness.

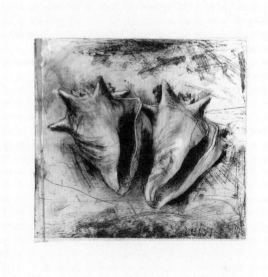

88. Key West Print 1981

Offset lithograph from four 16⅝ × 18⅛ (42.2 × 46) aluminum
plates; etching from one 16⅜ × 17⅞ (41.6 × 45.4) copper plate
Printed once in blue, once in pink, once in yellow, once in
mauve, and once in black
Paper: 41⅜ × 29⅜ (105.1 × 74.6) Arches Cover
Edition: 40, plus 10 AP
Lithograph printed by Joseph Petruzelli, Sienna Studios, New
York; etching proofed by Mitchell Friedman, printed by Mitchell
Friedman and Nicholas Dine, Putney; published by Pace
(193-107)

This is Dine's first use of the shell theme in his prints since
its appearance in his 1977–78 still life paintings. He
continued with this image later this year (107), in 1982
(121), and in a major exploration of the subject, *Lost Shells,*
made in 1984 (186). The parallel marks on the etching
plate were made with a wire brush on the hard-ground
surface. About 100 impressions of the lithograph, which
originated with a watercolor and pencil drawing, were
pulled as a poster for the Cape and Islands Chamber Music
Festival, Martha's Vineyard.

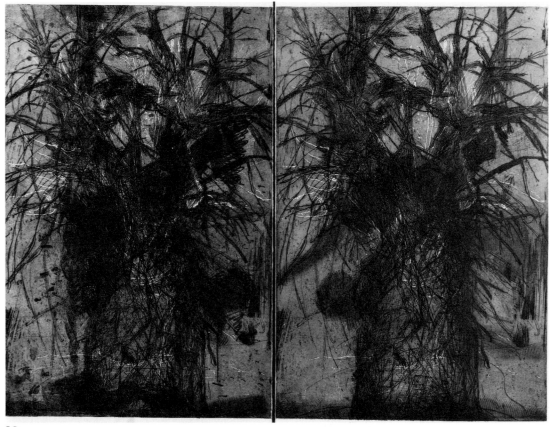

89.

89. Blue 1981

Diptych etching and electric tools from four 35½ × 23¾ (90.2 × 60.3) copper plates
Each sheet printed once in blue (surface roll) and twice in black
Paper: two sheets of 41 × 26¾ (104.1 × 68) Rives BFK
Edition: 29, plus 9 AP
Proofed by Mitchell Friedman, printed by Mitchell Friedman and Nicholas Dine, assisted by Rebecca Gardener, Putney; published by Pace (193-108)

Blue (89) is characterized by Friedman's penchant for heavily worked plates and richly inked printings. Both sheets begin with the plate used for the *Strelitzia* series (73–78). Prepared with a surface roll of royal blue, this plate prints up as thin white lines amidst a blue field. Both sheets were then printed in black from a tree image plate. A final black printing, with a different tonal plate for each sheet, provides the diptych with subtle variation. There are many paintings and works on paper related to this print for this was a time when Dine explored his newly introduced tree subject.

90. Rachel Cohen's Flags, State II 1981

Six-part drypoint and electric tools from six 15¾ × 21¾ (40 × 55.3) copper plates
Each sheet printed twice in black with hand painting in blue, yellow, and green acrylic between printings
Paper: six sheets, overall 19 × 138 (45.1 × 337.5) Rives BFK
Edition: 14, plus 3 AP
Proofed by Mitchell Friedman, printed by Mitchell Friedman, Nicholas Dine, and Celia Reisman, assisted by Rebecca Gardener, Putney; published by Pace (193-110)

In the summer of 1981, Dine reworked the six plates from *Rachel Cohen's Flags, State I* (41) with power tools, strengthening the original drypoint lines and adding more flowers. The same procedure of a light printing, followed by hand work and a dark second printing was used. However, this second state is characterized by Mitchell Friedman's rich printing style that eschews careful wiping and Dine's new attitude towards hand coloring. This process is no longer viewed as a subtle addition of color, but as a major component of the printmaking process.

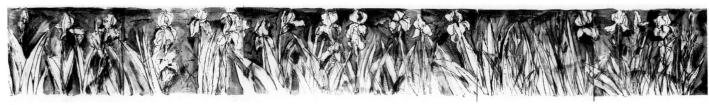

90.

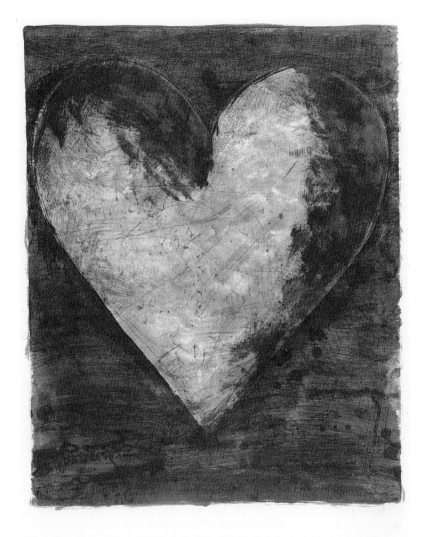

91. A Heart on the Rue de Grenelle 1981

Etching, soft-ground etching, and aquatint from two 32¼ × 26¼ (81.9 × 66.7) copper plates
Printed once in red and once in black with hand painting in green and blue acrylic between printings
Paper: 41⅞ × 29⅝ (106.4 × 75.2) Rives BFK
Edition: 36, plus 6 AP, 2 PP
Proofed by Aldo Crommelynck, printed at Atelier Crommelynck; published by Pace (193-101)

The use of spit-bite aquatint in combination with precise marks from hard and soft-ground etching characterizes much of Dine's work with Aldo Crommelynck. It is thus appropriate that the first print done at the Atelier Crommelynck during this period, other than the *Nancy* series and one characterized by these techniques, should take the workshop's address for its title. The same two plates were used for the single heart (91) and double heart (92), with generous hand painting between printings. Several proofs of the diptych version, without hand coloring (elsewhere referred to as *Two Red French Hearts,* although never released as such) are in the artist's possession.

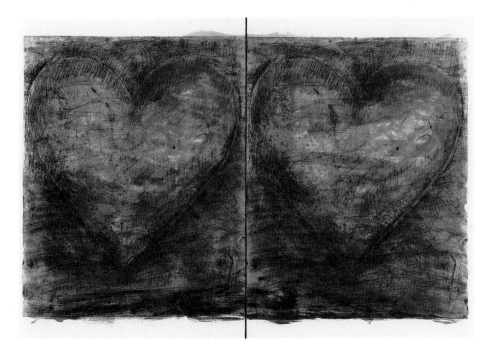

92. Two Tomatoes 1981

Diptych etching, soft-ground etching, and aquatint from two 32¼ × 26¼ (81.9 × 66.7) copper plates
Each sheet printed once in red and once in black with hand painting in blue and orange acrylic between printings
Paper: two sheets of 41⅝ × 29½ (105.7 × 75) Rives BFK
Edition: 25, plus 9 AP, 2 PP
Proofed by Aldo Crommelynck, printed at Atelier Crommelynck; published by Pace (193-102)

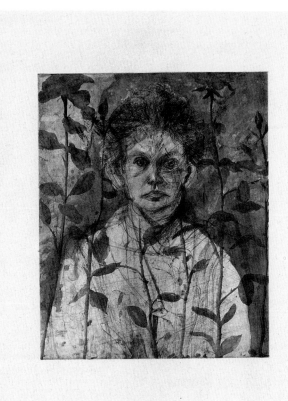

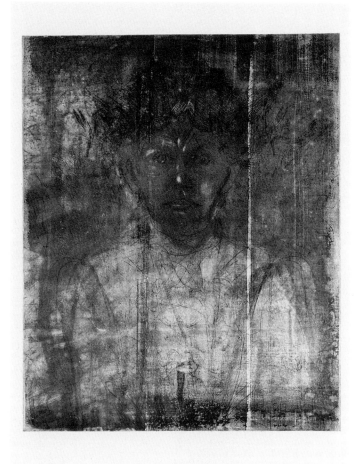

Following the *Nancy Outside in July* prints of 1978–80 (18–22, 61, 68–72), Dine returned to the Atelier Crommelynck in 1981 to end the series of twenty-five prints with fourteen additional images (93–106).

93. Nancy Outside in July XII: Green Leaves 1981

Etching, soft-ground etching, aquatint, and electric tools from five 23 × 19½ (58.4 × 49.5) copper plates
Printed once in green, once in blue, once in flesh, and four times in black
Paper: 41⅞ × 29⅝ (106.4 × 75.2) Rives BFK
Edition: 30, plus 8 AP
Proofed by Aldo Crommelynck, printed at Atelier Crommelynck; published by Crommelynck (Pace 193-98)
Inscribed with edition numbering by Aldo Crommelynck

94. Nancy Outside in July XIII: Dissolving in Eden 1981

Etching, soft-ground etching, aquatint, and electric tools from four 23 × 19½ (58.4 × 49.5) copper plates
Printed twice in black, once in pink, once in turquoise, and once in yellow
Paper: 30 × 22¼ (76.2 × 56.5) Rives BFK
Edition: 30, plus 10 AP
Proofed by Aldo Crommelynck, printed at Atelier Crommelynck; published by Crommelynck (Pace 193-99)

The woven texture of the print (94) and the vertical strip to the right of Nancy's face are the results of Dine's experimentation with lift-ground aquatint. Instead of brushing the sugar and ink solution directly on one of the plates, Dine brushed it on a screen laid over the plate's surface. The plate was covered with ground which lifted off only in the areas where the sugar solution had filtered through the screen. When bitten and printed, the plate yielded an all-over gray tone resembling the texture of the screen. The title refers to the dissolving process of the lift-ground technique.

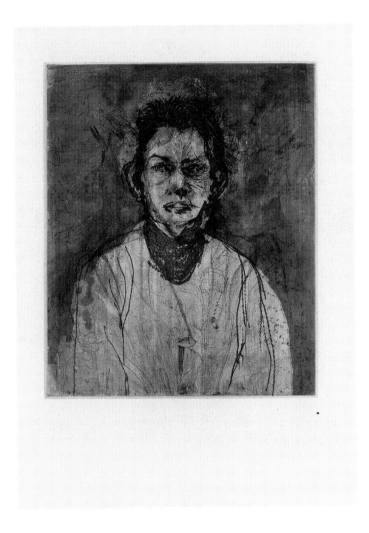

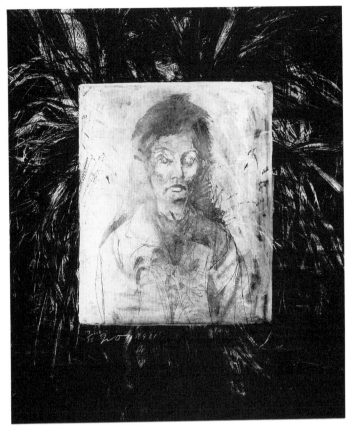

95. Nancy Outside in July XIV: Wrestling with Spirits 1981

Etching, soft-ground etching, aquatint, and electric tools from
three 23 × 19½ (58.4 × 49.5) copper plates and one blank plate
larger by ½ inch in both dimensions
Printed once in cobalt blue (surface roll), twice in black, once in
blue-gray, and once in gray
Paper: 36 × 25 (91.5 × 63.5) Rives BFK
Edition: 30, plus 9 AP
Proofed by Aldo Crommelynck, printed at Atelier Crommelynck;
published by Crommelynck (Pace 193-100)
Inscribed with edition numbering by Aldo Crommelynck

96. Nancy Outside in July XV: Nancy Over the Trees
1981

Photogravure and electric tools from one 23 × 19½ (58.4 ×
49.5) copper plate
Printed in black with hand painting in white acrylic before
printing and with white acrylic and oil pastel after editioning
Paper: 40¾ × 34⅝ (103.5 × 88) Arches printed with an
unpublished variant of the 1981 *Tree* series (79–84), printed twice
in black and once in white
Edition: 15, plus 6 AP
Proofed by Aldo Crommelynck, printed at Atelier Crommelynck;
published by Crommelynck (Pace 193-114)
Signed in white crayon

This print (96) was made from a photogravure of an early
state of the key plate reworked with the electric burnisher
and vibrating needle. Dine painted the sheet in white
before printing and added white to areas of the image after
its editioning. By hand painting and by imprinting the plate
on a monochromatic variant of the Tampa *Tree* series
(79–84), Dine gave the portrait the illusion of transparency.
His re-use of an image from an earlier work is related to
several drawings of the period which are surrounded by
strips of recycled drawings. It is also reminiscent of the practice
of late nineteenth-century European printmakers in using
etched marginalia to comment on the central image.

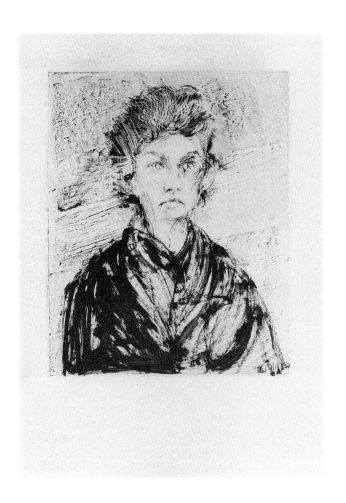

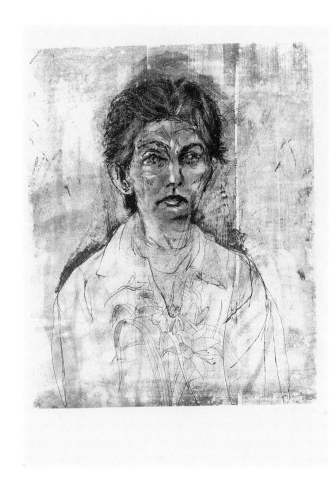

97. Nancy Outside in July XVI: Japanese Bistre 1981

Photogravure from one 23 × 19½ (58.4 × 49.5) copper plate
Printed in brown
Paper: 36½ × 26⅝ (92.7 × 67.6) oatmeal ivory
Edition: 19, plus 6 AP
Proofed by Aldo Crommelynck, printed at Atelier Crommelynck;
published by Crommelynck (Pace 193-115)

Dine made an India ink and grease crayon drawing of
Nancy on a sheet of mylar. In rubbing the crayon on the
image as it lay on the floor of his Putney house, Dine
picked up the texture of wood grain which appears in areas
of the print. He scraped the hair with a pocket knife for
highlights and then had the drawing transferred to the plate
by photogravure. This procedure for *Nancy Outside in July
XVI* (97) is described and reproduced in Deli Sacilotto,
Photographic Printmaking Techniques (New York, 1982), pp.
131–35.

**98. Nancy Outside in July XVII: The Reddish One
1981**

Photogravure, aquatint, and electric tools from two 23 × 19½
(58.4 × 49.5) copper plates
Printed twice in Rubine red
Paper: 29⅞ × 22⅛ (75.9 × 56.2) Rives BFK gray
Edition: 26, plus 6 AP
Proofed by Aldo Crommelynck, printed at Atelier Crommelynck;
published by Crommelynck (Pace 193-116)

**99. Nancy Outside in July XVIII: Full of Expression
1981**

Photogravure, etching, soft-ground etching, aquatint, and electric
tools from two 23 × 19½ (58.4 × 49.5) copper plates
Printed three times in black with hand coloring in blue, red,
orange, yellow, and green oil pastel between first and second
printings
Paper: 36 × 24¾ (91.5 × 62.9) Rives BFK
Edition: 15, plus 4 AP
Proofed by Aldo Crommelynck, printed at Atelier Crommelynck;
published by Crommelynck (Pace 193-117)

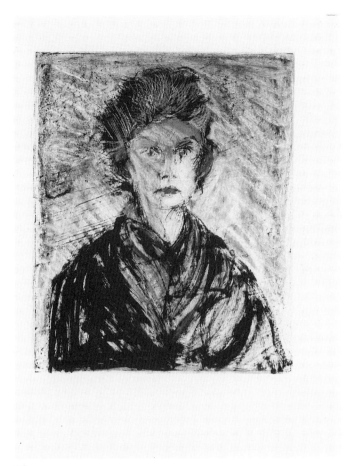

99.

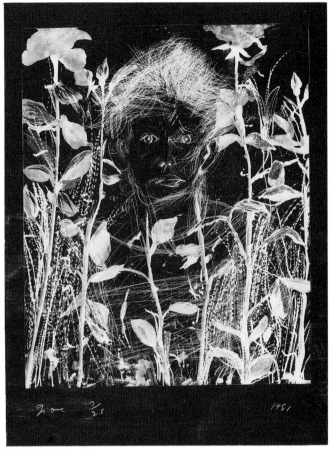

100.

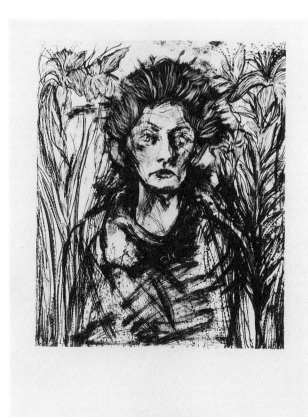

101.

100. Nancy Outside in July XIX: The Fish in the Wind 1981

Etching, soft-ground etching, aquatint, and electric tools from three 23 × 19½ (58.4 × 49.5) copper plates
Printed three times in white
Paper: 29⅞ × 22 (75.9 × 55.9) Rives BFK painted in black acrylic
Edition: 25, plus 6 AP
Proofed by Aldo Crommelynck, printed at Atelier Crommelynck; published by Crommelynck (Pace 193-137)

101. Nancy Outside in July XX: Among French Plants 1981

Photogravure, aquatint, and electric tools from three 23 × 19½ (58.4 × 49.5) copper plates
Printed twice in black and once in orange
Paper: 29⅞ × 22 (75.9 × 55.9) Rives BFK
Edition: 8 AP
Proofed by Aldo Crommelynck, printed at Atelier Cromelynck; published by Crommelynck (Pace 193-138)

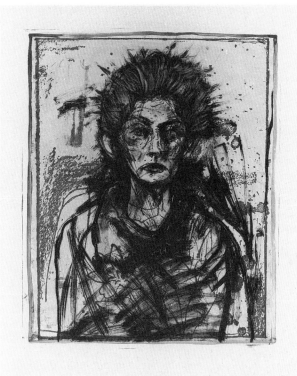

102.

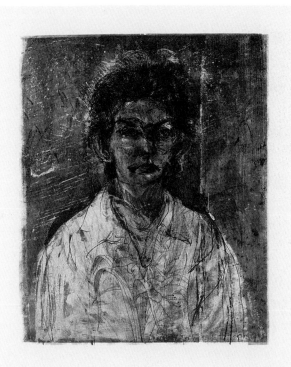

103.

102. Nancy Outside in July XXI: The Red Frame
1981

Photogravure, aquatint (from rubber stamp), and electric tools
from two 23 × 19½ (58.4 × 49.5) copper plates
Printed three times in black with hand painting in blue acrylic
between first and second printings and in red acrylic before the
third printing
Paper: 35⅞ × 24⅞ (91.1 × 63.2) Arches
Edition: 22, plus 4 AP
Proofed by Aldo Crommelynck, printed at Atelier Crommelynck;
published by Crommelynck (Pace 193-139)

103. Nancy Outside in July XXII: Ten Layers of Gray
1981

Etching, soft-ground etching, aquatint, and electric tools from
eight 23 × 19½ (58.4 × 49.5) copper plates
Printed once in gray, twice in dark gray, four times in black,
twice in white, and once in light gray
Paper: 36 × 25 (91.5 × 63.5) Rives BFK
Edition: 28, plus 9 AP
Proofed by Aldo Crommelynck, printed at Atelier Crommelynck;
published by Crommelynck (Pace 193-140)

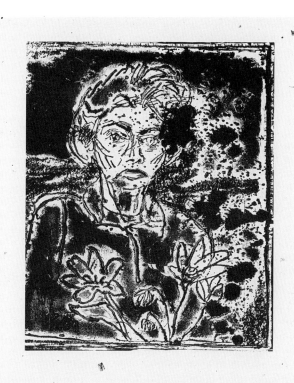

104.

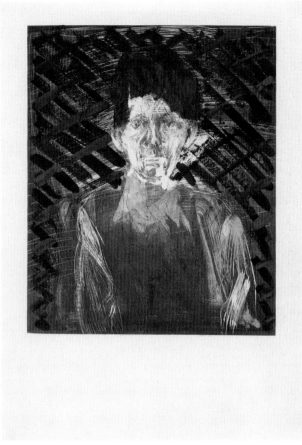

105.

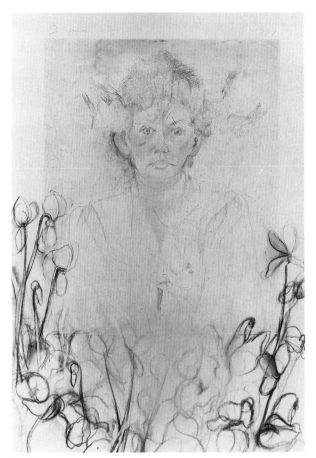

106.

104. Nancy Outside in July XXIII: Squeezed Out on Japanese Paper 1981

Aquatint (from rubber stamp) from one 23 × 19½ (58.4 × 49.5) copper plate
Printed in brown
Paper: 36 × 24½ (91.5 × 62.2) Chiri
Edition: 25, plus 6 AP
Proofed by Aldo Crommelynck, printed at Atelier Crommelynck; published by Crommelynck (Pace 193-141)

105. Nancy Outside in July XXIV: Brilliant Dutch Gloss 1981

Etching, soft-ground etching, drypoint, aquatint, and electric tools from two 23 × 19½ (58.4 × 49.5) copper plates
Printed once in gray and once in black with hand painting in blue, orange, red, yellow, and green enamel between printings
Paper: 36 × 24⅞ (91.5 × 63.2) Rives BFK
Edition: 18, plus 4 AP
Proofed by Aldo Crommelynck, printed at Atelier Crommelynck; published by Crommelynck (Pace 193-142)

106. Nancy Outside in July XXV: Charcoal Cyclamen 1981

Etching, soft-ground etching, and aquatint from two 23 × 19½ (58.4 × 49.5) copper plates
Printed once in black and once in flesh with hand drawing in charcoal after editioning
Paper: 35¾ × 24⅞ (90.8 × 63.2) Arches cream
Edition: 9, plus 2 AP
Proofed by Aldo Crommelynck, printed at Atelier Crommelynck; published by Crommelynck (Pace 193-143)

107. Shell from the Gulf of Acaba 1981

Screenprint from one 27¼ × 26⅜ (69.2 × 67) screen; etching from one 8¼ × 6¾ (21 × 17.2) copper plate, cut to shape of shell
Printed twice in black
Paper: 39¾ × 29¼ (101 × 74.3) Rives BFK
Edition: 30, plus 10 AP
Screenprinting by Itzik Schwarz, etching printed by Ami Rosenberg, Burston Graphic Center; published by Pace (193-106)

108. Three Trees in the Shadow of Mt. Zion 1981

Triptych screenprint from two screens; drypoint and electric tools from one 34⅞ × 26⅛ (88.7 × 66.3) copper plate
Each sheet printed twice in colors (left: blue and tan, center: blue and green, right: pink and yellow) and once in black with hand painting in clear acrylic between second and third printings
Paper: three sheets; left and right: 37⅝ × 28 (95.6 × 71.1); center: 37½ × 26⅝ (95.2 × 67.6) Rives BFK
Edition: 27, plus 6, 1 BAT
Screenprinting by Itzik Schwarz; intaglio printed by Ami Rosenberg and Keren Ronin, Burston Graphic Center; published by Pace (193-109)

Each of the three sheets for *Three Trees in the Shadow of Mt. Zion* (108) has a colored screenprint background sealed with a layer of clear acrylic. On top of this a tree image plate, the same for each sheet, was printed in black. The title refers to the omnipresent vision of Mt. Zion throughout Jerusalem, as well as from the window of the Burston Graphic Center where this print was made. This is Dine's first triptych since the 1976 *Portrait of Peter Eyre.*

107.

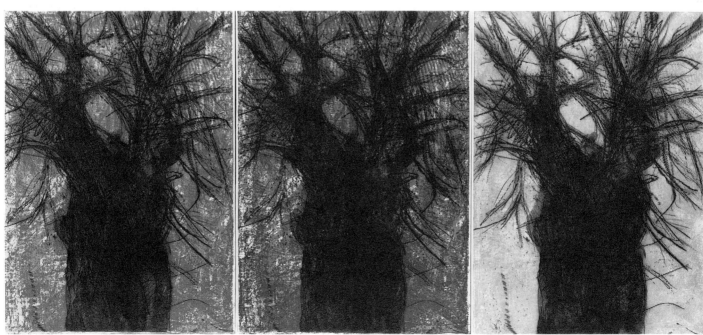

108.

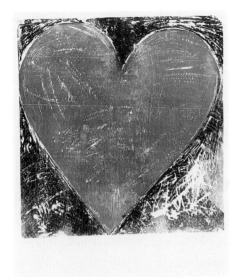

109.

109. The Bezalel Woodcut 1981

Woodcut from one 27 × 26⅛ (68.6 × 66.3) plywood block
Printed once in red, blue, and green
Paper: 39⅞ × 30 (101.3 × 76.2) John Koller HMP buff
Edition: 6, plus 3 AP on John Koller HMP white, 3 TP on Rives BFK
Printed by the artist, Burston Graphic Center; published by Pace (193-112)

The print takes its title from the Bezalel Academy of Art, now the National Art School, Jerusalem. Printed in colors applied to the surface for a single run through the press *(a la poupée),* the block was used again in *The Jerusalem Woodcut Heart* (110).

110. The Jerusalem Woodcut Heart 1981–1982

Woodcut from one 27 × 26⅛ (68.6 × 66.3) plywood block and one rubber stamp
Printed twice in black with hand painting in watercolor between printings
Paper: 37⅜ × 29½ (95 × 75) Rives BFK
Edition: 20, plus 6 AP, 1 TP without hand painting and stamping
Printed by Ami Rosenberg and Keren Ronin, Burston Graphic Center; published by Pace (193-111)

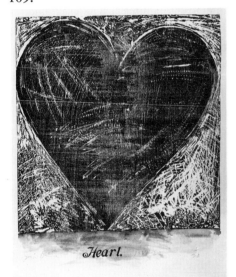

110.

111. Fortress of the Heart 1981–1982

Lithograph from three zinc plates and two aluminum plates
Printed once in yellow and green, once in orange, once in pink, and twice in black
Paper: 36 × 60½ (91.5 × 153.7) Arches rolled
Edition: 22, plus 5 AP, 2 PP, 1 BAT
Lithograph (zinc plates) printed by Julio Juristo, Topaz Editions, Tampa; lithograph (aluminum plates) printed by Maurice Sanchez, Derriere L'Etoile Studios; published by Pace (193-119)

Fortress of the Heart (111) relates to *Two Hearts in the Forest* (86).

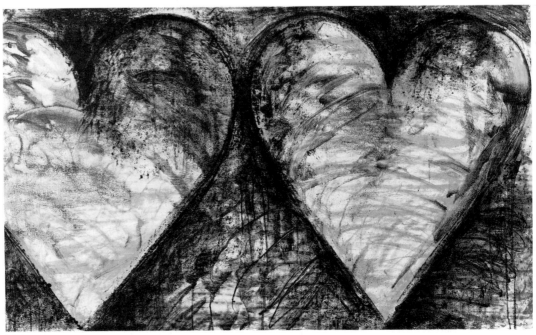

111.

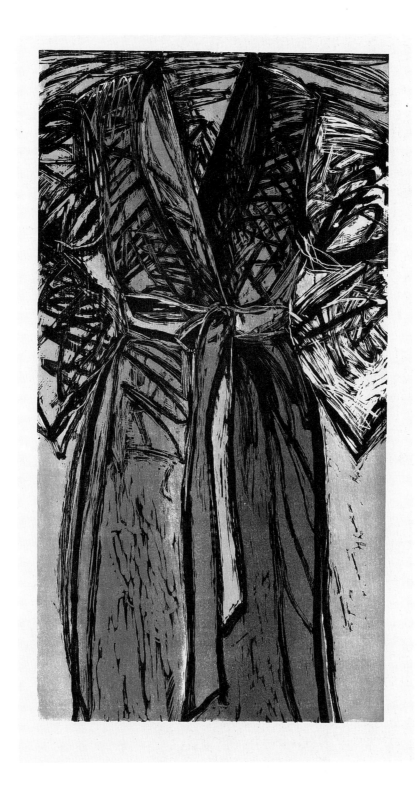

112. Fourteen Color Woodcut Bathrobe 1982

Woodcut from two 65½ × 35½ (165.4 × 90.2) plywood blocks
Printed once in thirteen colors from sawn block and once in black
Paper: 76 × 42 (193 × 106.7) Rives BFK
Edition: 75, plus 15 AP, 4 PP
Printed by Garner Tullis, Experimental Printmaking Workshop,
San Francisco; published by Pace (193-120)

Dine painted a robe on a sheet of plywood and cut away the negative space with a power gouge and the Dremel. This accounts for the painterly quality of the printed black 'strokes.' The robe's form was traced to another block with the tracing serving as a guide for its division into many sections. The sawn block was inked in colors part by part, reassembled, and printed. The key image block was overprinted in black. Both blocks were cut down and reused for *The Kindergarten Robes* (146).

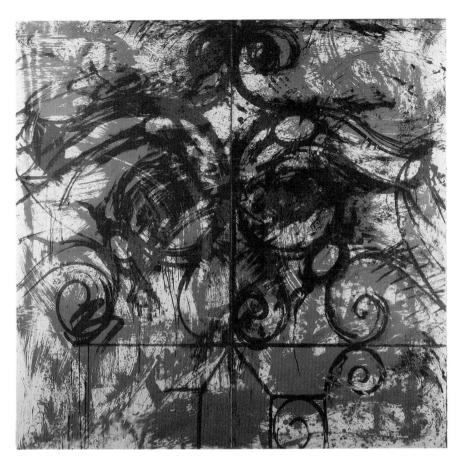

113. Blue and Red Gate 1982

Diptych lithograph from four aluminum plates
Each sheet printed once in red and once in black
Paper: two sheets of 72 × 36¼ (182.9 × 92.1) Arches Cover rolled, painted in blue by Winston Roeth before printing
Edition: 12, plus 4 AP, 1 PP
Printed by Maurice Sanchez, Derriere L'Etoile Studios; published by Pace (193-133)

The nineteenth-century iron grillwork gate at the Atelier Crommelynck was the source for Dine's gate paintings of 1981, the gate prints of 1982 and 1983, and the monumental sculpture of 1983. In No. 113, the black assumes two values because it was overprinted on colors of blue and red. Dine drew on two proofs of the key image. These were made into transfer surfaces with the addition of a gum arabic and glycerine solution and were used to produce the two lithographic plates printed in silver for No. 114.

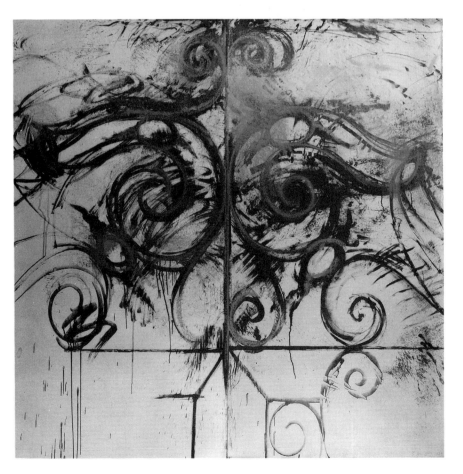

114. Blue Crommelynck Gate 1982

Diptych lithograph from four aluminum plates
Each sheet printed once in black and once in silver
Paper: two sheets of 72 × 36¼ (182.9 × 92.1) Arches Cover rolled, painted in blue by Winston Roeth before printing
Edition: 15, plus 4 AP, 2 PP
Printed by Maurice Sanchez, Derriere L'Etoile Studios; published by Pace (193-118)

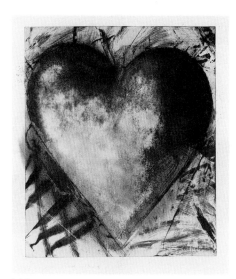

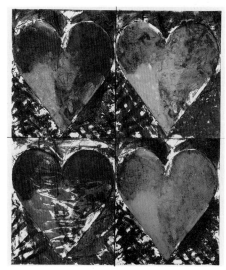

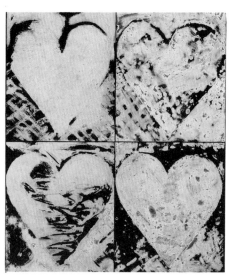

115. 116. 117.

The heart images printed in 1982 at the Kelpra Studio, London, (115–117) begin with an etching and spit-bite aquatint plate of a heart printed in black on a yellow aquatint field for *The Bee* (115). These two plates were printed in the same colors on four sheets of paper as the basis of *L.A. Eye Works* (116). They were then overprinted from three carborundum plates. To make these, Dine mixed carborundum grit with polyester laminating resin and painted this mixture onto the plates. After it hardened, the plates were printed in red or in red combined with colors of purple and green on the etching and aquatint images. For the negative image, *Winter Windows* (117), four sheets of paper were screenprinted in black and then three carborundum plates from *L.A. Eye Works* and an additional plate were printed in white. The hardened relief surfaces of these carborundum plates emboss their colors and pitted textures deeply into the paper. Dine titled No. 116 after an optician's firm in Los Angeles and No. 117 after a street in London where he formerly had a studio.

115. The Bee 1982

Etching and aquatint from two 21¾ × 18⅝ (55.3 × 47.3) copper plates
Printed once in yellow and once in black with hand coloring in white spray and charcoal after editioning
Paper: 26⅛ × 22⅝ (66.3 × 57.5) Arches Aquarelle Fin
Edition: 40 (several without hand coloring), plus 10 AP, 1 PP without hand coloring
Printed by Nigel Oxley, Kelpra Studio, London; published by Pace (193-125)

116. L. A. Eye Works 1982

Four-part etching, aquatint, and carborundum from five 21¾ × 18⅝ (55.3 × 47.3) copper plates
Each sheet printed once in yellow, once in black, and once in red, purple, and green
Paper: four sheets of 25 × 21½ (63.5 × 54.6) Velin Arches
Edition: 70, plus 10 AP, 1 PP
Printed by Nigel Oxley, Kelpra Studio, London; published by Pace (193-123)

117. Winter Windows on Chapel Street 1982

Four-part screenprint and carborundum from one screen and four 21¾ × 18⅝ (55.3 × 47.3) copper plates
Each sheet printed once in black and once in white
Paper: four sheets of 25 × 21½ (63.5 × 54.6) Velin Arches
Edition: 40, plus 10 AP, 1 PP
Printed by Nigel Oxley, Kelpra Studio, London; published by Pace (193-124)

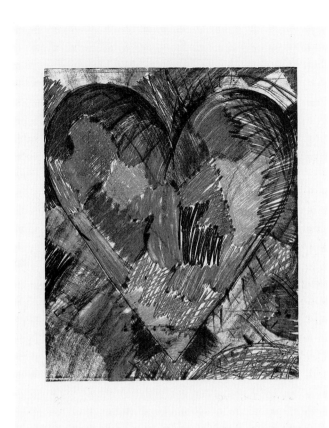

118.

118. The Heart Called Paris Spring 1982

Soft-ground etching and electric tools from six or more 23½ × 19⅝ (59.7 × 49.9) copper plates
Printed six or more times in thirteen colors: turquoise, 3 shades of green, 2 shades of blue, brown, ochre, red, orange, violet, magenta, and black
Paper: 35⅞ × 25 (91.1 × 63.5) Rives BFK
Edition: 90, plus 20 AP
Proofed by Aldo Crommelynck, printed at Atelier Crommelynck; published by Crommelynck (Pace 193-122)

The color in *The Heart Called Paris Spring* (118) was printed from soft-ground etching plates, inked in two or more colors before their run through the press. Dine worked the black printing plate, dropped over the color impressions, with a disc sander. The print is the basis for *Louisiana Hearts* (119).

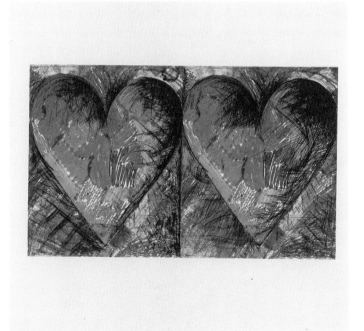

119.

119. Louisiana Hearts 1982

Offset lithograph from four aluminum plates; etching from one 8½ × 14 (21.5 × 35.5) copper plate
Printed four times in colors and once in black
Paper: 17½ × 17¾ (44.5 × 45) T.H. Saunders HP finish
Edition: 100, plus 12 PP, 1 PP on English Cartridge
Lithograph printed by Hillingdon Press, Uxbridge, etching printed by Nigel Oxley, Kelpra Studio, London

Louisiana Hearts is a doubled image of *The Heart Called Paris Spring* (118), which was reproduced as a color offset lithograph and overprinted in black from a new intaglio plate. Its entire edition of 100 prints was commissioned for subscribers by the Louisiana Museum, Humlebaek, Denmark.

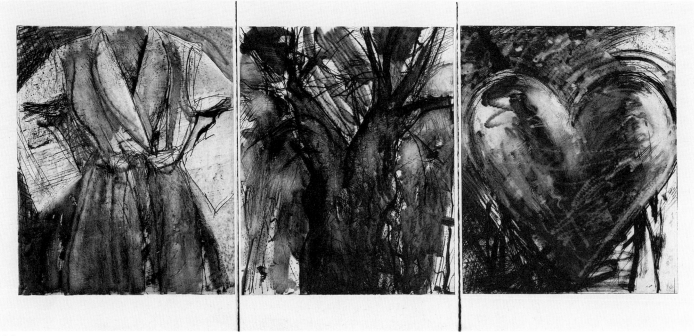

120.

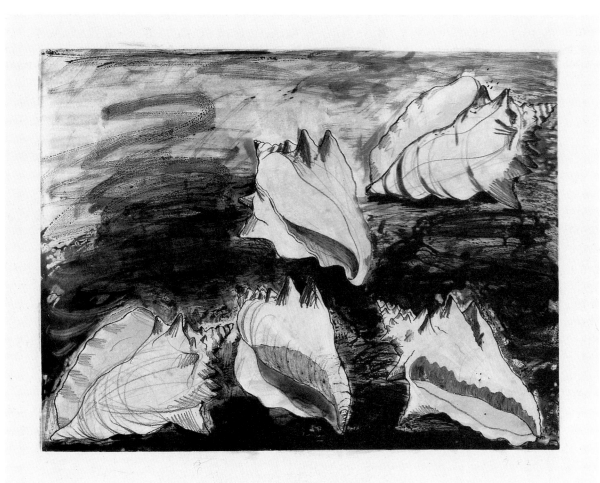

121.

122.

120. Desire in Primary Colors 1982

Triptych aquatint and electric tools from four 23½ × 19½ (59.7 × 49.5) copper plates
Each sheet printed once in one color (left: light red, center: light yellow, right: light blue) and once in black
Paper: three sheets; left and right: 30 × 22½ (76.2 × 57.1); center: 30 × 20 (76.2 × 50.8) Rives BFK
Edition: 40, plus 12 AP
Proofed by Aldo Crommelynck, printed at Atelier Crommelynck; published by Pace (193-126)

For *Desire in Primary Colors* (120), Dine took three plates from the *Nancy Outside in July* series and ground them down with the die-grinder and hand scraper and reworked them with an electric German vibrating needle and the Dremel. While remnants of the original etching and aquatint remain, the robe, tree, and heart were created without the use of acid. For the triptych, one aquatint plate was first printed on each sheet in a different primary color, creating soft colored backgrounds for the black robe, tree, and heart plates. This print relates to the three-panelled black and white painting, *Desire (The Charterhouse)*, 1981 (Collection of the artist) of the same thematic sequence.

121. Five Shells 1982

Soft-ground etching, drypoint, and aquatint from one 22⅞ × 30½ (58.1 × 77.5) copper plate
Printed twice in black with hand painting in blue, pink, and ochre acrylic between printings
Paper: 29¾ × 36⅝ (75.6 × 93) Rives BFK
Edition: 50, plus 12 AP
Proofed by Aldo Crommelynck, printed at Atelier Crommelynck; published by Pace (193-127)

122. Blue Detail from the Crommelynck Gate 1982

Diptych etching, aquatint, and electric tools from two 33½ × 23⅛ (85.1 × 58.7) copper plates
Each sheet printed in black with hand painting in blue watercolor and charcoal after editioning
Paper: two sheets of 39¼ × 25½ (99.7 × 64.8) Arches
Edition: 30, plus 1 AP
Proofed by Aldo Crommelynck, printed at Atelier Crommelynck; published by Pace (193-128)

The grillwork in Dine's first gate print with the Atelier Crommelynck is executed primarily with lift-ground aquatint.

Dine's *Eight Little Nudes* (123–130), each printed from two plates in two colors, were produced primarily with soft-ground contour and an aquatint plate in flesh tones, worked with spit-bite to resemble watercolor washes. The dark marks on several of the plates *(Little Nude #6 and #7)* were made with roulette and wire brush. The suite relates to nude studies by Auguste Rodin and, in particular, to charcoal drawings by Henri Matisse.

123–130. Eight Little Nudes, Suite of Eight Prints 1982

8 prints: soft-ground etching, drypoint, and aquatint from sixteen 11½ × 8⅝ (29.2 × 21.9) copper plates
Each sheet printed once in black and once in flesh
Paper: 22½ × 16½ (57.1 × 41.9) Rives BFK
Edition: 30, plus 5 AP
Proofed by Aldo Crommelynck, printed at Atelier Crommelynck; published by Pace (193–144–01–08)

119

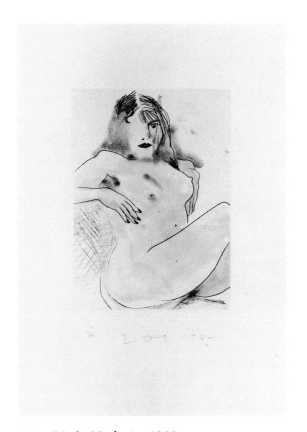

123. Little Nude 1 1982

Printed once in pink and once in black

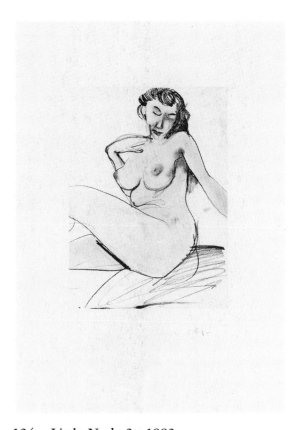

124. Little Nude 2 1982

Printed once in light orange and once in black

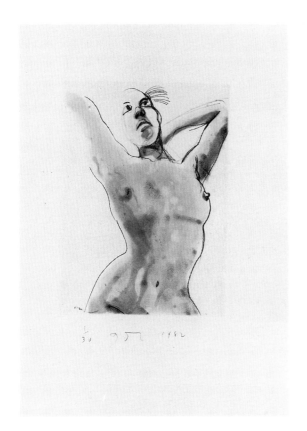

127. Little Nude 5 1982

Printed once in light brown and once in black

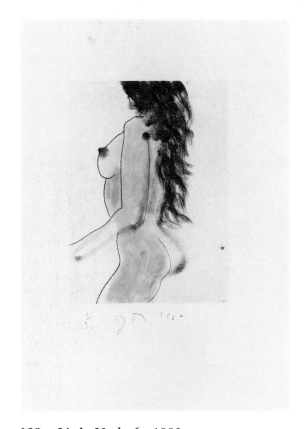

128. Little Nude 6 1982

Printed once in light brown and once in black

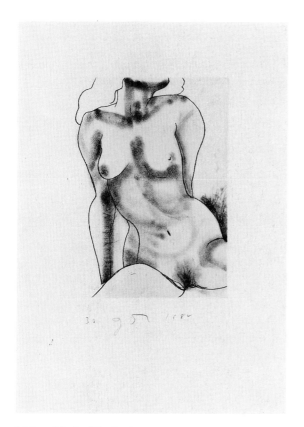

125. Little Nude 3 1982

Printed once in ochre and once in black

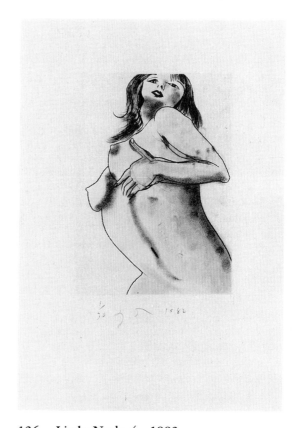

126. Little Nude 4 1982

Printed once in ochre and once in black

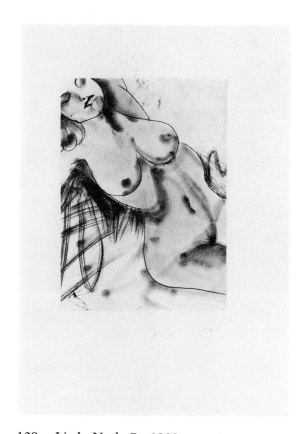

129. Little Nude 7 1982

Printed once in light orange and once in black

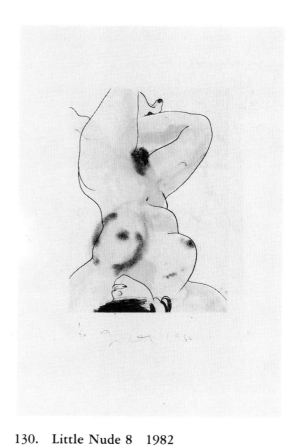

130. Little Nude 8 1982

Printed once in light orange and once in black

The eight *Jerusalem Plant* images of 1982–84 (131–136, 148, 176) are derived from charcoal drawings of a Dracena, produced earlier by Dine in Jerusalem (Dine family collection). One of the drawings was first reproduced as an offset lithographic poster for the 1981 opening of the west wing at the Museum of Fine Arts, Boston. The key image in the poster was transferred onto a stone on which Dine added further drawing and work with the die-grinder. This was printed in white for the plant image in No. 131 and in brown for No. 134. It was transferred in reverse for the left side of the image in Nos. 132 and 133 and reworked in the block. These woodcuts are identical except for the paper on which they are printed. The second drawing was the basis for the right-hand plant in the woodcuts and, in reverse, for the stone in No. 135 and 176. Dine produced a free translation of the woodcut plants onto a huge lithographic plate for No. 136, handling tusche with a loaded brush in drip and spatter and dragging a dry brush across the surface. This plate, together with the stones used earlier, was used for *Jerusalem Plant #7* (148). The last print in the series (176) incorporates surfaces from No. 135, two added lithographic plates, and two intaglio plates.

131. The Jerusalem Plant #1 1982

Lithograph from one 35¾ × 25¾ (90.7 × 65.4) stone and one aluminum plate
Printed twice in white
Paper: 40½ × 26¼ (102.8 × 66.7) Fabriano black
Edition: 10, plus 4 AP, 2 PP
Printed by Thomas Cox, ULAE; published by ULAE (Pace 193-129)

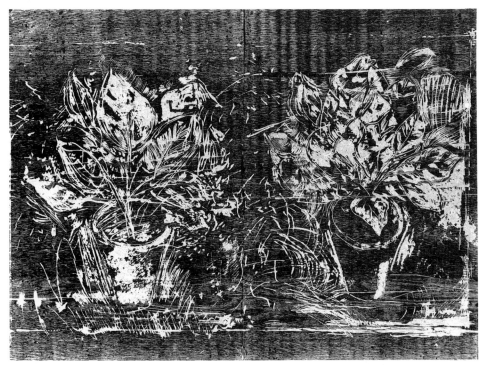

132. The Jerusalem Plant #2
1982

Diptych woodcut from one block of
exterior housing plywood
Each sheet printed in black
Paper: two sheets of 37¼ × 25 (94.6 ×
63.5) Chiri
Edition: 11, plus 4 AP, 2 PP
Printed by Thomas Cox, ULAE; published
by ULAE (Pace 193-129A)
Signed on right sheet

133. The Jerusalem Plant #3
1982

Diptych woodcut from one block of
exterior housing plywood
Each sheet printed in black
Paper: two sheets of 38 × 25½ (96.5 ×
64.8) Kozo
Edition: 11, plus 4 AP, 2 PP
Printed by Thomas Cox, ULAE; published
by ULAE (Pace 193-129B)
Signed on left sheet

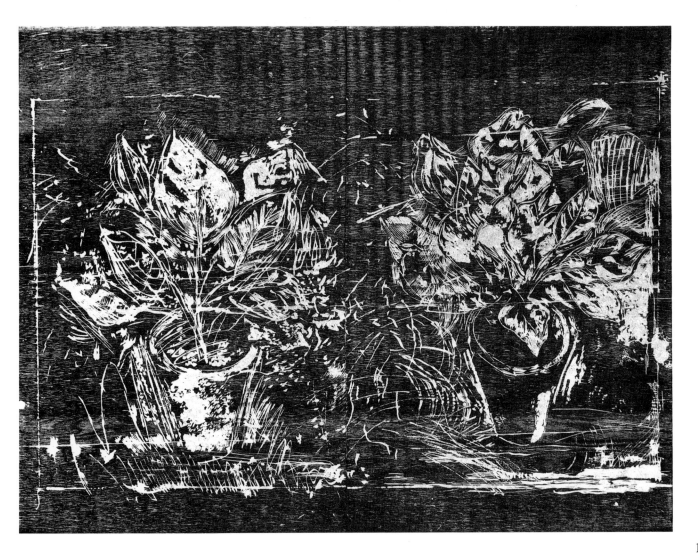

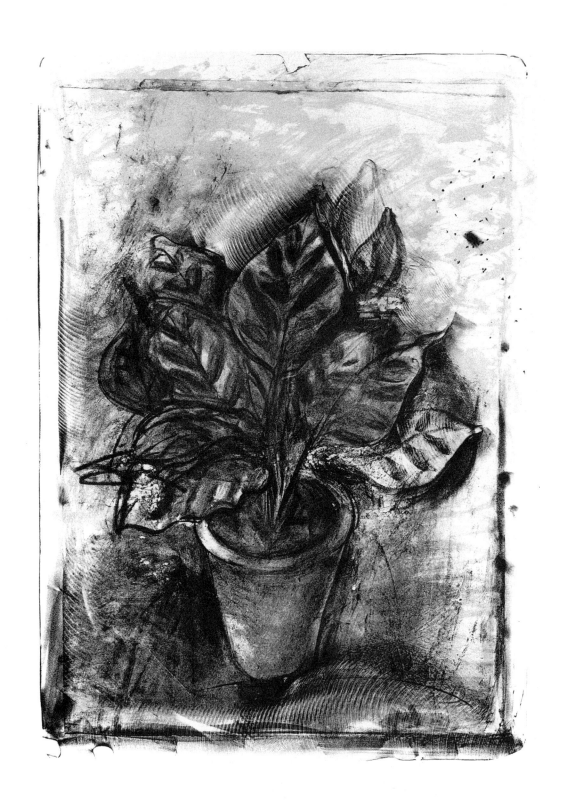

134. The Jerusalem Plant #4 1982

Lithograph from one aluminum plate and one 35¾ × 25¾ (90.7
× 65.4) stone
Printed once in green and once in brown
Paper: 41 × 27¾ (104.1 × 70.5) J. Green English
Edition: 25, plus 4 AP, 3 PP
Printed by Keith Brintzenhofe, ULAE; published by ULAE (Pace
193-134)

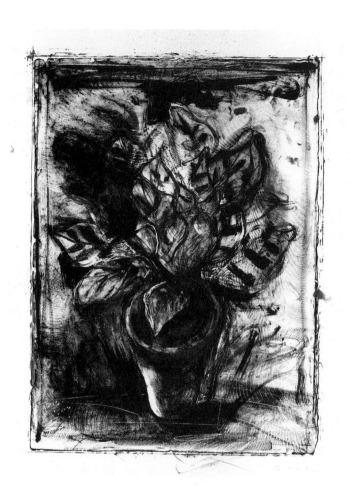

135. The Jerusalem Plant #5 1982

Lithograph from one 35¾ × 25¾ (90.7 × 65.4) stone and three
aluminum plates
Printed twice in black, once in graphite gray, and once in red
with hand sanding by die-grinder on left margin after editioning
Paper: 39½ × 30 (100.3 × 76.2) St. Amand handmade
Edition: 9, plus 4 AP, 3 PP
Printed by Thomas Cox, ULAE; published by ULAE (Pace
193-135)

136. The Jerusalem Plant #6 1982

Lithograph from one aluminum plate
Printed in black
Paper: 40¼ × 60¼ (102.2 × 153) Arches Cover buff
Edition: 20, plus 4 AP, 2 PP
Printed by Thomas Cox, ULAE; published by ULAE (Pace
193-136)

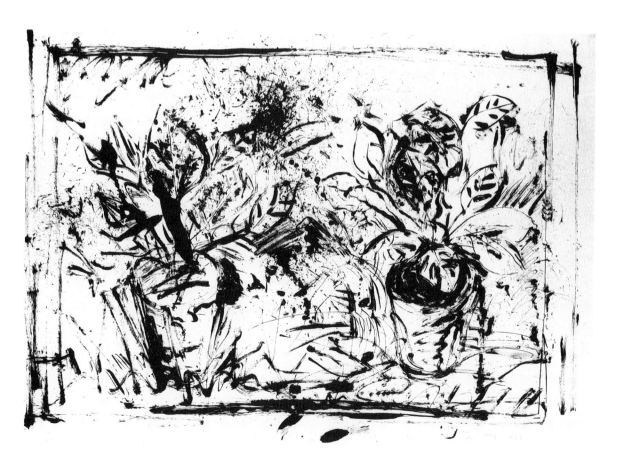

137. The Hammer (with Watercolor Marks) 1982

Diptych lithograph from two aluminum plates
Each sheet printed in black with hand painting in watercolor after editioning
Paper: two sheets of 44⅝ × 30⅞ (113.3 × 78.5) Arches Cover
Edition: 46, plus 11 AP, 3 PP, 1 BAT
Proofed by Maurice Sanchez, Hartford Art School, printed by Maurice Sanchez, Derriere L'Etoile Studios; published by Pace (193-132)
Signed upper left on left sheet

In *The Hammer* (137), Dine used rubbing stick and liquid tusche, contrasting the handling of these materials by dragging the side of the stick across the plate and varying his brushstrokes in tusche. The hand applied watercolor along the lower edge recalls Dine's work of the 1960s and his *Realistic Poet Assassinated,* 1970.

138. The Jewish Heart 1982

Etching and drypoint from one 11¾ × 8¾ (29.8 × 22.2) copper plate
Printed in black
Paper: 26 × 20 (66 × 50.8) Richard DeBas Floral
Edition: 100
Printed by Mohammed Kahlil, New York; published by the artist for the Federation–United Jewish Appeal

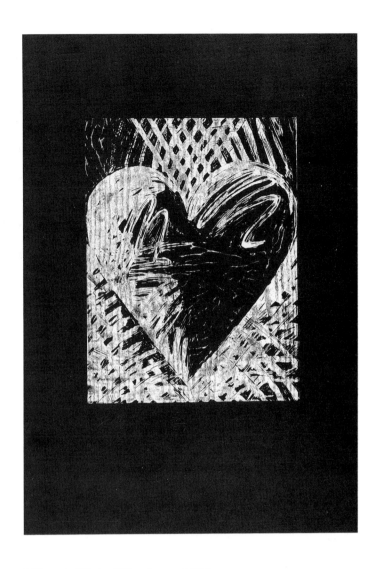

139. A Sunny Woodcut 1982

Woodcut from two 23½ × 18½ (59.7 × 47) oak blocks
Printed once in yellow and once in black with hand painting in
green and blue spray enamel before printings
Paper: 31⅝ × 31 (80.3 × 78.8) John Koller HMP
Edition: 42, plus 6 AP, 1 PP
Printed by Jeremy Dine, Putney Fine Arts; published by Pace
(193-130)

John Koller handmade paper, distinguished by a heavy
deckle, was prepared with green and blue enamel paint for
A Sunny Woodcut (139). A block cut away at the sides, but
left largely untouched at the center (the heart area) was
printed in yellow. A second block, cut to emphasize the
reverse areas so that the yellow of the first printing remains
prominent, was dropped on top. The result is a heart that
shines like a sun amidst a blue sky and green field; the
lattice background pattern recalls a garden trellis. *A Night
Woodcut* (140) is a white printing on black paper from the
second block.

140. A Night Woodcut 1982

Woodcut from one 23½ × 18½ (59.7 × 47) oak block
Printed in white
Paper: 44½ × 30⅛ (113 × 76.5) Arches Cover black
Edition: 38, plus 4 AP
Printed by Jeremy Dine, Putney Fine Arts; published by Pace
(193-131)

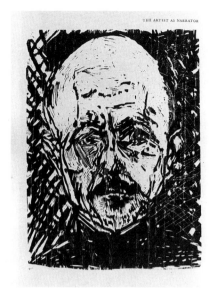

a. The Artist as Narrator

b. Candlesticks

c. Feet as if They Burned in a Furnace

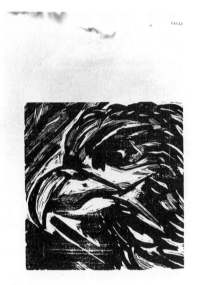

g. Eagle

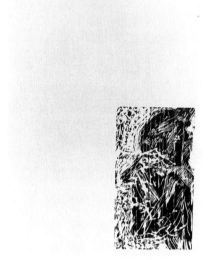

h. And I Saw

i. Robes Were Given Unto Everyone

141. The Apocalypse: The Revelation of Saint John the Divine 1982

Twenty-nine woodcuts from twenty-nine oak blocks bound in a book of 64 pages (binding in oak veneer plywood boards, stained with a lightning bolt image, with a white pigskin spine)
Printed in black
Paper: 14⅞ × 11⅛ (37.8 × 28.3) Richard DeBas Apta velin
Edition: 150, plus 15 hors de commerce
Printed and published by The Arion Press, San Francisco, Andrew Hoyem, Director (Pace 193-146)
Signed in pencil on the title page

Dine was inspired to adopt the centuries-old printmaker's theme of the Apocalypse from his reading of *Unforgettable Fire: Pictures Drawn by Atomic Bomb Survivors,* ed. Japan Broadcasting Corporation (Tokyo, 1977, repr. New York: Pantheon, 1981). Several of the themes which Dine introduced here (the burning hand and the skull) recur in subsequent prints. Dine cut the oak blocks in Putney, using a Dremel and hand tools to achieve strong graphic contrasts of black and white. This is perhaps his most traditional work in woodcut. Thematically, it is related to his eighteen-panel painting, *Lessons in Nuclear Peace,* 1982 (Library, Louisiana Museum, Humlebaek, Denmark).

d. The Mystery of the Seven Stars

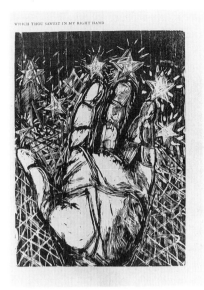

e. Which Thou Sawest in
My Right Hand

f. The Morning Star

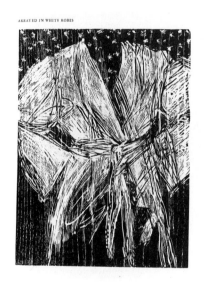

j. Arrayed in White Robes

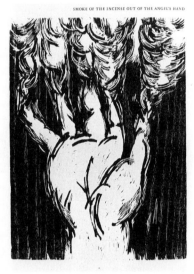

k. Smoke of the Incense out of
the Angel's Hand

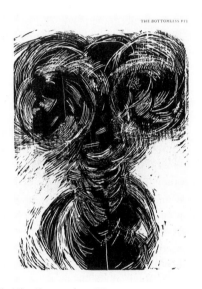

l. The Bottomless Pit

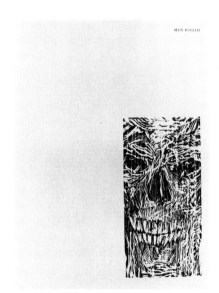

m. Men Killed

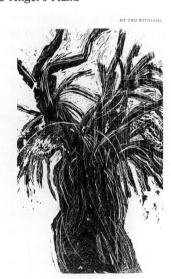

n. My Two Witnesses

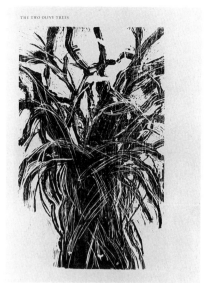

o. The Two Olive Trees

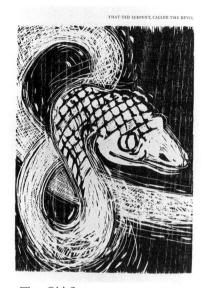

p. That Old Serpent,
Called the Devil

q. The Beast

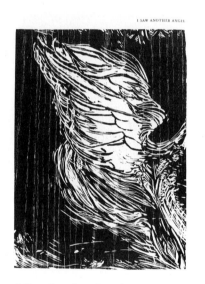

u. I Saw Another Angel

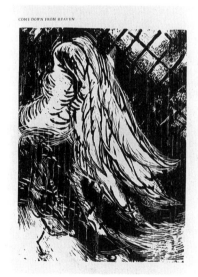

v. Come Down From Heaven

w. Babylon

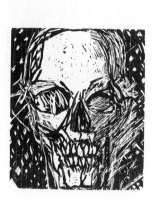

aa. There Shall Be No More Death

bb. Every Several Gate Was of
One Pearl

130

r. Pruning Shears

s. Smoke from the Glory of God

t. Scorched with a Great Heat

x. The Voice of the Bridegroom
and of the Bride

y. Behold a White Horse

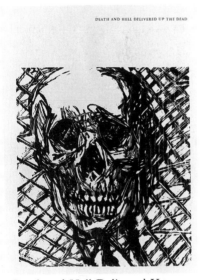

z. Death and Hell Delivered Up
the Dead

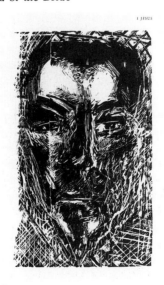

cc. I Jesus

131

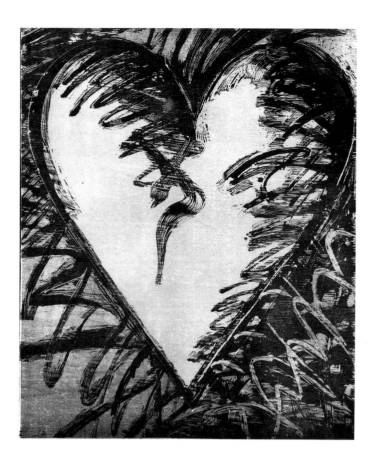

142. Rancho Woodcut Heart 1982

Woodcut from two plywood blocks
Printed once in red and green from sawn block and once in black
Paper: 47¾ × 40½ (121.3 × 102.9) Rives BFK rolled
Edition: 75, plus 15 AP
Proofed by Garner Tullis, Experimental Printmaking Workshop,
San Francisco; printed by R. E. Townsend, Inc., Boston; published
by Pace (193-121)

The *Rancho Woodcut Heart* was treated in the same manner
as the *Fourteen Color Woodcut Bathrobe* (112).

143. Swaying in the Florida Night 1983

Etching, drypoint, aquatint, and electric tools from two 42¾ ×
33¾ (108.6 × 85.7) copper plates
Printed in black
Paper: 47 × 70½ (119.4 × 179.1) Arches rolled
Edition: 65 (15 subscriber's impressions, 1/65–15/65, and 50
artist's edition, 16/65–65/65), plus 10 AP, 5 PP, 1 USF
Graphicstudio II proof, 1 USF proof, 1 BAT, 1 workshop proof
(all USF proofs printed on Somerset textured)
Proofed by Susie Hennessy, Stephen Thomas, and Susan McDonough,
in consultation with Donald J. Saff, USF Graphicstudio II; printed
by R. E. Townsend, Inc., Boston; published by Pace (193-149)

Dine drew on the aquatint-grounded plates with a
lithographic grease crayon and then applied acid with the

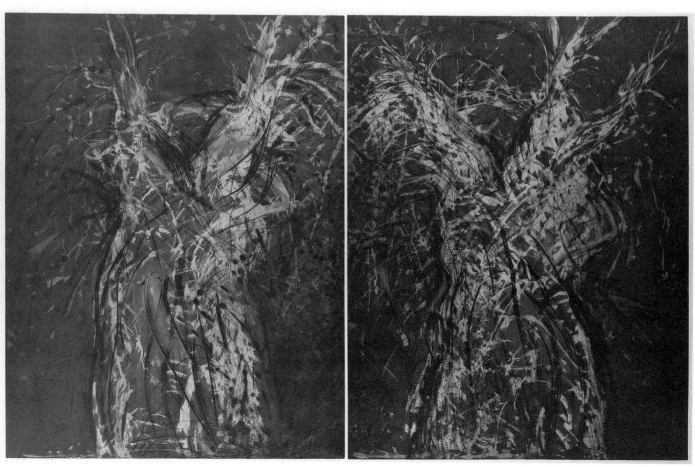

spit-bite technique. Similar in technique to *Nancy Outside in July IX* (70) and *The Robe Goes to Town* (144), the crayon resists acid and acts as a stop-out to achieve light areas. The plates were then worked with etching, wire brush, electric drill, and Dremel. They were set ¼″ apart and printed in a single run through the press.

144. The Robe Goes to Town 1983

Aquatint from one 24¼ × 20⅞ (61.6 × 53) copper plate; screenprint from nine screens
Printed in white on sheet hinged to screenprint printed in nine colors
Paper: 44½ × 30 (113 × 76.2) Arches Cover black, hinged to 57 × 36 (144.8 × 91.4) Arches Cover buff
Edition: 59 (15 subscriber's impressions, 1/59–15/59, 44 artist's edition, 16/59–59/59), plus 10 AP, 4 PP, 1 USF Graphicstudio II proof, 1 USF proof, 1 workshop proof
Aquatint printed by Stephen Thomas, Berkeley; screenprint from floral cotton fabric, printed by Imperial Graphics, Largo; assemblage supervised by Roy Trapp; project assisted by Susie Hennessy and Susan McDonough in consultation with Donald J. Saff, USF Graphicstudio II; published by Pace (193-147)

When the plate was bitten and printed in white ink, the resist process (see 143) allowed the black paper to represent the contours and modeling of the robe. The print was hinged onto a larger sheet printed with a floral pattern.

145. The Heart and the Wall 1983

Four-part soft-ground etching, aquatint, and electric tools from twelve 42¼ × 33⅜ (107.3 × 84.8) copper plates
Each sheet printed once in yellow, once in black, and once in blue
Paper: four sheets; upper left and right: 43⅝ × 34¾ (110.8 × 88.3); lower left and right: 45¾ × 34¾ (116.2 × 88.3)
Somerset textured
Edition: 28, plus 6 AP, 4 PP, 1 USF Graphicstudio II proof, 1 USF proof, 1 BAT, 1 workshop proof
Proofed by Stephen Thomas, printed by Susie Hennessy and Susan McDonough in consultation with Donald J. Saff, USF Graphicstudio II; published by Pace (193-148)

Rather than using ferric acid to bite these plates (145), Dine poured on the more toxic nitric acid, hosing them down outside the Florida workshop. This resulted in their deeply etched areas and drip effects, especially noticeable in the lower half of the print.

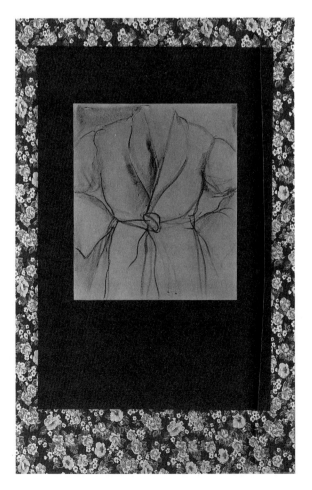

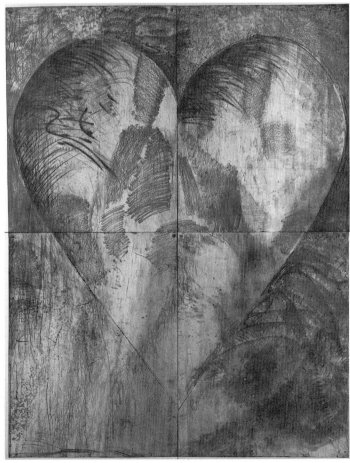

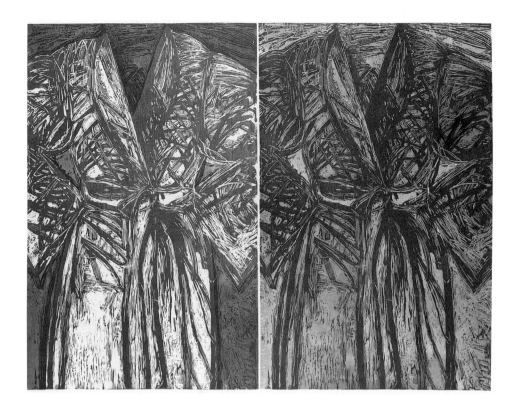

146. The Kindergarten Robes 1983

Woodcut from two 54¾ × 35⅝ (139.1 × 90.5) plywood blocks
Left side of sheet printed once in yellow and blue from sawn block and once in black, right side printed once in red and green from sawn block and once in black
Paper: 59¾ × 73⅝ (151.8 × 187) Lenox
Edition: 75, plus 10 AP
Printed by R. E. Townsend, Inc., Georgetown, Massachusetts; published by Pace (193-150)

The Kindergarten Robes (146) was printed from the same two blocks, cut down, used for the *Fourteen Color Woodcut Bathrobe* (112). This is Dine's largest single-sheet print to date.

147. The Three Sydney Close Woodcuts 1983

Triptych woodcut from three plywood blocks
Each sheet printed in black
Paper: three sheets of 46 × 31⅞ (116.9 × 81) Nonesuch cream laid
Edition: 24, plus 8 AP
Printed by Jack Shirreff, 107 Workshop, Wiltshire; published by Pace (193-145)

The Three Sydney Close Woodcuts (147) is named for Dine's studio address in London where he carved the triptych. Dine worked the three blocks over a long period of time, using a combination of electric and hand tools to achieve the painterly character of their surface textures.

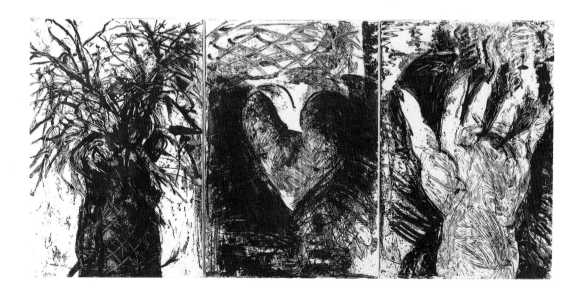

148. The Jerusalem Plant #7 1983

Lithograph from two 35¾ × 25¾ (90.7 × 65.4) stones and one aluminum plate; drypoint, electric tools, and gravure from two 34 × 24 (86.3 × 61) copper plates
Printed twice in black and once in white
Paper: two joined sheets, overall 40 × 53 (101.6 × 134.6)
Copperplate Deluxe
Edition: 11, plus 4 AP, 5 PP
Lithograph printed by Thomas Cox, intaglio printed by John Lund and Craig Zammiello, ULAE; published by ULAE

With *Jerusalem Plant #7* (148), Dine continued the series begun at ULAE in 1982 and finished in 1984 (131–136, 176). This is closely related to *Jerusalem Plant #6* in scale and reuse of the key plate. The two joined sheets were printed first in black in one run from two new intaglio plates, placed side by side. These were based on Dine's drawings on mylar which were made into gravure plates with additional work in drypoint and electric tools. The images were then over-printed in white in one run from the two lithographic stones used for *Jerusalem Plants #1* and *#5* (131, 135). The final printing in black tusche was produced from the large aluminum plate used for *#6* (136). The color of blue results from the overlay of white on top of the initial black printing.

149. A Heart at the Opera 1983

Lithograph from one stone and eight aluminum plates
Printed four times in three shades of black, three times in three shades of green, once in tan, once in pink, and once in maroon
Paper: 50 × 38 (127 × 96.5) Dieu Donné handmade with watermark of Metropolitan Opera Centennial logo
Edition: 50, plus 9 TP
Printed by Thomas Cox, ULAE; published by ULAE

For the background pattern (149), Dine inked real leaves and pressed them onto the stone on which he also drew the key image. In honor of the Centennial year, the Metropolitan Opera membership commissioned an edition of this print in 500 impressions with text, signed and numbered, as a seven-color offset lithograph from nine plates, printed on 46 × 29 (116.9 × 73.7) Arches paper, supervised by Keith Brintzenhofe, Crafton Graphics, published by ULAE. An unlimited edition was published for the Metroplitan Opera as an offset lithographic poster.

150. Two Robes with Watercolor 1980–1983

Diptych lithograph from two aluminum plates
Each sheet printed in black with hand painting in watercolor and
scraping after editioning
Paper: two sheets of 37¾ × 29½ (95.9 × 75) Arches Cover
white
Edition: 9, plus 3 AP, 1 PP
Proofed by Maurice Sanchez, printed by John C. Erickson,
Derriere L'Etoile Studios; published by Pace (193-153)

Two Robes with Watercolor and *Two Hand Colored Colorado
Robes* (150, 151) relate to *Red and Black Diptych Robe* (63).

151. Two Hand Colored Colorado Robes 1980–1983

Diptych lithograph from two aluminum plates
Each sheet printed in red with hand painting in blue and black
watercolor after editioning
Paper: two sheets of 37¾ × 29½ (95.6 × 75) Arches Cover buff
Edition: 10, plus 3 AP, 2 PP
Proofed by Maurice Sanchez, printed by John C. Erickson,
Derriere L'Etoile Studios; published by Pace (193-154)

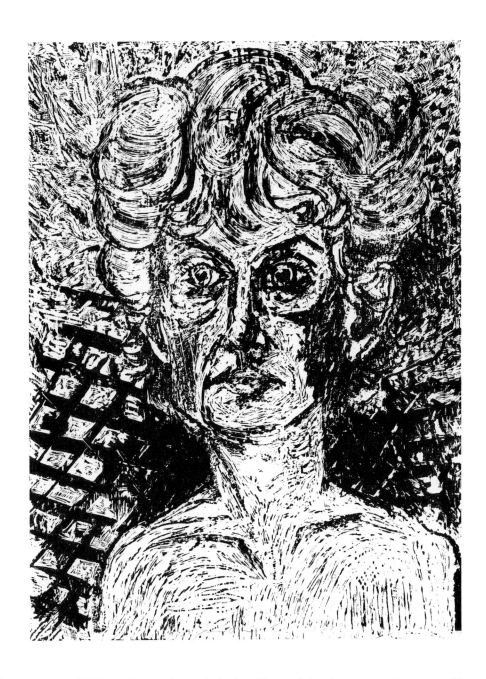

In Aspen during the summer of 1983, without the technical benefits and staff assistance of a professional printshop, Dine produced seven woodcuts (152–158). All were printed by hand rubbing with a door knob by the artist, his teenage son Nicholas, or his young cousin, Jeffrey Berman.

152. The Black and White Nancy Woodcut (First Version) 1983

Woodcut from one plywood block
Printed in black
Paper: 48 × 36½ (121.9 × 92.8) Masa
Edition: 27, plus 4 AP (2 AP in etching ink)
Printed by Jeffrey Berman, Aspen; published by Pace (193-151)
Signed in white pencil

Four of the Aspen woodcuts are of Nancy Dine (152–155). They are based on two mylar drawings that were transferred to screens with the intention of producing screenprint editions. This idea was abandoned, although proofs of these efforts were used as the basis for monoprints, and the portraits were screened onto two blocks that Dine cut just before coming to Aspen. There, the blocks were printed for the two versions of *The Black and White Nancy Woodcut* (152, 153) and then for two hand painted editions (154, 155).

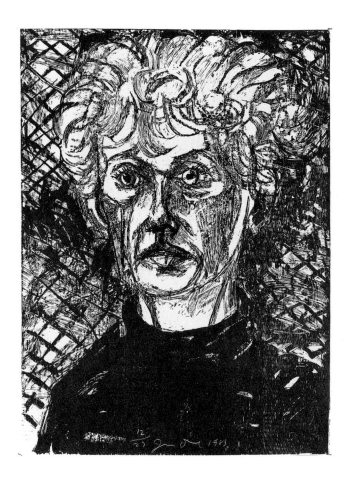

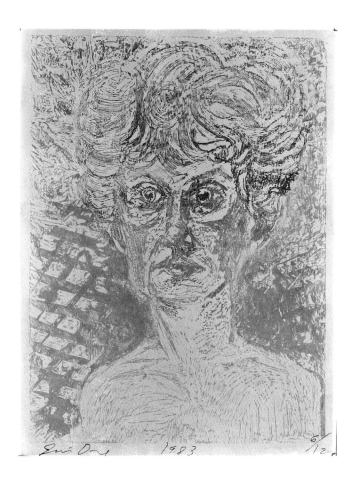

153. The Black and White Nancy Woodcut (Second Version) 1983

Woodcut from one plywood block
Printed in black
Paper: 48 × 36½ (121.9 × 92.8) Masa
Edition: 27, plus 4 AP, 2 PP
Printed by Nicholas Dine, Aspen; published by Pace (193-152)

154. The Hand Painted Nancy (Woodcut) 1983

Woodcut from one 47⅞ × 36⅛ (121.7 × 91.8) plywood block
Printed several times in rose, red, dark blue, light blue, and black oil with hand painting in oil after editioning
Paper: 51⅛ × 39¼ (129.9 × 99.7) Masa painted with flesh latex before printing
Edition: 12, plus 3 AP, 1 PP
Printed by Jeffrey Berman, Aspen; published by Pace (193-157)
Signed in brush with black oil

For No. 154, the first version block (152) was painted with many colors by Dine and printed *a la poupée.* This procedure was repeated several times, followed by hand coloring, until Nancy's face, hair, upper torso and the background were well defined. (Dine began the same sequence with the second version block but was disappointed with the results. Proofs were utilized for mixed media drawings.) Dine began the *Double Feature (Woodcut)* (155) with the intention of placing a colored version of each block side by side. On a sheet painted with black India ink, he printed both blocks in white. Displeased with the variant images juxtaposed, Dine reprinted in white the first-version block on both sides and then continued with *a la poupée* printings and hand coloring. These are Dine's first *Nancy* prints since the completion of *Nancy Outside in July* in 1981.

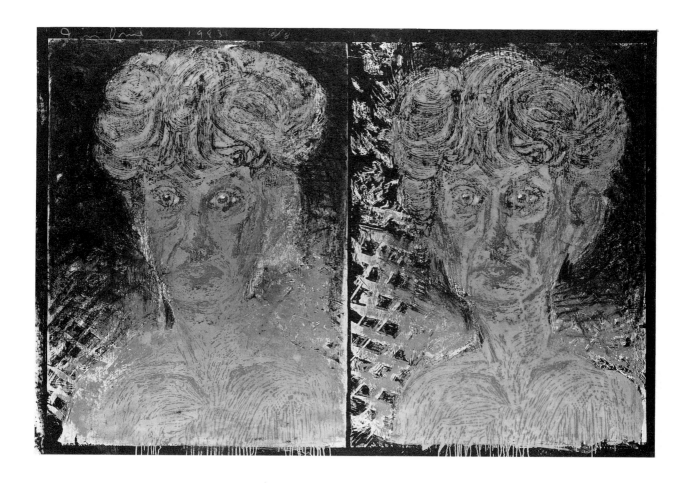

155. A Double Feature (Woodcut) 1983

Woodcut from two plywood blocks
Printed twice in white and several times in rose, red, light blue,
dark blue, and black with hand painting in white oil and charcoal
after editioning
Paper: 51⅛ × 76 (129.8 × 193) Masa painted with black India
ink before printing
Edition: 8
Printed by Jim Dine, Jeffrey Berman and Nicholas Dine, Aspen;
published by Pace (193-158)
Signed in brush with white paint

156. Cooper Street Robe 1983

Woodcut from one plywood block
Printed twice in black with hand painting in blue acrylic and red enamel spray between printings
Paper: 35¼ × 24¼ (89.5 × 61.6) Rives BFK painted in orange watercolor before printings
Edition: 13, plus 3 AP, 2 PP
Printed by Nicholas Dine, Aspen; published by Pace (193-155)

The *Cooper Street Robe* (156) follows the by now familiar Dine procedure of preparing the paper, printing once, hand coloring, and then, in effect, sealing the colored image by a final black printing.

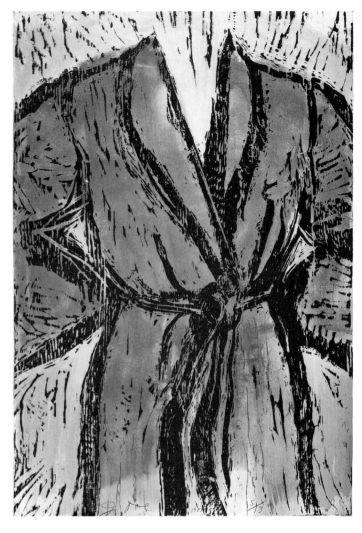

157. The First Woodcut Gate (The Landscape) 1983

Woodcut from one plywood block
Printed twice in black with hand painting in blue, green, and yellow acrylic between printings
Paper: 35¾ × 44¾ (90.8 × 113.7) Lenox 100
Edition: 49, plus 7 AP
Printed by Nicholas Dine, Aspen; published by Pace (193-156)
Signed diagonally in image

The plywood block is in the collection of the Museum of Fine Arts, Boston.

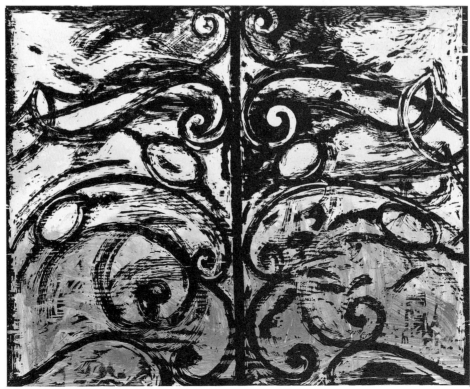

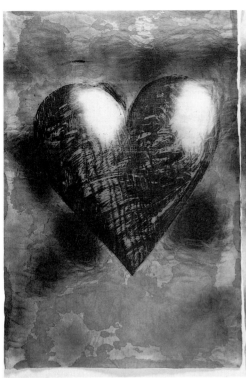
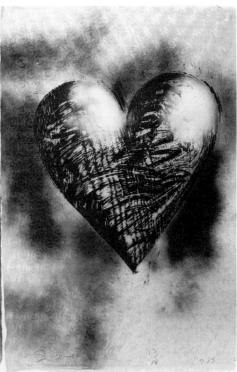

158. Two Very Strange Hearts 1983

Diptych woodcut from one 19⅛ × 19¾ (48.6 × 50.2) plywood block
Each sheet printed once in blue and once in black with hand painting in black, red, and white spray and blue acrylic after editioning
Paper: two sheets; left: 35¼ × 24 (89.5 × 61) tan Japanese stained with pomegranate juice; right: 36⅜ × 24 (92.4 × 61) pink Oriental
Edition: 18, plus 3 AP, 2 PP, 1 BAT
Printed by Jeffrey Berman, Aspen; published by Pace (193-159)

The dissimilarity in the paper types used for the diptych, *Two Very Strange Hearts* (158), is visually prominent. Both sheets were printed in blue from the first state of one block and then each in black from its second state. As is customary with Dine's recent work, the edition was pinned to the wall for the final hand painting.

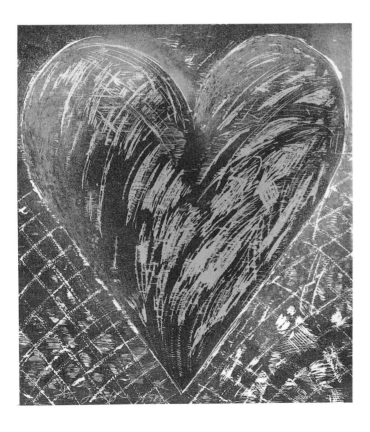

159. A Woodcut in the Snow 1983

Woodcut from one plywood block; lithograph from one aluminum plate
Printed once in blue-black and once in white
Paper: two sheets of 35½ × 32¼ (90.2 × 82) Okawara chine collé; lower sheet dipped in red Rustoleum before printing
Edition: 22, plus 2 AP, 1 PP, 1 TP, 1 BAT, 1 Angeles Press impression
Woodcut printed by R. E. Townsend, Inc., Georgetown, Massachusetts, lithograph printed by Toby Michel, Angeles Press; published by Pace (193-161)

Dine began *A Woodcut in the Snow* (159) by having a sheet of paper prepared with red paint. Over this he glued a second white sheet with a heart shape cut out of its center and had the woodblock (cut from the right side of *Two Hearts in the Forest*, 86) printed in blue-black. The impressions were sent to Los Angeles where Dine's lithographic plate was overprinted in white. This softens the upper contours of the heart and suggests a dusting of snow over the image.

141

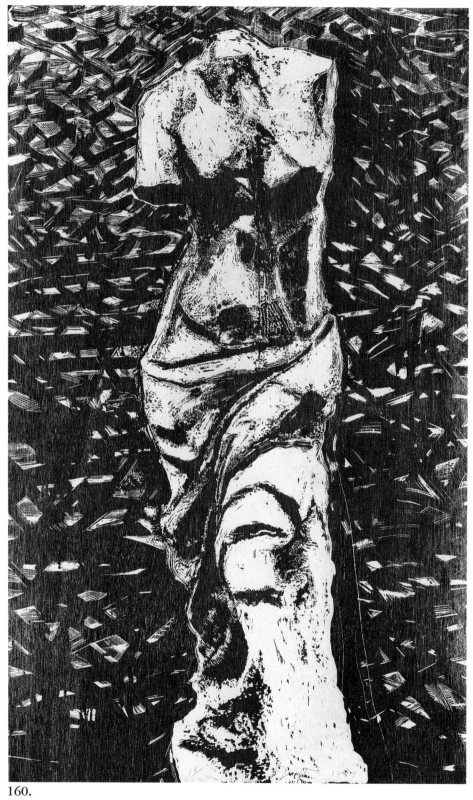

160.

142

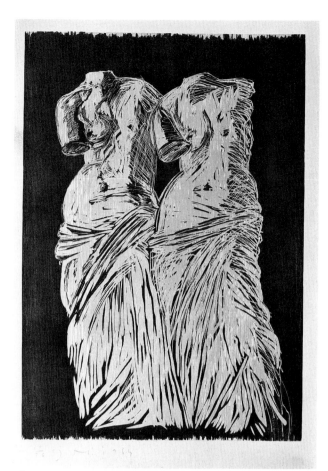

160. Black Venus in the Wood 1983

Woodcut from one mahogany plywood block
Printed in black
Paper: 60 × 37 (152.4 × 94) Okawara
Edition: 20, plus 2 AP, 1 PP, 1 TP, 1 BAT, 1
Angeles Press impression
Printed by Toby Michel, Angeles Press
(83-130); published by Pace (193-160)

The woodblock used for *Black Venus in the Wood* (160) was jigsawed into two pieces and used again for *The Yellow Venus* (163); see *Nine Views of Winter* for later use of the block (197–205). Transfers taken from the block before it was jigsawed are used for the lithographs Nos. 164 and 165. *Black Venus in the Wood* is Dine's first use of the Venus subject in printmaking and is based on the Venus de Milo. For further explanation of these and later *Venus* prints, see Jean E. Feinberg's essay in the present catalogue.

161.

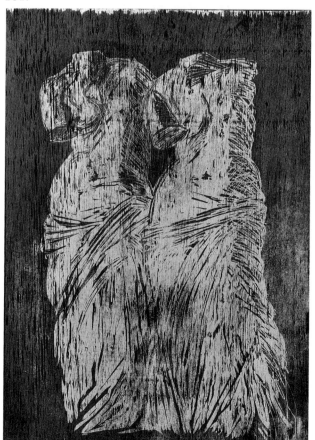

161. Double Venus Woodcut I 1984

Woodcut from two 39 × 27¾ (99 × 70.5) plywood blocks
Printed once in gray (surface roll) and once in black
Paper: 47⅞ × 31½ (121.6 × 80) Rives BFK
Edition: 36, plus 10 AP
Printed by Jack Shirreff, 107 Workshop, Wiltshire; published by Pace (193-168)

See entry for No. 166.

162. Double Venus Woodcut II 1984

Woodcut from two 38⅛ × 27¾ (96.2 × 70.5) plywood blocks
Printed once in white (surface roll) and once in black
Paper: 46⅞ × 33⅞ (119.1 × 86.1) Canson black
Edition: 36, plus 12 AP
Printed by Jack Shirreff, 107 Workshop, Wiltshire; published by Pace (193-169)

162.

163. The Yellow Venus 1984

Woodcut from one sawn mahogany plywood block and one sawn pine plywood block
Printed once in blue and yellow (surface roll), once in orange, and once in black
Paper: 60 × 37 (152.4 × 94) Okawara
Edition: 20, plus 6 AP, 3 TP, 4 color TP, 1 BAT, 1 Angeles Press impression
Printed by Toby Michel, Angeles Press (83-134); published by Pace (193-163)

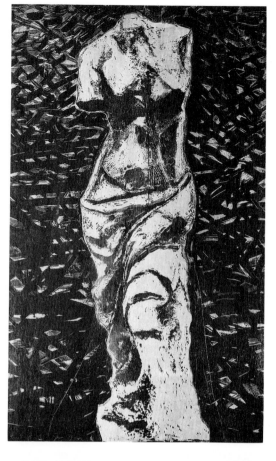

164. The Sky 1984

Lithograph from four aluminum plates; woodcut from one plywood block
Printed once in transparent black, once in dark blue, once in light blue, and twice in black
Paper: 54 × 35 (137.2 × 88.9) Arches buff
Edition: 25, plus 5 AP, 1 PP, 6 TP, 4 color TP, 1 BAT, 1 Angeles Press impression
Printed by Toby Michel, Angeles Press (83-135); published by Pace (193-164)

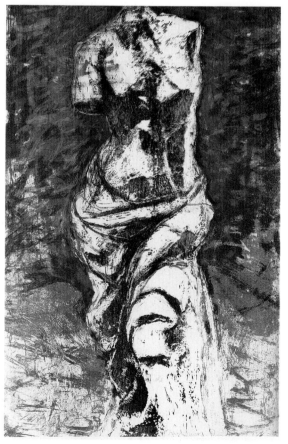

144

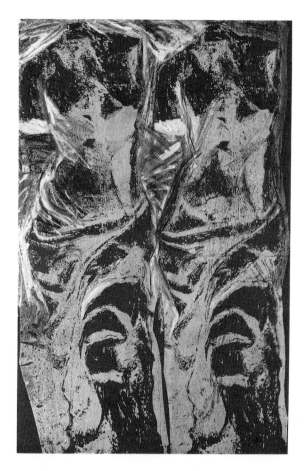

165. Handmade Double Venus 1984

Lithograph from two aluminum plates
Printed once in black (surface roll) and once in white with hand painting in white oil stick and black rubbing stick after editioning
Paper: 54 × 35 (137.2 × 88.9) Arches Cover buff
Edition: 15, plus 2 AP, 1 BAT, 1 unique impression for monotype, 1 Angeles Press impression
Printed by Toby Michel, Angeles Press (83-132); published by Pace (193-162)

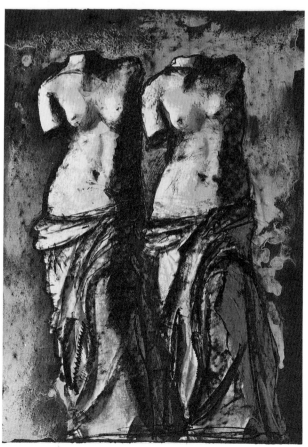

166. Double Venus in the Sky at Night 1984

Screenprint from eight screens; lithograph from two 39⅛ × 28¼ (99.4 × 71.7) aluminum plates
Printed in eight tones of black, gray, and brown, once in blue-green, and once in black
Paper: 41¼ × 30⅜ (104.8 × 77.2) William Morris Nonesuch buff
Edition: 50, plus 6 AP, 1 PP, 2 TP, 1 color TP, 1 BAT, 1 unique transfer
Screenprint printed by Christopher Betambeau, Advanced Graphics, London; lithograph printed by Toby Michel, Angeles Press (83-131); published by Pace (193-165)

Dine had a group of screenprints made from his mixed media collage of two postcards of the Venus de Milo (Fig. 13). Fifty of these screenprints were over-printed with two aluminum plates, producing the screenprint-lithograph, *Double Venus in the Sky at Night* (166). Dine had one of the screenprints traced to a plywood block which he cut with an electric gouge. The block was used for the *Double Venus Woodcut I* and *II* (161, 162) and for Appendix J and K.

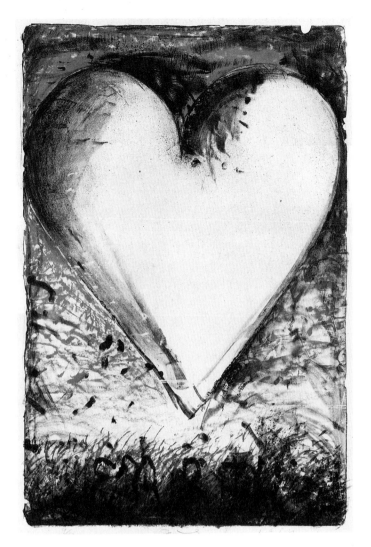 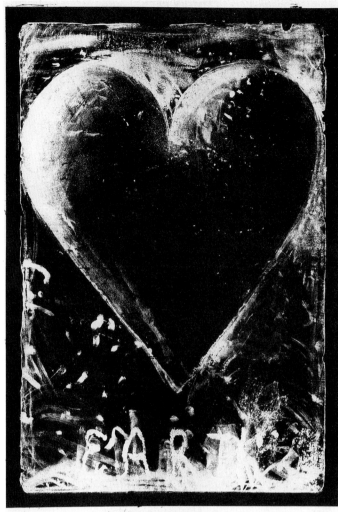

167. The Earth 1984

Lithograph from five 44¼ × 29¾ (112.4 × 75.6) aluminum
plates
Printed once in brown, once in blue, once in green, once in
yellow, and once in black
Paper: 46¼ × 32 (118.1 × 81.3) Arches buff
Edition: 50, plus 6 AP, 1 PP, 6 TP, 1 BAT, 2 Angeles Press
impressions
Printed by Toby Michel, Angeles Press (83-133); published by
Pace (193-166)

As *The Earth* (167) demonstrates, Dine prefers to work up
his lithographic image on stone rather than on an aluminum
plate. By using a stone for the key drawing, Dine was able
to exploit its texture and irregular edges as well as to work
into its surface with an electric grinder. The stone's design
was transferred onto a plate after further additions in
crayon and the inscription, "Earth," along the lower edge.
The plate was then inked in black and dropped over the
color impressions for the final run. It was printed in the
acrylic reversal process for *The Black Heart* (168) and
reused for *A Gray Version of the Heart* (Appendix L).

168. The Black Heart 1984

Lithograph from one 47¼ × 32⅝ (120 × 82.9) aluminum plate
Printed in black
Paper: 50⅝ × 35¼ (128.3 × 89.5) Arches buff
Edition: 20, plus 3 AP, 1 PP, 3 TP, 2 color TP, 1 BAT, 2
Angeles Press impressions
Printed by Toby Michel, Angeles Press (83-141); published by
Pace (193-178)

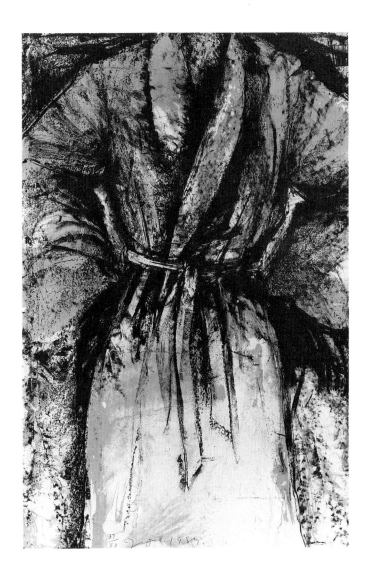

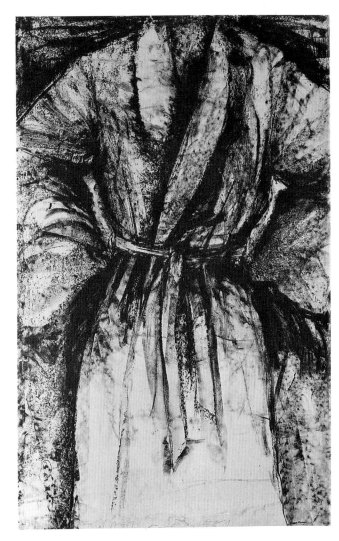

169. A Robe in Los Angeles 1984

Lithograph from three aluminum plates
Printed once in pink, once in orange, and once in black
Paper: 54 × 35 (137.2 × 88.9) Arches buff
Edition: 50, plus 6 AP, 1 PP, 10 proofs for monoprinting, 1
BAT, 2 Angeles Press impressions
Printed by Toby Michel, Angeles Press (83-137); published by
Pace (193-167)

The black plate was reused in *A Gray Version of the Robe*
(170). By first printing No. 170 with a gray surface roll,
Dine incorporated into the image the color of its aluminum
plate.

170. A Gray Version of the Robe 1984

Lithograph from two aluminum plates
Printed once in gray (surface roll) and once in black
Paper: 54 × 35 (137.2 × 88.9) Rives
Edition: 12, plus 5 AP, 3 TP, 1 BAT, 1 Angeles Press impression
Printed by Toby Michel, Angeles Press (83-137A); published by
Pace (193-175)

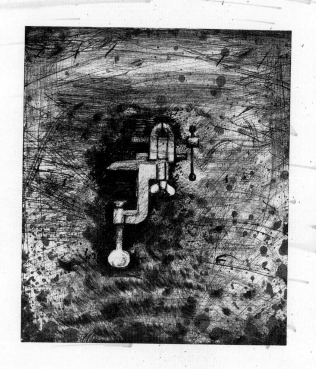

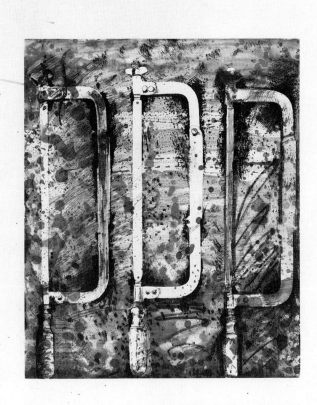

Dine's *New French Tools* (171–175), made in Paris in 1983–84, signal his return to subject matter which he used frequently in the 1960s and 1970s. The Crommelynck suite was produced from plates of varying dimensions and printed on sheets of different sizes and textures. Although all the plates for *New French Tools* were worked with etching and spit-bite aquatint, the images were created primarily with power tools, including a drill and rotary sander. Dine painted the image area of *New French Tools 5 —Boulevard Victor* (175) in blue acrylic to form a skin on the paper before printing. The subtitles of the set relate to personal reminiscences of the artist or to streets and a café (Roussillon) near the Atelier Crommelynck in Paris. "Pep" is the nickname of the wife of Aldo Crommelynck. Dine reworked the plates of *3* and *4* (173, 174) for *Tools and Dreams* (191).

171. The New French Tools 1—Wise 1984

Etching, aquatint, and electric tools from one 18¼ × 16 (46.4 × 40.7) copper plate
Printed in black
Paper: 30⅛ × 22½ (76.5 × 57.2) Japon nacré
Edition: 50, plus 10 AP
Proofed by Aldo Crommelynck, printed at Atelier Crommelynck; published by Pace (193-170)

172. The New French Tools 2—Three Saws from the Rue Cler 1984

Etching, aquatint, and electric tools from one 23⅜ × 19½ (59.4 × 49.6) copper plate
Printed in black
Paper: 35⅞ × 24⅞ (91.6 × 63.2) Arches velin
Edition: 50, plus 15 AP
Proofed by Aldo Crommelynck, printed at Atelier Crommelynck; published by Pace (193-171)

173. The New French Tools 3—For Pep 1984

Etching, aquatint, and electric tools from one 23¾ × 19⅝ (60.4 × 49.9) copper plate
Printed in black
Paper: 42⅜ × 30⅛ (107.6 × 76.5) Rives BFK buff
Edition: 50, plus 15 AP
Proofed by Aldo Crommelynck, printed at Atelier Crommelynck; published by Pace (193-172)

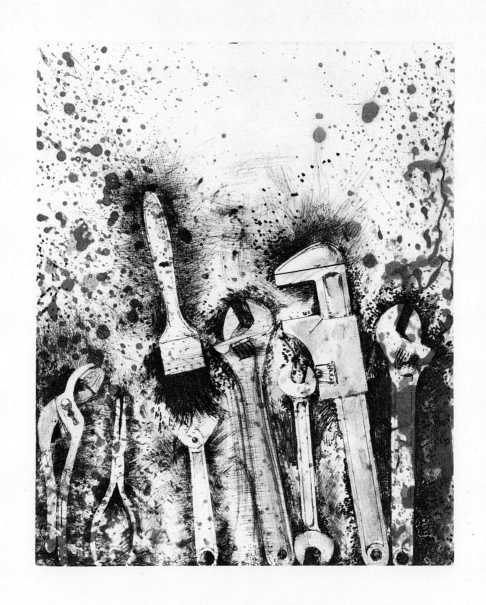

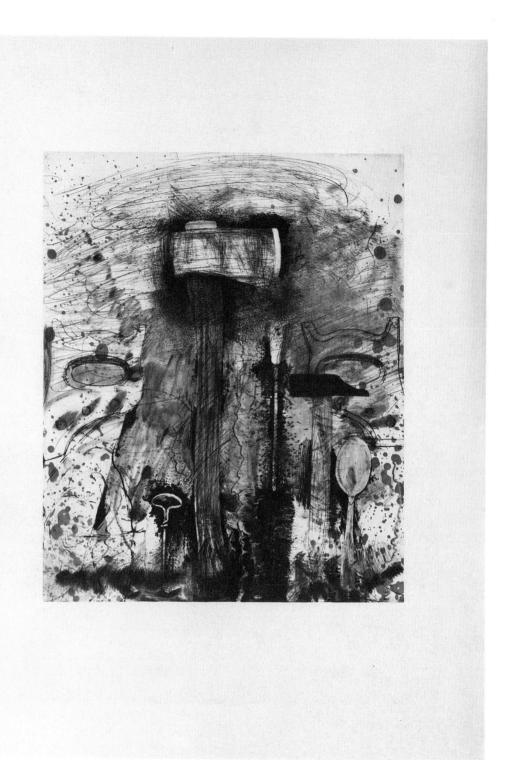

174.

174. The New French Tools 4—Roussillon 1984

Etching, aquatint, and electric tools from one 23¼ × 19⅝ (59.1 × 49.9) copper plate
Printed in black
Paper: 42⅜ × 29¾ (107.6 × 75.6) Rives BFK
Edition: 50, plus 15 AP
Proofed by Aldo Crommelynck, printed at Atelier Crommelynck; published by Pace (193-173)

175. The New French Tools 5—Boulevard Victor, Double Sky 1984

Etching, aquatint, and electric tools from two 23½ × 19 (59.7 × 48.3) copper plates
Printed twice in black, plates set ⅛″ apart, with hand painting in blue acrylic before printing
Paper: 31¾ × 45⅝ (80.7 × 115.9) Rives BFK
Edition: 50, plus 10 AP
Proofed by Aldo Crommelynck, printed at Atelier Crommelynck; published by Pace (193-174)

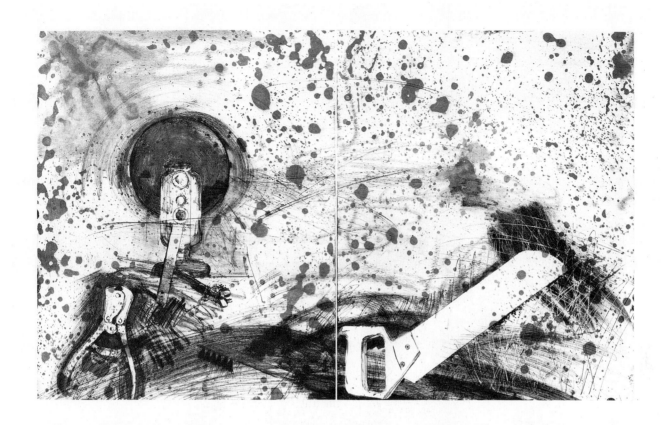

175.

176.

176. The Jerusalem Plant #8 1984

Lithograph from one 35¾ × 25¾ (90.7 × 65.4) stone and two aluminum plates; drypoint and electric tools from one copper plate; gravure from one 35½ × 25½ (90.2 × 64.7) copper plate
Printed once in green, once in blue, once in graphite gray, and twice in black
Paper: two joined sheets, overall 39½ × 30½ (103 × 77.4) Canadian handmade
Edition: 26, plus 5 AP, 5 PP
Lithograph printed by Thomas Cox, intaglio printed by John Lund and Craig Zammiello, ULAE; published by ULAE

Dine's eighth and last print in the *Jerusalem Plant* series (131–136, 148) reuses the stone from *#5* (135), reworked in a second state, and adds a new lithographic plate as well as two intaglio plates. A collar was placed around the drypoint and electric tools plate to make it the same size as the gravure plate for the printing process. The gravure was derived from a drawing of the plant made on mylar which Dine traced from the original key image on the stone (131).

a. (Frontispiece) Details from Nancy's Garden

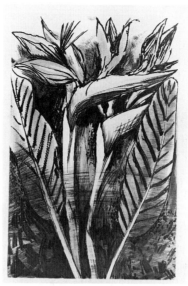

b. I Bird-of-Paradise

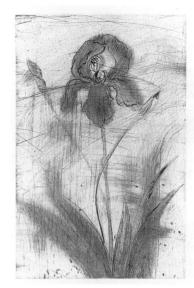

c. II Iris

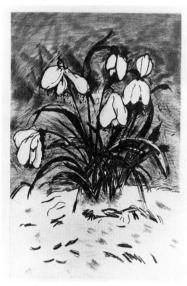

g. VI Snowdrop

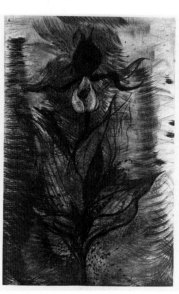

h. VII Lady's Slipper

i. VIII Persian Cyclamen

177. The Temple of Flora 1984

29 prints: drypoint, engraving, and electric tools from
twenty-eight 12 × 18 (30.5 × 45.7) copper plates, 28 bound in
a book of 136 pages (binding of dark-green goat-skin with
olive-gray cloth over boards in olive-gray cloth box with bronze
relief on lid), plus one loose print on chine collé
Printed in black
Paper: 14 × 20½ (35.6 × 51.4) Rives BFK
Edition: 150, plus 25 hors de commerce, 1 PP unbound
Proofed by Aldo Crommelynck, printed by R. E. Townsend, Inc.,
Georgetown, MA; published by The Arion Press, San Francisco,
Andrew Hoyem, Director
Signed on introductory page and on loose sheet

The twenty-eight plates used to produce the illustrations for
the 1984 *Temple of Flora* were worked with Dine's complete
inventory of hand and power tools (sandpaper, needles,
nails, a wire brush on an electric drill, a rotary sander, the
electric German vibrating needle, and the Dremel with its
assortment of bits), without a drop of acid. The Arion Press
publication is based in scale and format on the 1807
illustrated botanical treatise of the same name by Dr.
Robert John Thornton. Twenty-four of Dine's floral
compositions come directly from Thornton's. Three others
are based on illustrations in a 1983 exhibition catalogue,
*The Discovery of Nature: Botanical Drawings from Europe and
Asia 1650–1850,* Eyre and Hobhouse, London. A
twenty-eighth plate, used for the frontispiece and in its
second state for a loose print, is entitled *Details from Nancy's
Garden.* This volume, in addition to Dine's
'drypoint-engravings,' includes an introductory explanation
by the authors, a statement by the artist, and botanical text
by Glen Todd and Nancy Dine, who also selected the
contemporary poetry that faces each print.

d. III Chinese Limodorum

e. IV Tulip

f. V Pontic Rhododendron

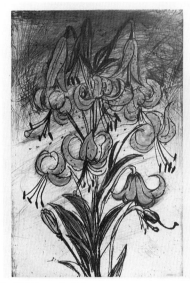

j. IX Superb Lily

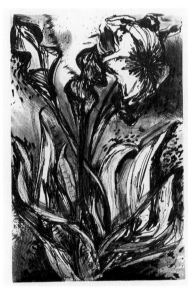

k. X Yellow Pitcher Plant

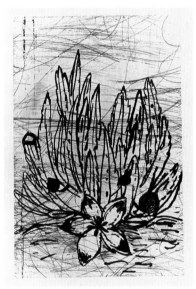

l. XI Carrion Flower

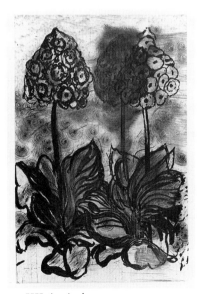

m. XII Auricula

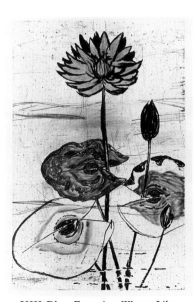

n. XIII Blue Egyptian Water Lily

153

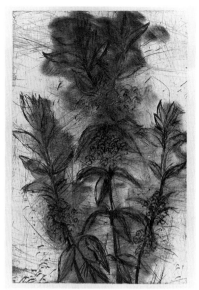

o. XIV Narrow-Leaved Kalmia

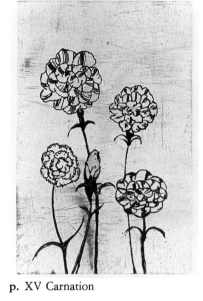

p. XV Carnation

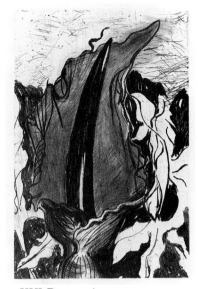

q. XVI Dragon Arum

u. XX Hyacinth

v. XXI Rose

w. XXII Winged Passionflower

aa. XXVI Shell Ginger

bb. XXVII Sacred Lotus of the East

r. XVII Shooting-Star

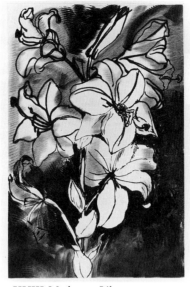

s. XVIII Madonna Lily

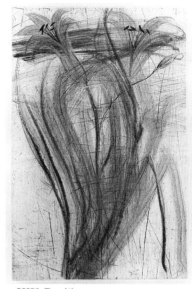

t. XIX Daylily

x. XXIII Blue Passionflower

y. XXIV Quadrangular Passionflower

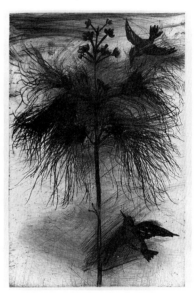

z. XXV Powder-Puff Tree

cc. Details from Nancy's Garden, State II

178. The Philadelphia Heart 1984

Soft-ground etching, drypoint, aquatint, and electric tools from
three 11¾ × 10⅞ (30.1 × 27.6) copper plates
Printed once in red-orange, once in turquoise, and once in black
Paper: 26 × 19¾ (66 × 50.2) Rives BFK
Edition: 50, plus 7 AP
Proofed by Aldo Crommelynck, printed at Atelier Crommelynck;
published by the Philadelphia Museum of Art

Dine donated the entire edition (178) to the Friends of the
Philadelphia Museum for benefit sale. An offset lithographic
poster, with a reproduction of the print inscribed "for the
Friends of the Philadelphia Museum of Art," was produced
at the same time.

179. Self-Portrait in a Convex Mirror 1984

Woodcut from one plywood block
Printed in black
Paper: 18 (45.7) diameter Twinrocker
Edition: 150, plus 25 hors de commerce
Printed and published by The Arion Press, San Francisco, Andrew
Hoyem, Director

The print is included in John Ashbery's *Self-Portrait in a
Convex Mirror,* published by The Arion Press. The book is
an unbound *livre deluxe* in a circular, stainless steel
container with a convex mirror mounted on the cover. The
text is accompanied by a recorded reading by the poet and
an essay by Helen Vendler. It is illustrated with works by
Richard Avedon, Elaine de Kooning, Willem de Kooning,
Jim Dine, Jane Freilicher, Alex Katz, R. B. Kitaj, and Larry
Rivers.

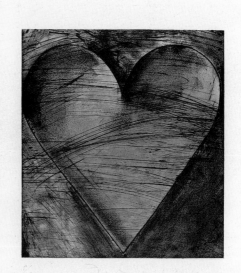

178.

180. Hiroshima Clock, First Version 1984

Soft-ground etching and electric tools from one 10½ × 8¼ (26.6
× 20.7) copper plate
Printed in white with hand painting in gray acrylic before printing
Paper: 15 × 11¼ (38.1 × 28.5) Rives BFK
Edition: 40, plus 2 AP
Proofed by Aldo Crommelynck, printed at Atelier Crommelynck

The first version of *Hiroshima Clock* (180 and see 181) was
published in association with Richard Hamilton in the
Greenham Common Portfolio. The project was a benefit
for the "Ladies of Greenham Common," a British group
demonstrating against nuclear weapons. Dine's image
represents a clock stopped at the moment of the destruction
of Hiroshima. The lettering was worked with the Dremel.

181. Hiroshima Clock, Second Version 1984

Soft-ground etching and electric tools from one 10½ × 8¼ (26.6
× 20.7) copper plate
Printed in white
Paper: 18⅝ × 15 (47.2 × 38.1) Arches black
Edition: 4
Proofed by Aldo Crommelynck, printed at Atelier Crommelynck

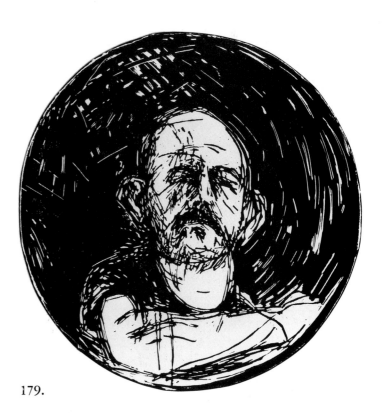

179.

156

180.

181.

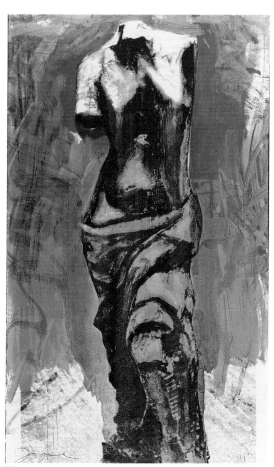

182.

182. The Red, White, and Blue Venus for Mondale
1984

Screenprint from twelve screens
Printed in twelve colors
Paper: 18 × 30 (45.7 × 76.2) Rives BFK
Edition: 150, plus 5 AP, 5 PP, 3 hors de commerce
Printed by Steven Maiorano, Screened Images, Port Washington

Dine donated this edition (182) for benefit sale to the presidential campaign of Walter Mondale. The entire edition is stamped on the reverse with its title and "silk screen print from a monotype: edition 150."

Included in Dine's work at the Atelier Crommelynck in October 1984, were three prints (183–185) related in their printing processes to *Louisiana Hearts* (119). The artist had multicolor offset lithographs made in London reproducing two of his recent paintings: one representing paired hearts (183) and the other a robe (184–185). These impressions were sent to Paris where Dine pinned them on a wall and painted them in acrylic colors related to those in the lithographic reproductions. Intaglio plates were dropped on both lithographs. The robe intaglio plate was printed high on the sheets so that the upper edge lacks a plate mark. Its vertical dimensions given here, therefore, differ slightly.

183. Two Hearts for the Moment 1985

Offset lithograph from four 17¼ × 34¼ (43.8 × 87) aluminum plates; soft-ground etching and electric tools from one 16⅞ × 34 (42.8 × 86.3) copper plate

Printed four times in four colors and once in black with hand painting in yellow, orange, green, blue, and red acrylic before black printing

Paper: 28¼ × 40⅛ (71.7 × 110.8) Rives BFK

Edition: 36, plus 6 AP

Lithograph printed at Hillingdon Press, Uxbridge; intaglio proofed by Aldo Crommelynck, printed at Atelier Crommelynck; published by Pace

184. The Robe in France 1985

Offset lithograph from four 30½ × 22½ (77.9 × 57.2) aluminum plates; soft-ground etching and electric tools from one 33 × 22⅝ (83.8 × 57.4) copper plate
Printed four times in four colors and once in black with hand painting in blue, green, red, and purple acrylic before black printing
Paper: 38½ × 28¼ (97.8 × 71.8) Rives BFK
Edition: 35, plus 7 AP
Lithograph printed at Hillingdon Press, Uxbridge; intaglio proofed by Aldo Crommelynck, printed at Atelier Crommelynck; published by Pace (193-197)

185. Red Robe in France 1985

Offset lithograph from four 30½ × 22½ (77.9 × 57.2) aluminum plates; soft-ground etching and electric tools from one 33½ × 22⅝ (85.1 × 57.4) copper plate
Printed four times in four colors and once in red with hand painting in black acrylic wash before red printing
Paper: 38½ × 28¼ (97.8 × 71.8) Rives BFK
Edition: 16, plus 6 AP
Lithograph printed at Hillingdon Press, Uxbridge; intaglio proofed by Aldo Crommelynck, printed at Atelier Crommelynck; published by Pace

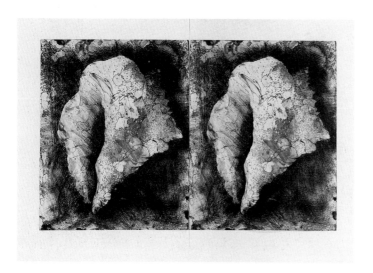

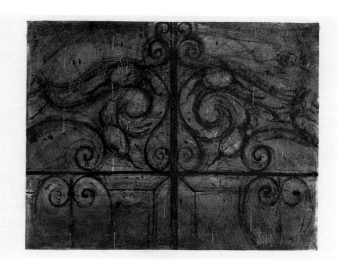

186. Lost Shells 1985

Diptych etching, soft-ground etching, drypoint, and electric tools from one 22⅝ × 18 (57.5 × 45.8) copper plate
Each sheet printed in black with hand painting in flesh, pink, and light-green acrylic before printing
Paper: two sheets of 30 × 21¼ (76.2 × 54) Rives BFK
Edition: 32, plus 9 AP
Proofed by Aldo Crommelynck, printed at Atelier Crommelynck; published by Pace (193-180)

In July 1984, while in London, Dine started work on the single plate for *Lost Shells* (186). With the Dremel he cut the basic shape of the large shell using a Magic Marker drawing as a guide. In October, Dine took the plate to Paris where it was etched with the open-bite technique—a small amount of stop-out was dabbed and smeared by Dine with his fingers. Soft ground was added to strengthen the drawing and grinding wheels and sandpaper were used to dramatize the background. The two parts of this diptych differ only in the hand coloring, for the single plate is identically printed on both abutted sheets.

187. Wallpaper in Paris 1985

Soft-ground etching, drypoint, aquatint, and electric tools from one 25⅞ × 33⅞ (65.7 × 86.1) copper plate
Printed in black
Paper: 34 × 44 (86.3 × 111.8) Dieu Donné painted with blue acrylic and rolled in yellow with floral-patterned roller before printing
Edition: 30, plus 6 AP
Proofed by Aldo Crommelynck, printed at Atelier Crommelynck; published by Pace (193-196)

The Dieu Donné paper for *Wallpaper in Paris* (187) was initially painted with blue acrylic. A yellow leaf pattern was then applied with a roller which Dine had found in a Parisian paint shop. Over this was printed a copper plate of the Crommelynck gate. The iron work of the gate was first drawn in soft ground as thin arabesques. These lines were given more weight with added drypoint and the Dremel. Aldo Crommelynck filled in the negative space with a soft ground through which Dine dragged a brush to produce an atmosphere of soft, wispy lines. *Wallpaper in Paris* was completed with small areas of sugar lift, providing parts of the iron work with increased blackness. Four stage proofs, illustrating the changes to the plate as well as Dine's experiments with hand coloring, are in the Davison Art Center Collection.

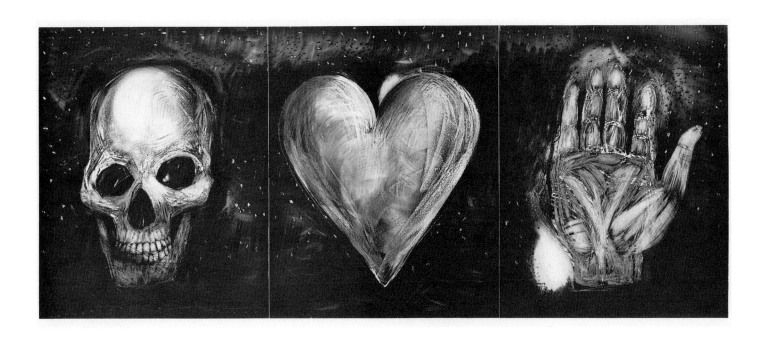

188. The Channel, My Heart, A Hand 1985

Drypoint, aquatint, and electric tools from three 19¼ × 15½ (49 × 39.4) copper plates
Printed in black
Paper: 26⅛ × 47¼ (66.4 × 120) Rives BFK
Edition: 15, plus 8 AP
Proofed by Aldo Crommelynck, printed at Atelier Crommelynck; published by Pace

The three plates for the skull, heart, and hand (188) went through five or six states in which the designs, drawn with grease crayon on an aquatint field, were burnished down for cloudy effects and the drawing sharpened and corrected by hand and electric tools. Dine added lift-ground aquatint around the images for the deep blacks. He based his skull and hand images on illustrations in a facsimile edition of *Gray's Anatomy,* a nineteenth-century medical treatise.

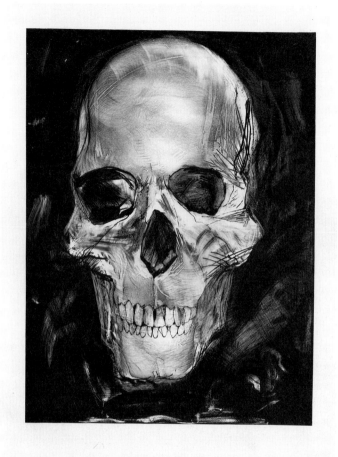

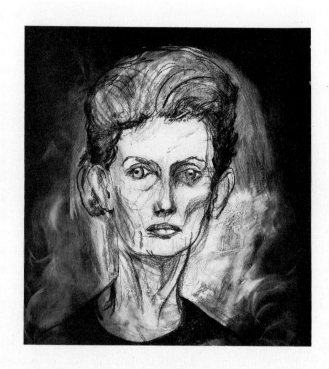

189. The Channel 1985

Drypoint, aquatint, and electric tools from one 33⅝ × 25⅞ (85.4 × 65.7) copper plate
Printed in black
Paper: 41¾ × 30¾ (160 × 78.1) Hahnemühle
Edition: 15, plus 8 AP
Proofed by Aldo Crommelynck, printed at Atelier Crommelynck; published by Pace

Hahnemühle paper is an especially sensitive surface for the grease-crayon resist treatment of aquatint. Dine reworked the plate of *The Channel* (189), intending to produce another print resembling an X-ray image of the skull. Instead he burnished the center of the plate, cut it down, and produced the portrait of his wife for *12 Rue Jacob* (190). Traces of the skull remain below Nancy Dine's portrait. It is titled after the Dines' Paris address.

190. 12 Rue Jacob 1985

Drypoint, aquatint and electric tools from one 27⅝ × 25⅞ (70.2 × 65.7) copper plate
Printed in black
Paper: 42⅛ × 31 (170 × 78.7) Hahnemühle
Edition: 20, plus 5 AP
Proofed by Aldo Crommelynck, printed at Atelier Crommelynck; published by Pace

Nancy Dine's portrait is a second state of *The Channel* (189).

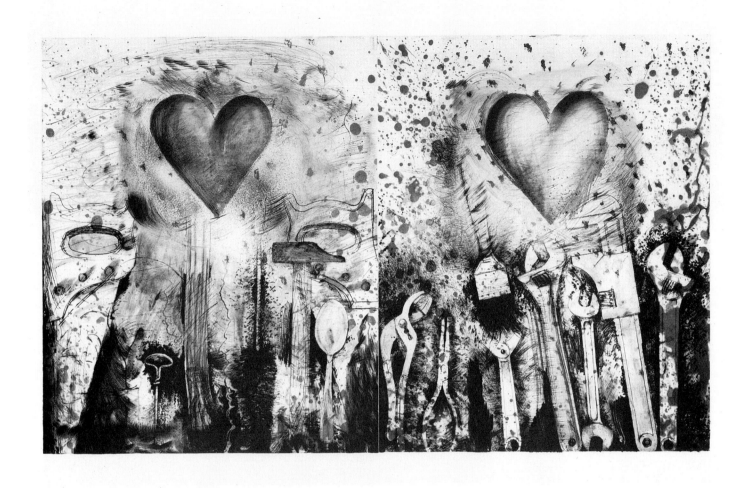

191. Tools and Dreams 1985

Drypoint, aquatint, and electric tools from two 23⅜ × 19⅜ (59.1 × 49.2) copper plates
Printed in black
Paper: 30¼ × 44 (76.9 × 111.7) Rives BFK
Edition: 50, plus 10 AP
Proofed by Aldo Crommelynck, printed at Atelier Crommelynck; published by Pace (193-179)

The plates (191), printed side by side in one run through the press, were reused from the *New French Tools* suite: on the left is the plate from *4* and on the right is the plate from *3* (174, 173). They were burnished down and reworked with aquatint and power tools to incorporate hearts above the row of tools as well as added areas of tone. In abutting the plates, Dine intended the image to be seen as a single landscape.

Three of the four *Venus* prints editioned in 1985 at the Atelier Crommelynck (192-195) are from the same copper plate, a deeply bitten soft-ground drawing that was accented with electric tool work. For No. 192, Dine experimented with paper types, hand coloring the majority of the edition with pink flesh tones and a turquoise background. No. 194 is distinguished by a rainbow of watercolor and for No. 193 Dine used rubber stamps to add a line of Sappho's poetry, "Love shakes my heart again, an inescapable bitter-sweet thing." The fourth print in this group, the *Black and White Cubist Venus* (195), began as a Magic Marker drawing on a plate that was covered with rosin particles. Dine painted the plate with acid. The marker acted as a resist and the plate, when first proofed, printed up as a white, ropey line amidst a dark aquatint field. Dine, with a rotary sander, obliterated most of the original drawing, bringing large areas back to soft gray or white.

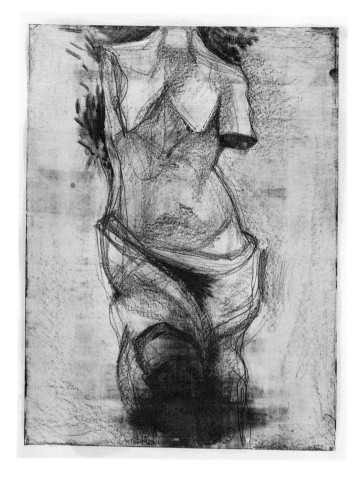

192. Venus at Sea 1985

Soft-ground etching and electric tools from one 34 × 26 (86.3 × 66.1) copper plate
Printed in black with hand painting in turquoise and flesh acrylic before printing on Dieu Donné paper
Paper: 35¾ × 27⅞ (95.9 × 70.7) Dieu Donné
Edition: 30, plus 9 AP; two variant editions without hand painting: I–VIII, plus 3 AP on 33½ × 24½ (85.1 × 62.2) Chiri, and IX–XVI, plus 4 AP on 45 × 30⅛ (114.3 × 76) Rives beige
Proofed by Aldo Crommelynck, printed at Atelier Crommelynck; published by Pace (193-190; 193-191; 193-192)

193. Night Venus and Sappho 1985

Soft-ground etching and electric tools from one 34 × 26 (86.3 × 66.1) copper plate and rubber stamps
Printed once and hand stamped in white with hand painting in gesso and white grease crayon after editioning
Paper: 38⅞ × 30 (98.7 × 76.2) Arches black
Edition: 15, plus 6 AP
Proofed by Aldo Crommelynck, printed at Atelier Crommelynck; published by Pace (193-194)

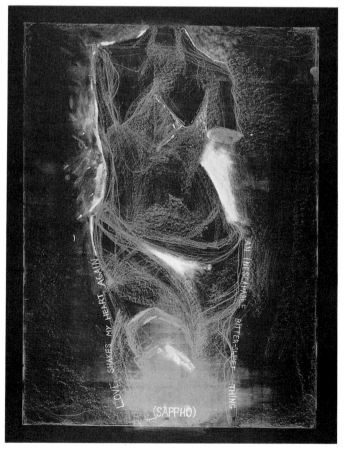

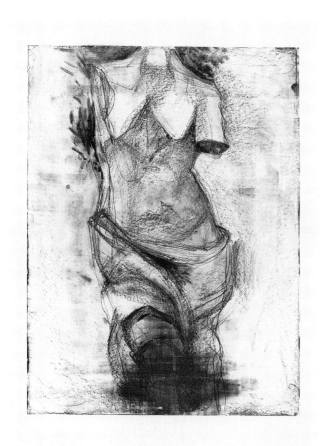

194. The French Watercolor Venus 1985

Soft-ground etching and electric tools from one 34 × 26 (86.3 × 66.1) copper plate
Printed in black with hand painting in red, blue, green, orange, and yellow watercolor after editioning
Paper: 41⅝ × 31¾ (115.7 × 80.6) Rives BFK
Edition: 8, plus 4 AP
Proofed by Aldo Crommelynck, printed at Atelier Crommelynck; published by Pace (193-193)

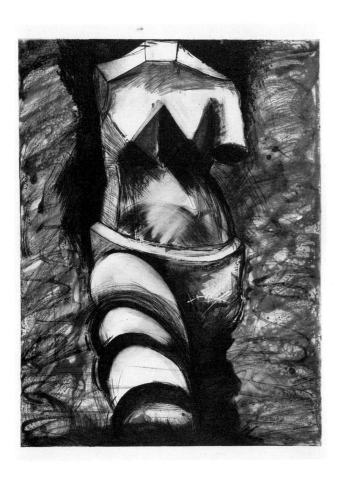

195. Black and White Cubist Venus 1985

Drypoint, aquatint, and electric tools from one 33¾ × 26 (90.8 × 66.1) copper plate
Printed in black
Paper: 41¾ × 30¾ (105.4 × 78.1) Hahnemühle
Edition: 50, plus 11 AP
Proofed by Aldo Crommelynck, printed at Atelier Crommelynck; published by Pace (193-195)

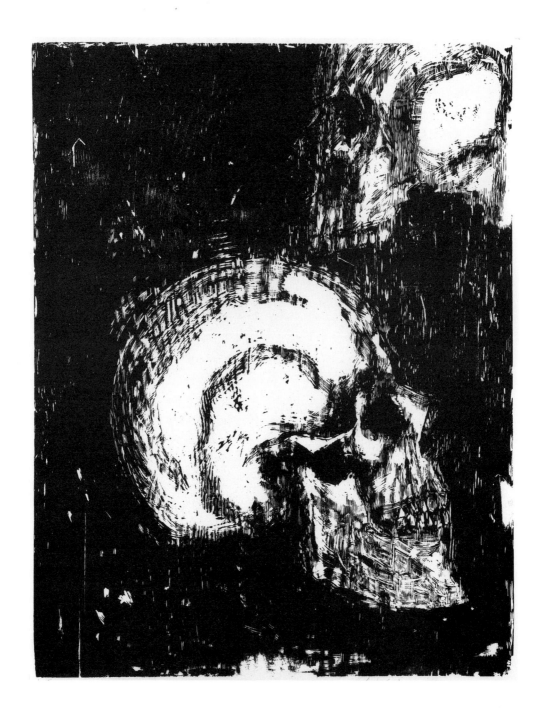

196. The Channel, Two Side Views 1985

Woodcut from one 47 × 37 (119.3 × 94) pine plywood block
Printed in black
Paper: 49 × 39 (124.5 × 99.1) Arches buff
Edition: 12, plus 21 AP, 2 TP, 1 Angeles Press impression, 1 BAT
Printed by Toby Michel, Angeles Press (84–141); published by Pace

Dine cut the large woodcut of two skulls in profile (196) in the autumn of 1984 while working on sculpture at the foundry in Walla Walla, Washington. The plywood block is in the collection of the Museum of Fine Arts, Boston.

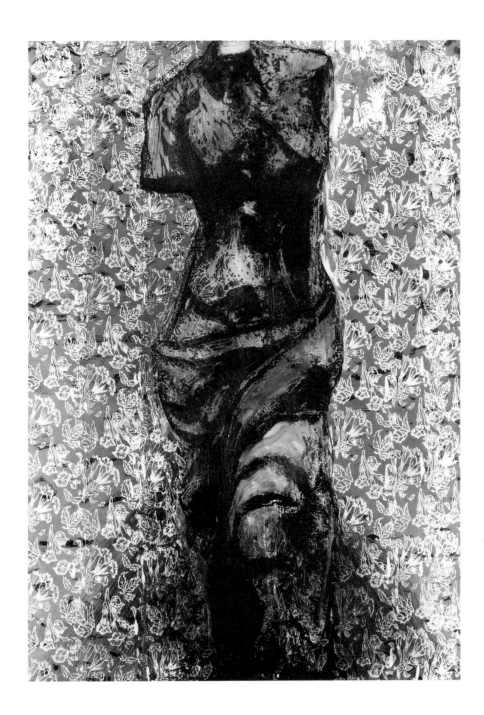

Nine Views of Winter (197-205) is from the same block as *Black Venus in the Wood* (160) and its related prints. The block was trimmed at the top and bottom so that the earlier jigsawed two-part block now becomes three: a central Venus shape and two side pieces. The printing of the nine editions, utilizing one, two, or three parts of the block, took place during two extended visits at Angeles Press. The block was altered during the course of the editioning with the following results: *Nine Views of Winter (1–7),* prints numbered 1–7, and 5 AP's are from the block's first state with 8-24 (through 35 for No. 3) being from the third state; *Nine Views of Winter (8),* prints numbered 1–7, and 5 AP's, are from the second state, with 8-24 being from the third state; and *Nine Views of Winter (9),* the entire edition is from the third state. This series is created not only with

this sawn, gouged block, but with a stainless steel plate and another sawn plywood block. These additional surfaces provide flat color.

197. Nine Views of Winter (1) 1985

Woodcut from one sawn mahogany plywood block and one stainless steel plate
Printed twice in black (once as surface roll), once in blue, and once in red, and rolled with floral-patterned roller in white latex with hand painting in flesh oil and solvent before final black printing
Paper: 52½ × 37 (133.3 × 94) Arches buff
Edition: 24, plus 5 AP, 1 unique state proof
Printed by Toby Michel, Angeles Press (84–130); published by Pace (193-181)

167

198. Nine Views of Winter (2) 1985

Woodcut from one sawn mahogany plywood block and one stainless steel plate
Printed once in red-orange (surface roll) and twice in green with hand painting in black oil stick, charcoal, and solvent after second printing
Paper: 52½ × 37 (133.3 × 94) Arches buff
Edition: 24, plus 5 AP, 2 unique state proofs
Printed by Toby Michel, Angeles Press (84-131); published by Pace (193–182)

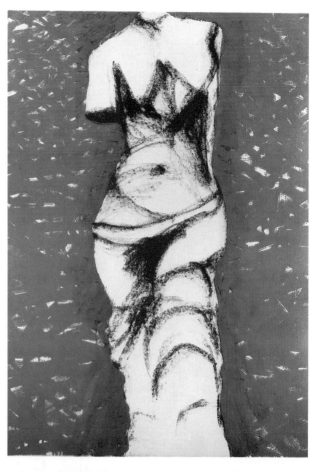

199. Nine Views of Winter (3) 1985

Woodcut from one sawn mahogany plywood block and one stainless steel plate
Printed once in gray (surface roll), once in transparent black, and once in black with hand painting in several colors of oil and white oil stick after second printing, with scraping after editioning
Paper: 52½ × 37 (133.3 × 94) Arches buff
Edition: 35, plus 5 AP, 1 unique state proof
Printed by Toby Michel, Angeles Press (84-132); published by Pace (193–183)

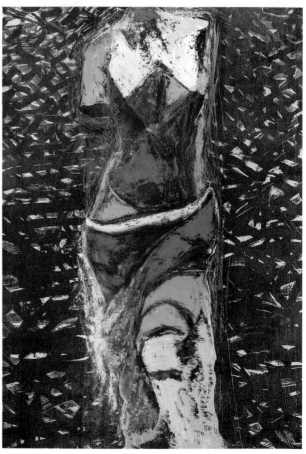

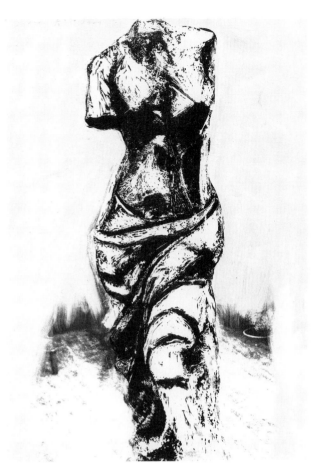

200. Nine Views of Winter (4) 1985

Woodcut from one sawn mahogany plywood block; screenprint from four screens
Screenprint printed four times in tones of black and gray, and woodblock printed in black with hand painting in white latex and gray acrylic between screen and woodcut printings
Paper: 52½ × 37 (133.3 × 94) Arches velin
Edition: 24, plus 5 AP, 1 unique state proof
Printed by Toby Michel, Angeles Press (84-133); published by Pace (193-184)

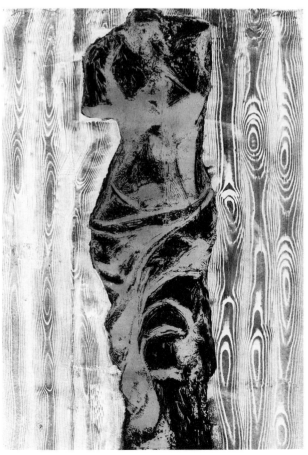

201. Nine Views of Winter (5) 1985

Woodcut from one sawn mahogany plywood block and one stainless steel plate
Printed once in black (surface roll) and twice in white with hand rubbing in solvent after first white printing and hand painting in white latex rubbed with a wood grainer after editioning
Paper: 52½ × 37 (133.3 × 94) Arches buff
Edition: 24, plus 5 AP, 2 unique state proofs
Printed by Toby Michel, Angeles Press (84-134); published by Pace (193-185)

202. Nine Views of Winter (6) 1985

Woodcut from one sawn mahogany plywood block
Printed once in blue, once in yellow, and once in orange, and
rolled in red, blue, and yellow from three floral-patterned rubber
rollers before printing, impressions 1–7 and 5 AP's also printed
once in white and once in transparent black
Paper: 52½ × 37 (133.3 × 94) Masa
Edition: 24, plus 5 AP
Printed by Toby Michel, Angeles Press (84–135); published by
Pace (193-186)

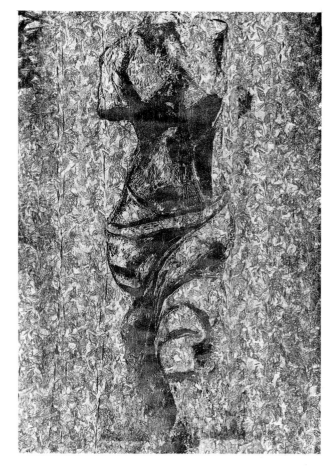

203. Nine Views of Winter (7) 1985

Woodcut from one sawn mahogany plywood block
Printed once in blue and green with hand painting in yellow
acrylic, blue oil, and charcoal and scraping after editioning
Paper: 52½ × 37 (133.3 × 94) Arches buff
Edition: 24, plus 5 AP
Printed by Toby Michel, Angeles Press (84-136); published by
Pace (193-187)

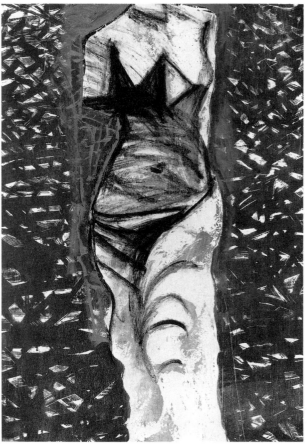

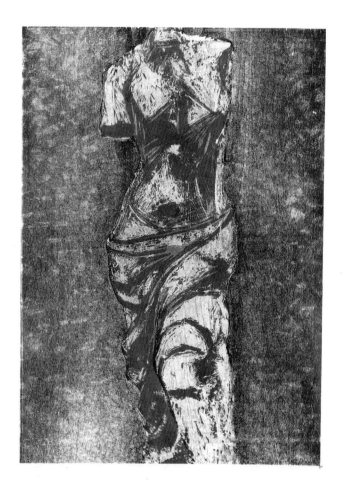

204. Nine Views of Winter (8) 1985

Woodcut from one sawn mahogany plywood block and one sawn pine plywood block
Printed once in transparent black, once in black, once in pink, and once in hot red with hand painting in interference red acrylic after black printing
Paper: 52½ × 37 (133.3 × 94) Okawara
Edition: 24, plus 5 AP
Printed by Toby Michel, Angeles Press (84-137); published by Pace (193-188)

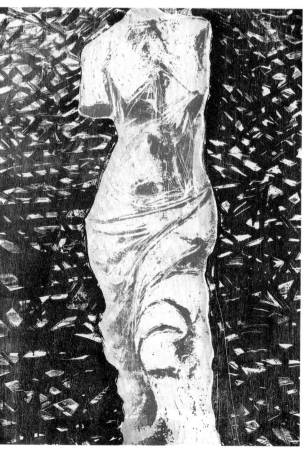

205. Nine Views of Winter (9) 1985

Woodcut from one sawn mahogany plywood block and one sawn pine plywood block
Printed once in ochre, once in hot red, and once in green
Paper: 52½ × 37 (133.3 × 94) Arches buff
Edition: 24, plus 5 AP, 1 TP
Printed by Toby Michel, Angeles Press (84-138); published by Pace (193-189)

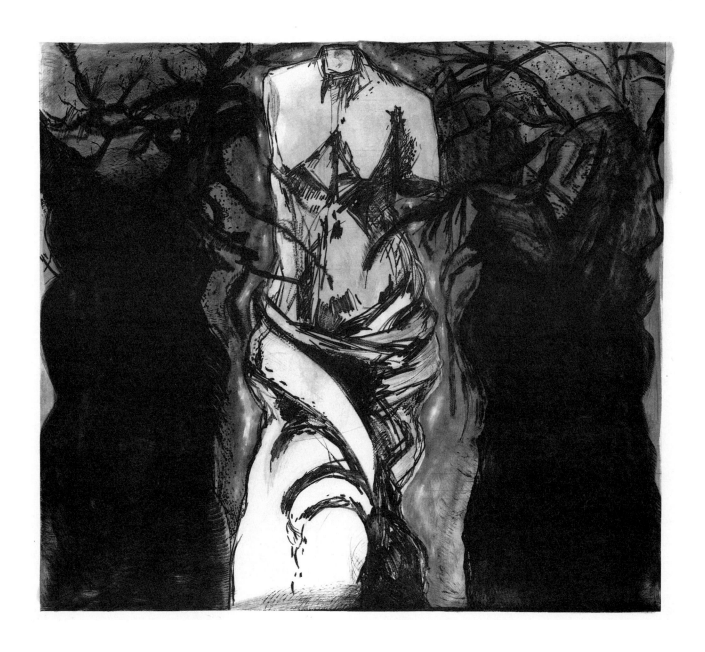

206. Rise Up, Solitude! 1985

Drypoint and electric tools from one 48 × 54 (121.9 × 137.2)
copper plate
Printed in black with hand painting in blue and flesh acrylic
before editioning and white and yellow watercolor after editioning
Paper: 52 × 58 (132.1 × 147.3) Arches rolled
Edition: 35; plus 10 AP, 1 PP
Printed by R. E. Townsend, Inc., Georgetown, MA; published by
Pace

APPENDIX

A. Primrose 1978

Drypoint from one 8¼ × 6¾ (21 × 17.2) copper plate
Printed in black
Paper: 29¾ × 21 (75.6 × 53.4) Copperplate Deluxe
Edition: 17, plus 6 AP, 2 WP
Proofed by Mitchell Friedman, printed by Jeremy Dine, New York (Pace 193-35)

Working proofs of *Primrose* show that it began as a double image. The second primrose was burnished out and then the plate was cut in half and trimmed down. These proofs, as well as working proofs of other uneditioned floral images from the same period, are in the artist's possession.

B. Portrait of Jeremy 1979

Etching from one 35¼ × 25 1/3 (89.6 × 64.3) copper plate
Printed twice in black with hand painting in blue and magenta or orange oil between printings and after editioning
Paper: 40⅞ × 29¼ (103.8 × 74.3) white wove
Edition: unknown
Proofed by Mitchell Friedman, printed by Jeremy Dine (Pace 193-40)

The plate of *Asian Woman, Pregnant and Grieving,* 1976, was burnished down and extensively reworked for this portrait of Dine's son with a camera. The edition is now with the artist for possible additional work.

C. Portrait of Anna Ticho 1979

Soft-ground etching and drypoint from one 9¾ × 8⅞ (24.7 × 22.8) copper plate
Printed in brown
Paper: 30 × 22¼ (76.2 × 56.5) Arches Aquarelle
Edition: unknown, plus 3 AP
Printed by Ami Rosenberg, Burston Graphic Center (Pace 193-74)

D. Portrait of Peter Hillman 1979

Drypoint from one 10 × 8½ (25.4 × 21.5) copper plate
Printed in black
Paper: 30 × 22¼ (76.2 × 56.5) Rives BFK
Edition: unknown
Printed by Ami Rosenberg, Burston Graphic Center

E. Red Jerusalem Flowers 1980

Lithograph from one stone
Printed in yellow
Paper: 39⅜ × 27¾ (100.1 × 70.5) red wove
Edition: 6
Printed by Yehuda Zion, Burston Graphic Center

The series of unreleased flower prints (Appendix E,F,G)
were pulled from the same stone but printed in yellow,
black, and white on different colors of paper.

F. White Jerusalem Flowers 1980

Lithograph from one stone
Printed in black with hand painting in white oil after editioning
Paper: 41¼ × 29½ (104.8 × 74.9) Rives BFK
Edition: 1 AP
Printed by Yehuda Zion, Burston Graphic Center

G. Black Jerusalem Flowers 1980

Lithograph from one stone
Printed in white
Paper: 39⅜ × 27¾ (100.1 × 70.5) black wove
Edition: 8
Printed by Yehuda Zion, Burston Graphic Center

H. Lithograph from Marcus Street 1981

Five-part lithograph from five stones
Each stone printed once in black
Paper: five sheets of 26 × 19¾ (66 × 50.2) Rives BFK
Edition: 30, plus 11 AP
Printed by Yehuda Zion, Burston Graphic Center (Pace 193-113)
Signed lower left of right panel

I. Double Hearts 1982

Lithograph from two aluminum plates
Printed twice in black
Paper: 38 × 63 (96.6 × 160) Yoshobi
Edition: 20, plus 9 AP, 3 PP
Printed by Maurice Sanchez, Derriere l'Etoile Studios

The same plates were used in *Fortress of the Heart* (111).

J. Double Venus Woodcut III 1984

Woodcut from one 38⅛ × 27¾ (96.2 × 70.5) plywood block
Printed in white
Paper: 47 × 33⅝ (119.4 × 85.4) black
Edition: 14, plus 4 AP, plus 2 TP
Printed by Jack Shirreff, 107 Workshop, Wiltshire

K. Double Venus Woodcut IV 1984

Woodcut from one 38⅛ × 27¾ (96.2 × 70.5) plywood block
Printed in black
Paper: 47 × 33⅝ (119.4 × 85.4) olive
Edition: 9, plus 3 AP
Printed by Jack Shirreff, 107 Workshop, Wiltshire

L. A Gray Version of the Heart 1984

Lithograph from two 44¼ × 29¾ (112.4 × 75.6) aluminum
plates
Printed once in gray (surface roll) and once in black
Paper: 46½ × 32 (118.1 × 81.3) Arches buff
Edition: 15, plus 2 AP, 3 TP, 1 BAT, 1 Angeles Press impression
Printed by Toby Michel, Angeles Press (83–133a)

For an explanation of Appendix L, see No. 167.

CHRONOLOGY OF JIM DINE'S
MAJOR PRINTMAKING ACTIVITIES

1935 Born Cincinnati, Ohio.

1954–57 Student experimentation with drypoint, etching, lithography, and woodcut. Studies with Ture Bengtz, Boston Museum School, and Donald Roberts, Ohio University.

1957 Marries Nancy Minto.

1958 Moves to New York City.

1960 First published prints, 6 *Car Crash* lithographs, printed by Emiliano Sorini, Pratt Graphic Art Center, Andrew Stasik, Director.

1961 First published intaglio prints, 5 *Tie* drypoints with hand coloring, printed by Nono Reinhold, Pratt Graphic Art Center.

1962 Summer. Meets Tatyana Grosman, Universal Limited Art Editions, West Islip, New York. From 1962–69, Dine publishes 23 lithographic editions at ULAE; subjects include tools, bathrooms, palettes, hearts. Dine's favorite prints of this period are *Brush After Eating*, 1963, *Eleven Part Self-Portrait (Red Pony)*, 1965, *Kenneth Koch Poem*, 1966, and *Midsummer Wall*, 1966.

1964 First bathrobe images and first etchings, *Bathrobe*, printed by Emiliano Sorini in 1964, for *New York Ten* portfolio, published in 1965 by Rosa Esman, New York, and *Self-Portrait in Zinc and Acid.*
First published screenprints, *Awl, Throat,* and *Calico,* for three *11 Pop Artists* portfolios.

1966 April. First published portfolio, *A Tool Box,* 10 screenprints, printed by Christopher Prater, Kelpra Studios, Ltd., London, for Editions Alecto.

1967 June. Moves to London; meets Paul Cornwall-Jones at Editions Alecto.

1968 Cornwall-Jones establishes Petersburg Press and Dine begins a seven-year affiliation resulting in numerous editions of lithographs and etchings. Major Petersburg projects include *Picture of Dorian Gray,* 1968, *Photographs and Etchings* (collaboration with Lee Friedlander), 1969, *Oo la la (with Ron Padgett),* 1970, *Thirty Bones of My Body,* 1972, *Five Paintbrushes,* 1973, and *Self-Portrait in a Ski Hat,* 1974.
First published woodblock in *Bleeding Heart with Ribbons and a Movie Star.* With the exception of *Woodcut Bathrobe,* 1975, Dine waits until 1981 to explore woodcuts in depth.

October 18–December 8. *Prints by Five New York Painters,* The Metropolitan Museum of Art, New York, features graphic work of Dine, Lichtenstein, Rauschenberg, Rivers, and Rosenquist.

1970 February 27–April 19. *Jim Dine,* The Whitney Museum of American Art, New York, a solo exhibition with a large section devoted to Dine's prints.
Publication of *Jim Dine: Complete Graphics,* Berlin: Galerie Mikro, with essays by John Russell, Tony Towle, and Wieland Schmied, accompanying exhibitions in Berlin and elsewhere in Europe. Dine will continue to show his prints regularly throughout Europe and the United States, both in combination with his painting, sculpture, or work on paper, as well as in exhibitions devoted entirely to the prints.

1971 Spring. Returns to the United States to live in Putney, Vermont.
First group of *Self-Portraits,* 9 drypoints, printed by Maurice Payne, published by Petersburg Press, New York
With the tool prints of the early 1970s, claims that he "hit his stride" as a printmaker.

1973 Summer. Meets the master printer, Aldo Crommelynck, in Paris.

1974 Meets Donald J. Saff, Director, Graphicstudio, University of South Florida, Tampa, who is influential on Dine's printmaking. Produces three editions at USF in 1974–75 and returns in 1983 to produce three others.
Summer. In London, experiments in woodcut with the printer Hartmut Freilinghaus. None of these prints are released.
Fall. While a visiting artist at Dartmouth College, Hanover, meets Mitchell Friedman, with whom he will work until 1981. Uses die-grinder as an electric sander or erasing tool. In 1975, starts using it for line and tone.
Begins regular sessions of drawing from the model; this will have a major impact on his printmaking techniques and themes.

1975 August 1975–August 1976. Works with Friedman as his printer in workshop set up in "Little Red Schoolhouse," near house in Putney. Now prefers intaglio to other media and uses monoprinting techniques in his etchings for the first time.

1976 Publishes *Eight Sheets for an Undefined Novel, Saw,* and *Two Figures Linked by Pre-Verbal Feelings* with Pyramid

Arts, Ltd., Tampa, directed by Alan Eaker and Donald J. Saff.
Joins Pace Gallery and hereafter publishes the majority of his prints with Pace Editions, Inc., New York.
First editions of four Eiffel Tower images printed at Atelier Crommelynck. Dine continues to work regularly with Aldo Crommelynck.
September. Mitchell Friedman moves Dine's printshop from Putney to 205 Elizabeth Street, New York, where Dine works regularly until 1979.

1977 Publication of Thomas Krens, ed., *Jim Dine Prints: 1970–77*, New York: Harper & Row. In conjunction with the catalogue, there is an exhibition at the Williams College Museum of Art, Williamstown, followed by a tour in the northeast.
July. Makes first soft-ground drawing for what becomes a twenty-five print series, *Nancy Outside in July*, 1978–81, published by Atelier Crommelynck.

1978 Serves on the Pennell Committee with Karen F. Beall and Donald J. Saff; the committee's function is the acquisition of prints for the Library of Congress.
March. While a visiting artist at Harvard University, Cambridge, meets the master printer, Robert E. Townsend who shortly thereafter editions *Pine in a Storm of Aquatint*. Continues to work occasionally with Townsend who has one of the largest, and Dine believes, best etching presses in the U.S.
June 6–September 5. *Jim Dine's Etchings*, a major exhibition at the Museum of Modern Art, New York, Riva Castleman, Curator, followed by a national tour.
Begins showing prints with Waddington Galleries, London, which regularly organizes other Dine print exhibitions throughout Europe.

1979 Spring–Summer. Completes eighteen editions at Burston Graphic Center, Jerusalem, Nehama Hillman, Director, and returns for short periods in 1980 and 1981.

1980 Summer. First major use of the Dremel for the *Strelitzia* series. Continues to experiment with a variety of power tools and has gradually incorporated them into his working methods.

1981 First published *Tree* prints: six intaglio editions printed at the Palm Press, Tampa by Betty Ann Lenahan, Susie Hennessy, and Stan Gregory, the *The Big Black and White Woodcut Tree*, printed at ULAE by Keith Brintzenhofe.
Summer. Mitchell Friedman returns to Putney to proof and print four editions, his last work for Dine.

1982 First published *Gate* prints: two lithographs with Maurice Sanchez, Derriere l'Etoile Studios, New York, and one intaglio at Atelier Crommelynck.
Begins the eight print series, *The Jerusalem Plant*, at ULAE.
August. Cuts twenty-nine blocks for the *Apocalypse*, published by The Arion Press, San Francisco.

1983 February and November. Makes two visits to the Angeles Press, Los Angeles, and begins what will be an ongoing relationship with the master printer, Toby Michel.
Summer. In Aspen, editions seven woodblock prints.
Publication of Clifford Ackley, *Nancy Outside in July: Etchings by Jim Dine*, West Islip: ULAE, followed by a related exhibition at The Art Institute of Chicago and a national tour.

1983–84 First published *Venus* prints: five editions printed by Toby Michel and four by Jack Shirreff, Wiltshire, England.

1984 Publication of *The Temple of Flora*, San Francisco: The Arion Press, a limited edition volume with twenty-nine floral illustrations by Dine.
Releases first tool prints since 1976, *The New French Tools 1–5*, printed at Atelier Crommelynck.

1985 Publishes *Nine Views of Winter*, nine *Venus* woodcuts printed by Toby Michel, Angeles Press.

SELECTED BIBLIOGRAPHY

This compilation is a sequel to the bibliographies prepared for the preceding catalogue raisonnés of Dine's prints: *Jim Dine: Complete Graphics,* Berlin: Galerie Mikro, 1970; and Thomas Krens, ed., *Jim Dine Prints: 1970–1977,* New York: Harper & Row in association with Williams College, 1977.

Articles and Reviews

Ackley, Clifford S. "Face in a Frame." *Art News* 81 (Summer 1982): 63–64.

———. "A Conversation with Jim Dine." Unpublished transcript of an interview. Boston, Museum of Fine Arts, 23 March 1983.

"Apocalypse Now, New." *Print Collector's Newsletter* 14 (March–April 1983): 14.

Artner, Alan G. "All I am Here For is to Paint and Draw." *Chicago Tribune,* 20 February 1983, Section 6, p. 19.

Ashbery, John. "New Dine in Old Bottles." *New York Magazine,* 22 May 1978, pp. 107–109.

———. "Metaphysical Overtones." *New York Magazine,* 11 February 1980, pp. 72–73.

Boorsch, Suzanne. "New Editions." *Art News* 74 (September 1975): 50–51.

Bruckner, D.J.R. "With Art and Craftsmanship, Books Regain Former Glory." *New York Times Magazine,* 28 October 1984, pp. 37–44, 49–52.

Cavaliere, Barbara. "Jim Dine." *Arts* 51 (March 1977): 27–28.

———. "Jim Dine." *Arts* 53 (September 1978): 30.

———. "Jim Dine." *Arts* 54 (May 1980): 26.

Childs, Clovis. "Album—Jim Dine." *Arts* 57 (December 1982): 50–51.

Duffy, Robert W. "Jim Dine's Thoughtful and Intensely Personal Vision." *St. Louis Post-Dispatch,* 29 July 1984, p. 5.

Feinberg, Jean E. "Jim Dine's 'Temple of Flora'." *Garden Design* 4 (Spring 1985): 98, 100.

Feinstein, Roni. "Jim Dine's Early Work." *Arts* 59 (March 1984): 70–71.

Ffrench-Frazier, Nina. "New York Reviews: Jim Dine." *Art News* 76 (March 1977): 135.

———. "Jim Dine." *Art International* 23 (March–April 1980): 56.

Field, Richard S. "On Recent Woodcuts." *Print Collector's Newsletter* 13 (March–April 1982): 1–6.

Figuerola-Ferretti, Luis. "Obra Grafice de Jim Dine." *Goya* 172 (January–February 1983): 257.

Gardner, Paul. "Will Success Spoil Bob & Jim, Louise & Larry?" *Art News* 81 (November 1982): 102–109.

Gilmour, Pat. "Symbiotic Exploitation or Collaboration: Dine & Hamilton With Crommelynck." *Print Collector's Newsletter* 15 (January–February 1985): 193–198.

Glenn, Constance W. "Artist's Dialogue: A Conversation with Jim Dine." *Architectural Digest* (November 1982): 74, 78, 82.

Glueck, Grace. "20th Century Artists Most Admired by Other Artists." *Art News* 76 (November 1977): 78–103.

Goldberger, Paul. "Two Hotels in Los Angeles: Contrast in Fresh Attempts." *New York Times,* 5 March 1977, p. 6.

Goldman, Judith. "Prints: The Print Establishment." *Art in America* 61 (July–August 1973): 105–109.

———. "New Editions." *Art News* 76 (February 1977): 108.

———. "Jim Dine's Robes: The Apparel of Concealment." *Arts* 51 (March 1977): 128–29.

Grant, Daniel. "The Process of Making a Poster That Sings." *Newsday,* 28 August 1983.

Gruen, John. "Jim Dine and the Life of Objects." *Art News* 76 (September 1977): 38–42.

Harnett, Lila. "Marketing a Los Angeles Landmark: Spend the Night in an Art Gallery." *Marketing Communications* (August 1979): 60–61.

Heinemann, Susan. "Jim Dine, Sonnabend Gallery." *Artforum* 13 (January 1975): 65–66.

Hennessy, Susie. "A Conversation with Jim Dine." *Art Journal* 39 (Spring 1980): 168–75.

Henry, Gerrit. "New York Reviews." *Art News* 81 (March 1982): 210.

———. "A Backward Look at American Printmaking." *Art News* 76 (March 1977): 64–66.

Hughes, Robert. "Self-Portraits in Empty Robes." *Time,* 14 February 1977, p. 65.

"Jim Dine (Pace)." *Art News* 76 (March 1977): 135.

"Jim Dine: A Lady Smoking." *Artweek,* 30 April 1977, p. 16.

"Jim Dine." *Art International* 25 (April 1982): 110, 135.

"Jim Dine's 'The Pine in a Storm of Aquatint'." *Art News* 78 (March 1979): 43–44.

Kramer, Hilton. "The Best Paintings Jim Dine Has Yet Produced." *New York Times,* 9 January 1977, Section D, p. 23.

———. "The Return of Illusionism." *New York Times,* 28 May 1978, Section D, p. 26.

_____. "Jim Dine." *New York Times,* 18 January 1980, Section C, p. 19.

_____. "Art: Jim Dine Revisits Heart Motif with Tools." *New York Times,* 20 November 1981, Section C, p. 26.

Levin, Kim. "Digesting Dine." *Village Voice,* 6 March 1984, p. 75.

Liebman, Lisa. "New York Reviews: Jim Dine, Pace Gallery." *Artforum* 20 (February 1982): 87–88.

Lucie-Smith, Edward. "In View: Jim Dine." *Art and Artists* 12 (July 1977): 6.

Moorman, Peggy. "Jim Dine—Sculpture, Pace." *Art News* 83 (May 1984): 161.

Mower, David. "Through the Looking Glass and What the Artist Found There." *Art International* 23 (September 1979): 63–70.

"New Editions: Jim Dine." *Art News* 81 (April 1982): 102.

Phillips, Deborah. "Looking for Relief? Woodcuts are Back." *Art News* 81 (April 1982): 92–96.

Pomfret, Margaret. "Jim Dine." *Arts* 51 (April 1977): 39–40.

"Prints and Portfolios Published." *Print Collector's Newsletter* 8 (November–December 1977): 144.

_____. *Print Collector's Newsletter* 9 (May–June 1978): 51.

_____. *Print Collector's Newsletter* 9 (January–February 1979): 192.

_____. *Print Collector's Newsletter* 10 (May–June 1979): 55.

_____. *Print Collector's Newsletter* 10 (January–February 1980): 196.

_____. *Print Collector's Newsletter* 11 (March–April 1980): 16.

_____. *Print Collector's Newsletter* 12 (March–April 1981): 20.

_____. *Print Collector's Newsletter* 12 (May–June 1981): 48.

_____. *Print Collector's Newsletter* 12 (November–December 1981): 150.

_____. *Print Collector's Newsletter* 13 (July–August 1982): 97.

_____. *Print Collector's Newsletter* 13 (September–October 1982): 134.

_____. *Print Collector's Newsletter* 13 (January–February 1983): 218.

_____. *Print Collector's Newsletter* 14 (January–February 1984): 213.

_____. *Print Collector's Newsletter* 15 (May–June 1984): 64.

_____. *Print Collector's Newsletter* 15 (July–August 1984): 104, 108.

Ratcliff, Carter. "Jim Dine at Pace." *Art in America* 65 (May–June 1977): 116–17.

Raynor, Vivien. "Art: Jim Dine Etchings at the Modern." *New York Times,* 28 July 1978, Section C, p. 18.

_____. "Art: A Jim Dine Venture in the World of Bronze." *New York Times,* 24 February 1984, Section C, p. 22.

Rubinfien, Leo. "Review: Jim Dine, Pace Gallery." *Artforum* 15 (May 1977): 67–68.

_____. "Review: Jim Dine, Pace Gallery." *Artforum* 17 (September 1978): 79–80.

Schjeldahl, Peter. "Artists in Love with their Art." *New York Times,* 3 November 1974, pp. 30, 33.

Schwartz, Ellen. "New York Reviews: Jim Dine." *Art News* 79 (April 1980): 183–84.

Shapiro, David. "Jim Dine's Life in Progress." *Art News* 69 (March 1970): 42–46.

Shapiro, Michael Edward. Review of *Jim Dine* by David Shapiro. *Print Collector's Newsletter* 14 (March–April 1983): 27–28.

Smilansky, Noemi. "An Interview with Jim Dine." *Print Review* 12 (1980): 55–61.

Stayton, Richard. "Jim Dine." *Republic Airlines Magazine.* March 1984, pp. 40–45, 74.

Stevens, Mark. "Color Them Masters." *Newsweek* 89 (14 February 1977): 80–81.

Tallmer, Jerry. "Jim Dine: When the Image Changes." *New York Post Magazine,* 22 January 1977, p. 10.

"Turn on a Dine? Never." *Print Collector's Newsletter* 8 (March–April 1977): 14.

Turner, Norman. "Jim Dine." *Arts* 51 (April 1977): 39–40.

Zalkind, Simon. "Thirty Years of American Printmaking." *Arts* 51 (February 1977): 19.

Zeleransky, Lynn. "Jim Dine's Early Work, Sonnabend." *Art News* 83 (May 1984): 159–61.

Books and Catalogues

Ackley, Clifford S. *Nancy Outside in July: Etchings by Jim Dine.* Chicago: Art Institute of Chicago, 1983.

_____; Krens, Thomas; and Menaker, Deborah. *The Modern Art of the Print: Selections from the Collection of Lois and Michael Torf.* Williamstown: Williams College Museum of Art, 1984.

_____. *Ten Painters and Sculptors Draw.* Boston: Museum of Fine Arts, 1984.

Baro, Gene. *Graphicstudio USF: Collaboration as Education.* New York: Brooklyn Museum, 1978.

Beal, Graham W. J.; Creeley, Robert; Dine, Jim; and Friedman, Martin. *Jim Dine: Five Themes.* Minneapolis: Walker Art Center, 1984.

Belloli, Jay. *Jim Dine: The Summers Collection.* La Jolla: Museum of Contemporary Art, 1974.

Carey, Frances, and Griffiths, Antony. *American Prints, 1879–1979.* London: The British Museum, 1980.

Castleman, Riva. *Jim Dine's Etchings.* New York: Museum of Modern Art, 1978.

_____. *Printed Art.* New York: Museum of Modern Art, 1980.

_____. *Prints from Blocks.* New York: Museum of Modern Art, 1982.

Danoff, I. Michael. *Emergence and Progression: Six Contemporary American Artists.* Milwaukee: Wisconsin Art Center, 1979.

Davies, Hanlyn, and Murata, Hiroshi. *Art and Technology: Offset Prints.* Bethlehem: Ralph Wilson Gallery, Lehigh University, 1983.

Dine: Oeuvres sur Papier, 1978–1979. Paris: Galerie Claude Bernard, 1980.

Field, Richard S. *Recent American Etching.* Middletown: Davison Art Center, Wesleyan University, 1975.

Gale, Peter, and Towle, Tony. *Contemporary American Prints from ULAE.* Toronto: National Gallery of Canada, 1979.

Gardiner, Henry G. *Invitational American Drawing Exhibition.* San Diego: Fine Arts Gallery of San Diego, 1977.

Glenn, Constance W. *Jim Dine: Figure Drawings 1975–1979.* New York: Harper & Row in association with the Art Museum and Galleries, California State University, Long Beach, 1979.

_____. *Centric 8.* Long Beach: California State University Art Museum, 1983.

_____. *Jim Dine Drawings.* New York: Harry N. Abrams, Inc., 1985.

Goldman, Judith. *American Prints: Process and Proofs.* New York: The Whitney Museum of American Art, 1981.

Ives, Colta; Janis, Eugenia Parry; Kiehl, David W.; Mazur, Michael; Reed, Sue Welsh; and Shapiro, Barbara Stern. *The Painterly Print: Monotypes from the Seventeenth Century to the Twentieth Century.* New York: The Metropolitan Museum of Art, 1980.

Jim Dine: New Paintings. New York: The Pace Gallery, 1978.

Jim Dine: Paintings, Drawings, Etchings, 1976. New York: The Pace Gallery, 1977.

Jim Dine: Recent Work. New York: The Pace Gallery, 1981.

Kardon, Janet. *Artist's Sets and Costumes.* Philadelphia: Philadelphia College of Art, 1977.

Kitaj, R. B. *Jim Dine: Works on Paper, 1975–1976.* London: Waddington and Tooth Galleries, 1977.

Komanecky, Michael, and Butera, Virginia Fabbri. *The Folding Image: Screens by Western Artists of the Nineteenth and Twentieth Centuries.* New Haven: Yale University Art Gallery, 1984.

Lieberman, William. *A Treasury of Modern Drawings: The Avnet Collection.* New York: Museum of Modern Art, 1978.

Mellow, James. *Jim Dine.* New York: The Pace Gallery, 1979.

Noel, Bernard. *Jim Dine: Monotypes et Gravures.* Paris: Galerie Maeght, 1983.

Pop Art: Evoluzione de una Generazione. Venice: Palazzo Grassi, 1980.

Reaves, Wendy Wick, ed. *American Portrait Prints.* Charlottesville: University Press of Virginia, 1984.

Sacilotto, Deli. *Photographic Printmaking Techniques.* New York: Watson Guptill, 1982.

Saff, Donald J., and Sacilotto, Deli. *Printmaking: History and Process.* New York: Holt, Rinehart, and Winston, 1978.

Sandler, Irving. *The New York School: The Painters and Sculptors of the Fifties.* New York: Harper & Row, 1978.

Shapiro, David. *Jim Dine: An Exhibition of Recent Figure Drawings, 1978–1980.* Chicago: Richard Gray Gallery, 1981.

_____. *Jim Dine.* New York: Harry N. Abrams, Inc., 1981.

_____. *Jim Dine, New Paintings and Figure Drawings.* New York: Richard Gray Gallery, 1983.

Shapiro, Michael Edward. *Jim Dine: Sculpture and Drawings.* New York: The Pace Gallery, 1984.

Tuchman, Maurice. *Jim Dine in Los Angeles.* Los Angeles: Los Angeles County Museum, 1983.

Universal Limited Art Editions, A Tribute to Tatyana Grosman. New York: The Whitney Museum of American Art, Downtown Branch, 1982.

Van Straaten, William, and Sparks, Esther. *Universal Limited Art Editions.* Chicago: Van Straaten Gallery, 1980.

Walker, Barry. *The American Artist as Printmaker.* Brooklyn: The Brooklyn Museum, 1983.

Watrous, James. *A Century of American Printmaking, 1880–1980.* Madison: University of Wisconsin Press, 1984.

CHECKLIST OF PRINTS
IN THE EXHIBITION

Unless cited as from the Davison Art Center Collection (DAC), all prints were lent by the artist.

White Robe on Black Paper, 1977 (4)
Multi Colored Robe, 1977 (5)
Black and White Robe, 1977 (7)
Red Ochre Flowers, 1978 (8)
Anemones, 1978 (10)
Iris, 1978 (13)
Harvard Self-Portrait with Glasses in Sepia, 1978 (25)
Self-Portrait with Oil Paint, 1978 (28)
Self-Portrait on JD Paper, 1978 (29)
The Pine in a Storm of Aquatint, 1978, DAC (31)
Self-Portrait, 1979, DAC (42)
Hand Painted Portrait on Thin Fabriano, 1979 (44)
Unique Hand Painted Self-Portrait, 1979 (45)
Self-Portrait on Black Paper, 1979 (49)
Self-Portrait Hand Painted in Paris, 1979 (50)
Nancy in Jerusalem (Etching and Painting), 1979 (53)
Hand Painted Head of Nancy, 1979, DAC (55)
Nancy Outside in July II, 1978 (19)
Nancy Outside in July IV, 1978 (21)
Nancy Outside in July VI: Flowers of the Holy Land, 1979 (61)
Nancy Outside in July VII, 1980 (68)
Nancy Outside in July IX: March in Paris (Tulips), 1980 (70)
Nancy Outside in July XI: Red Sweater in Paris, 1980 (72)
Nancy Outside in July XV: Nancy Over the Trees, 1981 (96)
A Magenta Robe, A Rose Robe, 1979 (56)
A Well Painted Strelitzia, 1980 (73)
Strelitzia with Monotype, 1980, DAC (74)
White Strelitzia, 1980, DAC (78)
A Tree Painted in South Florida, 1981, DAC (80)
Tree (A Female Robe for Karen McCready), 1981 (81)
White Ground, Night Tree, 1981, DAC (84)
The Big Black and White Woodcut Tree, 1981 (85)
Two Hearts in the Forest, 1981 (86)
Key West Print, 1981, DAC (88)
Blue, 1981, DAC (89)
Fourteen Color Woodcut Bathrobe, 1982 (112)
Blue Crommelynck Gate, 1982, DAC (114)
Winter Windows on Chapel Street, 1982 (117)
The Heart Called Paris Spring, 1982 (118)
Desire in Primary Colors, 1982, DAC (120)
Blue Detail from the Crommelynck Gate, 1982 (122)
The Apocalypse, 1982, DAC (141)
The Jerusalem Plant #3, 1982 (133)
The Jerusalem Plant #5, 1982 (135)
The Jerusalem Plant #6, 1983 (136)
The Jerusalem Plant #8, 1984 (176)
A Sunny Woodcut, 1982, DAC (139)
A Night Woodcut, 1982 (140)
Swaying in the Florida Night, 1983 (143)
The Black and White Nancy Woodcut (First Version), 1983 (152)

Woodblock for The Black and White Nancy Woodcut (First Version), 1983 (152)
The Hand Painted Nancy (Woodcut), 1983 (154)
Cooper Street Robe, 1983 (156)
The First Woodcut Gate (The Landscape), 1983 (157)
Double Venus Woodcut I, 1984 (161)
The Yellow Venus, 1984 (163)
Double Venus in the Sky at Night, 1984, DAC (166)
Double Venus, collage with hand drawing
The Earth, 1984 (167)
The New French Tools 3—For Pep, 1984, DAC (173)
The New French Tools 4—Roussillon, 1984, DAC (174)
The New French Tools 5—Boulevard Victor, Double Sky, 1984, DAC (175)
The Temple of Flora, 1984 (177)
Lost Shells, 1985, DAC (186)
Wallpaper in Paris, 1985, DAC (187)
Wallpaper in Paris, 3 stage proofs, 1985, DAC (187)
12 Rue Jacob, 1985, DAC (190)
Tools and Dreams, 1985, DAC (191)
Venus at Sea, 1985, DAC (192)
Night Venus and Sappho, 1985, DAC (193)
Black and White Cubist Venus, 1985, DAC (195)
Nine Views of Winter (3), 1985 (199)
Rise Up, Solitude! 1985 (206)

INDEX OF PRINT TITLES

Numbers following the titles indicate references to the catalogue.

Apocalypse, The, 141a–141cc

Bee, The, 115
Bezalel Woodcut, The, 109
Big Black and White Woodcut Tree, The, 85
Black and White Cubist Venus, 195
Black and White Flowers, 2
Black and White Nancy Woodcut (First Version), The, 152
Black and White Nancy Woodcut (Second Version), The, 153
Black and White Robe, 7
Black Heart, The, 168
Black Jerusalem Flowers, App. G
Black Venus in the Wood, 160
Blue, 89
Blue and Red Gate, 113
Blue Crommelynck Gate, 114
Blue Detail from the Crommelynck Gate, 122
Brown Coat, The, 3

Channel, The, 189
Channel, My Heart, A Hand, The, 188
Channel, Two Side Views, The, 196
Cooper Street Robe, 156

Dark Portrait, A, 46
Desire in Primary Colors, 120
Double Feature (Woodcut), A, 155
Double Hearts, App. I
Double Venus in the Sky at Night, 166
Double Venus Woodcut I–IV, 161, 162, App. J, K

Earth, The, 167
Eight Little Nudes, 123–130
Eight Sheets from an Undefined Novel, State II, 33–40
Etching Heart, 87

First Woodcut Gate (The Landscape), The, 157
Five Shells, 121
Flowered Robe with Sky, 62
Fortress of the Heart, 111
Fourteen Color Woodcut Bathrobe, 112
French Watercolor Venus, The, 194

Gray Version of the Heart, A, App. L
Gray Version of the Robe, A, 170
Green Etched Strelitzia, 76
Green-Gold Strelitzia, 75

Hammer (with Watercolor Marks), The, 137
Hand Colored Flowers, 1
Hand Painted Nancy (Woodcut), The, 154

Hand Painted Portrait on Thin Fabriano, The, 44
Handmade Double Venus, 165
Harvard Self-Portrait with Glasses in Sepia, 25
Harvard Self-Portrait with Paint, 24
Harvard Self-Portrait without Glasses, 23
Heart and the Wall, The, 145
Heart at the Opera, A, 149
Heart Called Paris Spring, The, 118
Heart on the Rue de Grenelle, A, 91
Hiroshima Clock, First Version, 180
Hiroshima Clock, Second Version, 181

Jerusalem Plant, A, State I–III, 58–60
Jerusalem Plant #1–8, 131–136, 148, 176
Jerusalem Woodcut Heart, The, 110
Jewish Heart, The, 138

Key West Print, 88
Kindergarten Robes, The, 146

L.A. Eye Works, 116
Lithograph from Marcus Street, App. H
Little Black and White Self-Portrait, 48
Lost Shells, 186
Louisiana Hearts, 119

Magenta Robe, A; Rose Robe, A, 56
Me in Horn-Rimmed Glasses, 47
Men and Plants, 30
Multi Colored Robe, 5

Nancy in Jerusalem, 51–55
Nancy Outside in July I–XXV, 18–22, 61, 68–72, 93–106
New French Tools, 1–5, 171–175
Night Venus and Sappho, 193
Night Woodcut, A, 140
Nine Views of Winter (1–9), 197–205

Philadelphia Heart, The, 178
Pine in a Storm of Aquatint, The, 31
Pink Strelitzia, 77
Portrait of Anna Ticho, App. C
Portrait of Jeremy, App. B
Portrait of Peter Hillman, App. D
Primrose, App. A
Printing Outdoors, 65

Rachel Cohen's Flags, State I–II, 41, 90
Rancho Woodcut Heart, The, 142
Red and Black Diptych Robe, 63
Red Jerusalem Flowers, App. E
Red Ochre Flowers, 8
Red Robe in France, 185
Red, White, and Blue Venus for Mondale, The, 182
Rise Up, Solitude!, 206

Robe Against the Desert Sky, A, 57
Robe Goes to Town, The, 144
Robe in a Furnace, 67
Robe in France, The, 184
Robe in Los Angeles, A, 169
Roses, 32

Self-Portrait, 42
Self-Portrait Hand Painted in Paris, 50
Self-Portrait in a Convex Mirror, 179
Self-Portrait in Gray, 43
Self-Portrait on Black Paper, 49
Self-Portrait on JD Paper, 29
Self-Portrait with Blue Tint, 27
Self-Portrait with Oil Paint, 28
Self-Portrait without Glasses, 26
Shell from the Gulf of Acaba, 107
Sky, The, 164
Spray Painted Robe, 6
Strelitzia with Monotype, 74
Sunny Woodcut, A, 139
Swaying in the Florida Night, 143

Temple of Flora, A, 9–17
Temple of Flora, The, 177a–177cc
Three Sydney Close Woodcuts, The, 147
Three Trees in the Shadow of Mt. Zion, 108
Tools and Dreams, 191
Tree Covered with Rust, A, 83
Tree, Curvaceous and Blue, A, 79
Tree (A Female Robe for Karen McCready), A, 81
Tree in Soot, A, 82
Tree Painted in South Florida, A, 80
12 Rue Jacob, 190
Two Hand Colored Colorado Robes, 151
Two Hearts for the Moment, 183
Two Hearts in the Forest, 86
Two Robes with Watercolor, 150
Two Tomatoes, 92
Two Very Strange Hearts, 158

Venus at Sea, 192

Wallpaper in Paris, 187
Well Painted Strelitzia, A, 73
White Ground, Night Tree, 84
White Jerusalem Flowers, App. F
White Robe on Black Paper, 4
White Strelitzia, 78
Winter, 66
Winter Windows on Chapel Street, 117
Woodcut in the Snow, A, 159

Yellow Robe, The, 64
Yellow Venus, The, 163